MW00807254

Also On View

Unique and Unexpected Museums
of Greater Los Angeles

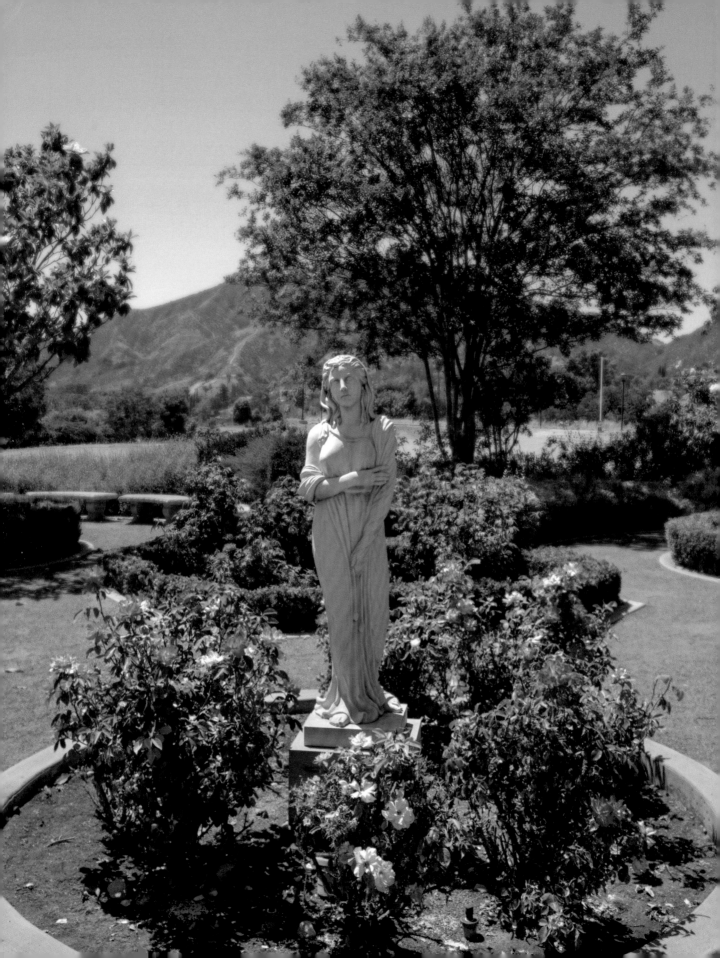

Also On View

Unique and Unexpected Museums
of Greater Los Angeles

Todd Lerew ■ Photography by Ryan Schude

ANGEL CITY PRESS
LOS ANGELES PUBLIC LIBRARY

*A sculpture in the rose garden
on the sixteen-acre grounds
of the Edward-Dean Museum
& Gardens.*

For Ken Brecher

whose deep curiosity, artful irreverence, incomparable talent for bringing out the truest version of others, and purposeful sense of adventure informs the spirit of this work, and for whose friendship and mentorship I am eternally grateful.

Contents

Overleaf: A dove nesting in the Museum of Jurassic Technology's rooftop courtyard and aviary.

Introduction

M ars rovers, Happy Meal toys, linotype machines, esoteric art, solid redwood surfboards, dioramas of Black history, a gold record for a 1973 country hit, tools for harvesting the silk of black widow spiders, neon signs, Lincoln's cufflinks, a Firestone factory's first and last tires off the line, a South Vietnamese army uniform, a spiral model of geological time, a pair of crutches abandoned after an act of divine healing, a working ranch, a million bird eggs and thousands of nests...

What all these things have in common is that they can be found somewhere within greater Los Angeles, and that they are the subject of a communal, personal, or institutional endeavor to share something unique and important through a display in a museum. These objects wouldn't make sense under the same roof, couldn't be given equal attention by any one institution— no matter how encyclopedic its aspirations—and are better off left, whenever possible, in the place from which they originate or with the people they directly represent. We can therefore be thankful that this vast metropolitan expanse is home to so many singular, enterprising individuals who have dedicated their efforts to creating a museum and welcomed others to visit.

While the definition of a museum is by no means fixed, it should be safe to suggest that its basic function is to highlight a set of interests, beliefs, creations, lived experiences, professions, identities, histories, and environments—and invite people in to engage with or learn from them. For the curious person, a glimpse of a world markedly different from one's own can be profoundly expansive and enlightening, often joyful and inspiring, occasionally disruptive or disagreeable. It is the capacity for inspiration, paired with a drive towards preservation, that is the underlying mission shared by most museums, big and small. And since curiosity plays an outsize role in my own identity, this subject is of particular interest, to the point of obsession. I've long been involved in arts and culture, especially music, and have always been most intrigued by the things that push the boundaries of our perception, cause us to ask basic questions about ourselves, and expose us to new experiments and experiences, even when rooted in tradition.

As a kid growing up on a small farm in conservative, rural South Dakota, I quickly grew averse to the mainstream, and was drawn to the unusual. Throughout high school, my bedroom had so many tchotchkes hanging from the ceiling and random ephemera collaged onto the wall that it resembled a nascent folk art environment, and while I've not had a chance to go back to confirm, I have to assume that one of the first things the family that bought our home did after getting the keys was to cover up the giant cat head with

bloodshot eyes that I crudely painted on the bathroom wall. I moved to Los Angeles in 2012 to pursue a master's degree in experimental music composition at CalArts, but before long I was also visiting noted Southern California folk and outsider sites—from the Watts Towers to the Integratron to Grandma Prisbrey's Bottle Village to the Rubel Castle (see page 245)—like it was my job.

At some point, I found that small historical society museums, which exist by the thousands in towns and neighborhoods across the country, often align somehow with my predilection for unique experiences, fascination with eccentric and iconoclastic individuals, and belief in the power of captivating and unbelievable stories. Sure, there is a lot of whitewashed history out there, but even time spent listening to those with whom I disagreed, or whose personal politics would normally guarantee that we would not commingle, felt valuable in our polarized, echo chamber-filled society. The promise of seeing or learning something unexpected was all I needed to set off in a given direction on a weekend road trip, often hitting as many as six or seven small museums in a single day.

With remarkable (almost comical) consistency, when people I meet in Los Angeles learn of my particular interest in unusual or niche museums, the first question is whether I've been to or even heard of the Museum of Jurassic Technology (MJT; see page 275)—or, just as often, that strange place in Culver City, what was it called...? Indeed, on one of my first visits prior to moving to Los Angeles, I made what felt like a pilgrimage to the MJT, which had been the topic of much discussion amongst my friend group and at my undergraduate alma mater, Hampshire College. When it comes up in conversation, I have to mention that not only am I well aware of this unique museum, but I also ended up marrying one of its former collaborators, artist and healthcare provider Bridget Marrin, who built models for several notable exhibits (and has additional work on display at the Velaslavasay Panorama, see page 255). Even after countless visits to the MJT, and peering behind the veil as it were, the original sense of enchantment persists, so perhaps it's only appropriate that now my own work involves proselytizing for it.

After a stroke of good fortune that brought me to work for the Library Foundation of Los Angeles, producing exhibitions and public programs with and in support of the Los Angeles Public Library, in 2018 I was tasked by my then boss and mentor Ken Brecher (to whom this book is dedicated) with curating a large-scale exhibition on the subject of collecting, which came to be called *21 Collections: Every Object Has a Story.* By that time, I had been to some two hundred museums across greater Los Angeles, and it was ostensibly for research purposes that I then decided I would try to visit them all. Though severely limited in the number of collections and stories that could be contained by a single exhibition, I also administered an Instagram account (@museumaday) where I shared a museum in the region on each of the 178 consecutive days the show was on view. In addition, we hosted what was likely the first ever Mobile Museum Fair, with more than twenty-five mobile museum

trucks and other itinerant institutions parked throughout the Los Angeles Central Library grounds on a Sunday afternoon. Around six thousand patrons of all ages came to enjoy pop-up and roving exhibits from the California Sneaker Museum, the Connecting Cultures Mobile Museum, the Aquarium of the Pacific on Wheels, and many others.

I've now spent the last decade attempting to find and visit every museum in greater Los Angeles, and it's likely that I've been to more of them than any other single person. This may seem a dubious distinction, but the collection of encounters with so many outstanding individuals, and the feeling of getting to better understand how this remarkable city and its environs operate, has been my reward. After years of stockpiling them, I am grateful to have this outlet to share some of these stories, celebrate them, and play a small role in helping to preserve them.

Define *Museum*

As with most things, the harder you look for museums, the more you will find. Greater Los Angeles is home to more than 750 museums by my count, which far outpaces any other American metropolis, and puts us close to the top worldwide: in the running with London and Moscow, and likely ahead of Paris and Mexico City. Granted, there are different ways of defining what constitutes a city or a metropolitan area's boundaries, but perhaps more importantly, the count depends on how liberal your definition of "museum" actually is. It wasn't until I decided to visit every local museum that it became clear there would be some difficulty in figuring out what should even count as one. I might have known: it is almost inevitable that a broad subject becomes increasingly more nuanced and complex as one's engagement with it deepens. Such is the case here, and I've had to contend with several gray areas, often struggling to be consistent.

Traditionally, museum professionals held that institutions should have a physical collection under their care to be considered museums. But *kunsthalles*—art museums that don't collect, like the ICA LA (formerly the Santa Monica Museum of Art, where I also worked briefly)—challenge that rule. Add to that the evolution and proliferation of children's museums, which favor experiential, play-based environments (see Pennypickle's Workshop on page 83), and the need to collect is no longer much of a sticking point. A museum should also be not-for-profit, according to some, though there are those which are corporate-sponsored and can't be ruled out on that basis alone (Wells Fargo and Bank of America's history centers downtown are good examples, even if the former shut down eleven of their twelve museums across the country in 2020, the LA location included). Most definitions will include zoos and aquaria as living museums; doesn't it follow that every little nature center with space for exhibits should also be allowable? Then there are college-based art spaces and nonprofit community galleries, some of which call themselves museums whereas others that operate in identical fashion will insist that they are not. Finally, many say

museums should be open to the public; but what if a museum is only open a few hours each month, only during special events, strictly by appointment, or if you can't seem to ever get ahold of someone?

Indeed, there is no single definition that satisfies everyone with a reason to care. I'm not a museologist by training (yes, that is an actual professional field), but I've dabbled in the literature enough to know that I'm not the only one who has been forced to conclude that the jury is still out, and maybe always will be. Even the International Council of Museums (ICOM), a well-established global consortium, found itself at the center of a heated debate in recent years, garnering rare mainstream press for this United Nations-esque assembly. In 2019, a new definition was proposed by an internal committee which stated that museums are "...democratising, inclusive and polyphonic spaces for critical dialogue...aiming to contribute to human dignity and social justice, global equality and planetary wellbeing." It sounds nice, but was met with backlash from members who decried it as politicized and aspirational. They've since gone back to something more traditional, and while ICOM plays an important role in the professional and especially government-run museum sphere, it means little to those like the volunteers who restored the Cucamonga Service Station on old Route 66 (see page 121) and don't require external validation to know what they've got.

All that to say, I don't have a fixed definition for this project, and prefer not to think of myself as a gatekeeper for the term, taking an inclusive approach. I'm left with the set of considerations listed above, relying on various aspects to build a case-by-case argument. I often defer to the creator or proprietor to see if they consider their display or space a museum, and rarely argue or deny a positive claim. An interesting case amongst those featured in this book is the visitor center at the Jet Propulsion Lab (see page 79), where multiple staff members said they didn't think there was in fact a museum, even though clear directional signage on campus and on the virtual tour menu say otherwise.

The Museum-scape of Greater Los Angeles

So, how can the more than 750 museums in the region—an unwieldy list by any metric—be organized by category? I've identified sixteen military museums, fifteen fire museums, nine relating to sports, huge numbers of art museums and nonprofit galleries, an even greater number of historical societies and house museums including more than twenty adobe homes (ancient history by Southern California standards), more than one hundred relating to natural history, about thirty representing ethnic groups, a dozen or so children's museums, plus forty-eight dedicated strictly to planes, trains, or automobiles. Even after all that, there are still around eighty that are highly specific and defy categorization.

To understand what can be gained from visiting so many disparate institutions, many of which likely don't intersect with one's own interests, consider again the prospect of entering new worlds. It might be a tattoo shop

that's the last vestige of the Long Beach Pike amusement zone, or an Armenian assisted-living facility in Mission Hills, a community-based nonprofit in Watts, a residential high school in Claremont with an unusually vibrant paleontology program, a shopping mall in Simi Valley, a downtown municipal office building, the LAX airport tarmac, or the top of a mountain in the Angeles National Forest. Approaching these places with an open mind can usher in new perspectives, nurture a sense of adventure, and contribute to the feeling of a well-rounded life—as well as provide fodder for cocktail party small talk.

I'm often asked how I find them all. In addition to lots of traditional research in books and articles and community newspapers, seeing things listed on the map, and pulling over if I happen to pass an interesting sign, I did become associated with this search, so friends and acquaintances would often reach out if they heard about a museum that sounded interesting or obscure. After a significant drive out to one, it was not uncommon to find it unexpectedly closed if no volunteers were available to open that day; other times, places with no listed hours happened to be open for an event of some kind, or I would find another site I hadn't been expecting. As my list has grown beyond all expectations, I'm more confident than ever that there are even more that continue to elude me.

Defining what constitutes greater Los Angeles has been another practical challenge. Speaking purely geographically, I found that I needed to draw a line somewhere. If one were limited strictly to Los Angeles city limits, there would be just over two hundred museums included—though the wild outline of that map is of course more a result of piecemeal annexations than any logical encircling of a coherent city. Taking Los Angeles County as a whole, there would be about five hundred museums available to visit, but the populated area is contiguous with several of the surrounding counties (one of which, Orange County, was even part of LA County before it seceded in 1889). So I take a broader view, with this survey considering an area encompassing all of Los Angeles, Orange, and Ventura Counties, as well as the Inland Empire portions of Riverside and San Bernardino Counties (excluding their mountains and deserts)—all within a reasonable day trip from downtown LA.

Another natural question may be: *why* so many museums here? Answering this is likely a project beyond my scope, but I do look to what it is that created and defined this place. Southern California's meteoric development was fueled by seekers: of a healthful and agreeable climate, of success in agriculture or industry or "the industry," and of a diasporic community or asylum. Combine this with stereotypes about the West Coast's relaxed and accepting culture, or how California is said to attract weirdos, free thinkers, and rugged individualists. Without making it out to be a grand thesis, this all must at least partially explain the propagation of museums throughout the area, as well as their heterogeneity and uniqueness.

Elitist cultural commentators advance a persistent narrative that Los Angeles has only in recent years emerged as a major player on the global cultural

scene. The commercial art market, and the presence and activities of mainstream museums, can often be misconstrued as standing in for *culture* more broadly. As perhaps I've made clear, it's my belief that this kind of thinking indicates a closed-minded view as to what warrants our collective attention, and it's become something of a crusade for me to advocate for the appreciation of stories that may not attract the awareness I feel they rightfully deserve—in other words, for everything that is Also On View.

It must be noted that within the last decade, a broad conversation (and hashtag) has emerged around the idea that "museums are not neutral." At many high-profile institutions, there have been internal and external pressures to address historical and structural inequities; large museums have struggled to meet the expectation that they serve everyone, and to eradicate bias in the ways they represent histories, engage with communities, and do business. Many have figural (and sometimes also literal) skeletons in their closet, and are rightly being compelled to change course if they wish to remain relevant. I am not here to suggest that small museums should be considered exempt from similar criticism, that they aren't touched by the specters of colonialism, or that they cannot do better, even if they are run by volunteers or by individuals who themselves have been historically marginalized. The project of this book is to lift up the places that operate on a different plane than professionalized, well-endowed museums (where the stakes are admittedly higher given their reach), and embrace them in their diversity and messiness. I want to help ensure that where anyone has an incredible story to share, others will show up and listen.

Also On View

I'm not a student of the Bhagavad Gita, am not Finnish or Garifuna, don't collect old personal computers, practice martial arts, listen to big band music, skateboard, or study citrus or warfare. Nevertheless, I can think of no better way to have explored our vast metropolis and the countless worlds that coexist within it than by visiting museums dedicated to those topics. I treasure each encounter with those who bring these spaces to life through their dedication and resolve, and my journey could hardly have been more meaningful or memorable— though I still struggle to respond when asked which is the most unusual, the most obscure, or my favorite.

Only sixty-four unique institutions could fit in this volume: a not insignificant effort, and yet it's still less than ten percent of the local museum-scape as it stands. Despite every attempt to ensure diversity of subject matter, representation, and geography, an inevitable reaction may be to protest the exclusion of a specific site. I can only say that any omissions weren't for lack of interest, and that I support every effort to promote the celebration and visitation of many more spaces beyond this eclectic survey.

Also on View is organized into nine thematic categories, from museums which are characterized by their representation of Community and Culture,

to the imaginative and immersive institutions filed under Portals in Time and Space. More than a few could easily fit under several of these broad themes. All of them have something to do with history, something to do with culture, and something that makes them totally unique. They have been ordered with intention, but each museum essay is self-contained and the book can be explored according to the reader's interest or itinerary.

This book is not meant to serve as a guidebook in the traditional sense, and will not be a practical resource for the average tourist. For each featured museum, I've attempted to delve into their history and context, sharing something of how they came about, what there is to see, and how it fits into the broader museum-scape of the region. No documentation or description can supplant the dynamic reality of being in these spaces and engaging with the creators or caretakers, and I would hope that readers are inspired to seek out some of the experiences I've attempted to convey. Exact instructions of how and when to visit any given museum are best confirmed via their website, social media, or direct communication; it's always advised to verify before commencing your journey. Inevitably, by the time you are reading this, some may have permanently closed.

Sadly, in the time since beginning to work on this project, two of the inimitable individuals featured have left us: Magic Castle co-founder and builder, Milt Larsen, and First Original McDonald's Museum creator and fast food restaurateur Albert "The Chicken Man" Okura both passed away in 2023. I feel fortunate to have met them; I will always be reminded of Milt when I see someone attempt the tablecloth-pulling trick, and of Albert every time I drive past a Juan Pollo or taste an inappropriately spicy hot sauce. While mourning this loss, we can also be grateful that the institutions for which they were a driving force will both carry on in their memory. There are quite a few others that would not be so lucky.

I didn't set out to be a historian, critic, or tour guide. I have been driven by a compulsive pursuit of new experiences, the joy of discovering stories that expand my worldview, and a belief in the value of getting outside of my comfort zone and meeting people who I would never otherwise encounter. Ultimately, it has proven to me that Los Angeles is even more vast and weird and wonderful—and that its inhabitants are more interesting, imaginative, generous, and wise—than we often allow or imagine. LACMA, the Broad, and the Natural History Museum are all great, and they'll be there, but here's a chance to take a trip to some of the other incredible places out there that are Also On View.

Garifuna Museum of Los Angeles (GAMOLA)
South LA

The most profound museum experiences can alter or broaden our worldview, exposing us to local communities and entire cultures with which we might otherwise be unfamiliar. While major encyclopedic or ethnographic museums sometimes have that goal, no amount of comprehensive study, tech-heavy immersion, or fabrication budget can compete with the subtle power of visiting the Garifuna Museum of Los Angeles, where the people themselves have not only created the displays but will also guide visitors on a personalized voyage of cultural awareness. The location, in a former home on a purely residential street in South LA, adds to the museum's intimacy, allowing for a greater impact for the many visitors who may go in knowing little or nothing about this dynamic and resilient culture.

The Garinagu (that's Garifuna, plural) trace their lineage to the seventeenth century, when native Carib and Arawak peoples on the Caribbean island of Saint Vincent intermixed with Africans who were likely shipwrecked survivors of the Spanish slave trade. Later, after a few decades of skirmishes and remarkably successful defenses against the British—who were on an ever-expanding imperial campaign to establish colonies with profitable plantations—the

Partial view of the Artifacts Room.

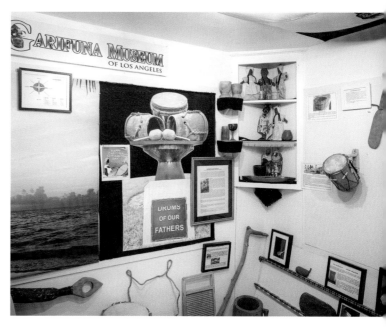

Garinagu were eventually defeated and exiled to the island of Roatán in Honduras in 1797. The diaspora today resides primarily in Belize, Honduras, and the US, with outposts in Nicaragua, Guatemala, and their native St. Vincent, or *Yurumein* as it is known to them.

There is no official count for the number of Garinagu in the LA area, but a significant presence goes back decades; the community has been hosting cultural festivals and performances since at least the 1970s. The Garifuna Museum of Los Angeles was founded by activist and linguist Ruben Reyes to bring greater cultural awareness to his own community and beyond. The museum opened in 2011 in a Craftsman-style home built exactly one hundred years prior and made available to them

Detail of a Wanaragua *warrior dancer costume.*

by the Blazers Learning Center, an after-school enrichment program for disadvantaged youth founded in 1969 and occupying the adjacent home.

Walking in the front door to the large and inviting living room, one will see a beautiful fireplace and an illustrated timeline filling up a long wall, but the thing that is most striking is the traditional costume of a *Wanaragua* warrior dancer holding a spear and posing mid-performance. A hallmark of the costume is that it includes Western-style women's clothing, as cross-dressing was a historical tactic of surprise attack used successfully against the British. The mask is the pale skin tone of the colonizers, perhaps in mockery, and is adorned with feathers as was common amongst the native Arawak; affixed to the lower legs are cloth straps with dozens of small shells that rattle during the dance. The best chance to see this performance in action (and to sample the traditional food and music) is during one of the community's signature events such as Garifuna Settlement Day (November 19th), a national holiday in Belize.

Continuing to the back of the house past the kitchen, the Artifacts Room is filled with unique objects of cultural significance, such as an *egi,* a board embedded with small, sharp rocks used to grate the cassava (or yuca) root, a critical food source. The *egi* is paired with an ingenious device called a *ruguma,* which is a tube-shaped woven basket that works similarly to a "Chinese finger trap" toy but with loops on the ends that can be twisted with inserted rods. This squeezes the shredded cassava and extracts the poisonous juice so that it is safe to be used in making *casabe* bread. In the corner, there is a shrine that includes *sísira* (musical shakers) fashioned

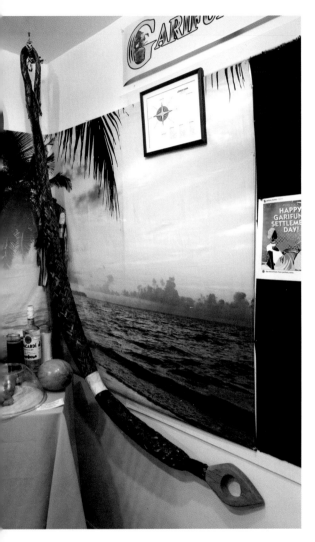

A ruguma, used to squeeze the poisonous juice out of shredded cassava.

from calabash gourds filled with dried wild beans or small rocks. In another case, a turtle's hollowed-out shell is repurposed as a drum, and a bottle of rum is filled with roots and herbs to make the traditional bitters called *gifiti.*

A former bedroom houses a library and reading room, with an array of print as well as audio and video resources for reference and study. Start with the trilingual Garifuna-English-Spanish dictionary that founder Ruben Reyes, a native of Honduras, compiled and published. Reyes notes that their language is important to preserve, as it is not the language of conquistadors but of a proud and free people. Within the room's walk-in closet is a diorama of a traditional Garifuna village made for the 2012 film, *Garifuna in Peril,* which Reyes co-produced and starred in. Available in the library, the film is a dramatized account

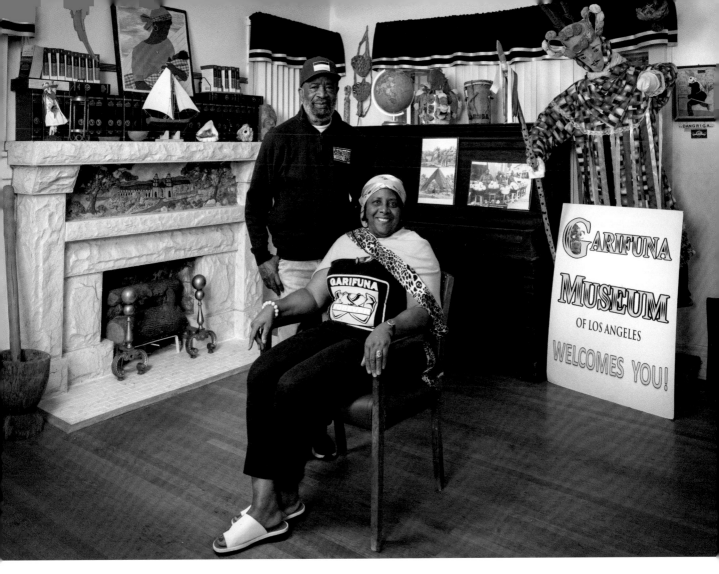

of the community's struggles to retain their cultural heritage, with Reyes's character working to build a language school back in Honduras while fighting off the encroaching development of a British-owned resort.

In the adjacent Heroes Room are portraits and stories of individuals who are important to the community, including scholars, artists, politicians, and the last leader of the resistance against the British, Chief Joseph Chatoyer, or *Satuye*. This room also showcases beautiful paintings by renowned Belizean Garifuna artist Isiah Nicholas, depicting traditional cooking techniques such as baking journey cakes and mashing plantains to make *hudutu*.

Curator and tour guide Cynthia Lewis is a vocal ambassador who is dedicated to educating herself and others in hopes of reversing the assimilation that is the culture's biggest threat. Her path of personal rediscovery is one that they hope to help others embark on through learning about and connecting with their unique heritage; indeed, their top priority is to engage with and educate other Garinagu, helping protect and preserve the culture for the future. That said, they are most definitely open to sharing with all curious individuals, outsiders included, and it's the city at large that is richer for their efforts.

GAMOLA Curator Cynthia Lewis with Bill Flores, museum volunteer and co-writer of the film, Garifuna in Peril.

Kuruvungna Springs Cultural Center & Museum
West LA

Behind an unassuming fence and small parking lot off Barrington Avenue in the Sawtelle district of West Los Angeles sits a two-acre parcel that is easily among the best examples of a natural oasis in the midst of the region's urban sprawl. In the cool shade under the trees, a miraculous natural spring bubbles up from beneath the sandy soil, pumping tens of thousands of gallons of crystal clear water daily, as it has for untold millenia, forming a small stream towards a peaceful pond before disappearing back underground. For the last century, the land has been owned by the Los Angeles Unified School District and now forms part of University High School's campus, but the springs remain one of the most important historical links to the Los Angeles Basin's Indigenous Tongva community.

Kuruvungna, which is Tongva for "a place where we are in the sun," is the name of the ancestral village that stood here prior to the arrival of the Spanish, but the springs themselves have been given several different names over the years. Fr. Juan Crespí visited the village while acting as official diarist of the 1769 Portolá Expedition that was the first recorded European exploration of present-day California's interior. Crespí called the springs *San Gregorio,* but the soldiers on that same expedition called them *El Berrendo* (the pronghorn) after a deer they had wounded. Junípero Serra, the architect of colonialist subjugation under Alta California's mission system, was on the expedition, lending the site another short-lived name as Serra Springs. The springs were at one point likened to the tears of Saint Monica *(Santa Monica),* who wept for her impious son, with this bizarre comparison inspiring the name of various nearby features, including a city and a mountain range. Although it was never within city limits, Santa Monica did reportedly source its water from these springs upon incorporation in 1886.

In the 1950s, Tongva tribal member Angie Dorame Behrns was a student at University High School, which had been built around the springs in 1924. When she returned for a class reunion after some thirty-five years, she was excited to bring her husband to see the idyllic springs that she remembered both from the horticultural program's use of the site and from the stories of her grandfather jumping the fence to access the waters for medicinal and spiritual purposes. Instead, she was shocked to find that they had been neglected for years. Photos from that time show the site was absolutely trashed, with the structures and even trees covered with graffiti and everything from school benches to garbage barrels tossed into the springs. Behrns resolved to rectify the situation and got permission from the school to come in on Saturdays to work. She quickly

A willow tree provides shade for this urban oasis.

The actual source of the natural spring, where clear water flows up through the sandy ground.

organized a group of family and community members to help clean up, even using her car and some rope to pull the larger objects out of the pond.

The group would soon formalize their efforts and create the Gabrielino-Tongva Springs Foundation in 1992, both in order to solicit grant funding for restoration, and to fight a proposed development that would have cut off the source of the springs. After a two-year battle, they were successful in getting the developer's plans withdrawn, and before long they secured a $250,000 grant from the state in support of their efforts to further revitalize the grounds and create a community center and small museum. Historic artifacts—as well as human remains—had been discovered during various construction and expansion projects in the school's development, and while some artifacts were lost and many more paved over, an interesting and important collection remains on view in the refurbished bungalow on site. There is also documentation of the foundation's various recognitions and accomplishments, and of their events, such as the annual Life Before Columbus Day gathering which, as the name suggests, celebrates aspects of native culture including song, dance, food, craft, and storytelling.

After almost a quarter-century of advocacy, Behrns retired from her post as foundation president in 2015. It has since been taken up by Bob Ramirez, an architectural and landscape designer who also traces his lineage to the Tongva tribe, and who had started volunteering after a visit from his ancestors in a dream. A new restoration campaign is underway, with an infusion of California native plants and additional volunteer support from the renowned Theodore Payne Foundation. Solar-powered pumps now irrigate crops that include staples of Indigenous North American agriculture known as the Three Sisters (beans, squash, and corn/maize), as well as medicinal plants such as sages, yucca, and artemisia.

The Gabrielino-Tongva Springs Foundation is in early planning stages for what they hope will someday be a world-class, indoor-outdoor museum campus, honoring the long and deep cultural significance of the site and the region with which it is interconnected. Despite their positive momentum, they are still on a year-to-year lease with LAUSD and could theoretically be evicted at any time, making it difficult to develop long-term plans. There is at least hope for today's Uni High students to be more aware of and involved in supporting the springs; there is even a recently formed student club called Shield of Kuruvungna (SOK) Club to educate peers about this treasure that, for better or worse, remains part of their campus.

As for Ramirez, every time he visits for a tour or work day, he checks crayfish traps that were set to eradicate this invasive species and allow for the reintroduction of natives, such as the small arroyo chub fish; efforts have been successful so far. And the springs themselves continue to push the clear, cool water to the surface, as the calming beauty of their timeless flow belies the complicated and rich history of this sacred place.

Tribal elder Angie Dorame Behrns, instigator of the Gabrieleno-Tongva Springs Foundation's restoration efforts, with Bob Ramirez current president of the Foundation.

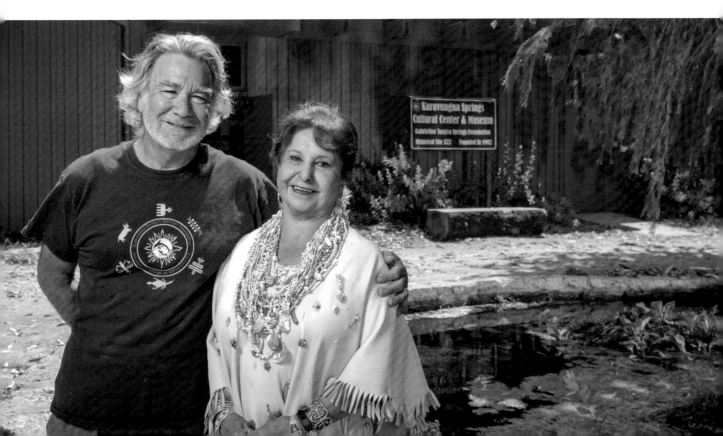

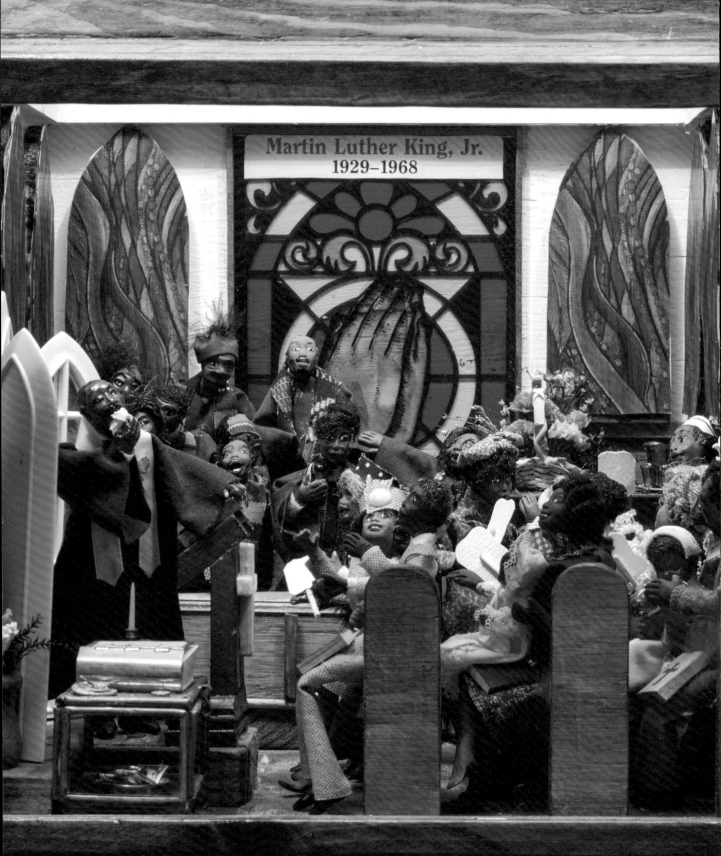

African American Miniature Museum
Mobile

Across Los Angeles, a number of major museums have created mobile museums as part of their supplementary educational and outreach program (LACMA's Maya Mobile and the Natural History Museum's Mobile Ocean Experience among them), but there are also a handful of fully itinerant exhibits with no brick-and-mortar headquarters. Mobile museums all share the basic goal of lowering barriers to access by bringing educational and cultural experiences to the people (mainly students) where they are. But the traveling African American Miniature Museum, created by the dedicated folk artist Karen Collins, is unique in taking a profoundly heartfelt and more directly personal approach.

Growing up in Indianapolis, Karen Collins's family was unable to afford a dollhouse for her as a child, so she made her own out of cardboard and scraps from around the house. As an adult, she took an interest in collecting dolls and miniatures, buying her first dollhouse around age forty. In 1992, her son was arrested weeks before his high school graduation and just after trying on tuxes for the prom; with three strikes on gang-related charges, he was sentenced to 167 years in prison, sending her into a deep depression. She was unable to continue in her job as a preschool teacher and became convinced there was more she could have done, and could do yet, to teach young people of color about their ancestors' challenges and strengths and give them hope and a sense of pride and purpose. She would adapt her pre-existing hobby and begin creating dioramas depicting Black historical figures and events, and their construction became a meditative process and a path for a kind of healing. Taking her creations to schools, libraries, and community events as a mobile museum, and training kids to act as docents who would share the stories and histories with their own classmates, her mission began to be fulfilled.

Karen's husband, Eddie Lewis, has played an important role in the museum over the years, building the actual boxes that house the scenes, as well as some of the small-scale furniture and fixtures, in the makeshift woodshop behind their home in Compton. There are now around fifty shadow boxes, including three made for the *21 Collections* exhibition at the Los Angeles Central Library, of the Black Lives Matter movement, Compton native Kendrick Lamar, and the homelessness crisis in LA that disproportionately affects the Black community. In one of many awe-inducing earlier pieces, Martin Luther King Jr. is preaching inside Ebenezer Baptist Church in Atlanta, and one can almost feel the heat in the tiny room based on the ecstatic expressions of congregants, not to mention their hand fans. One of the largest dioramas depicts the infamous Elmina Castle in Ghana, where slaves were sent out via the Door of No Return; included are

Martin Luther King, Jr. preaching at Ebenezer Baptist Church in Atlanta.

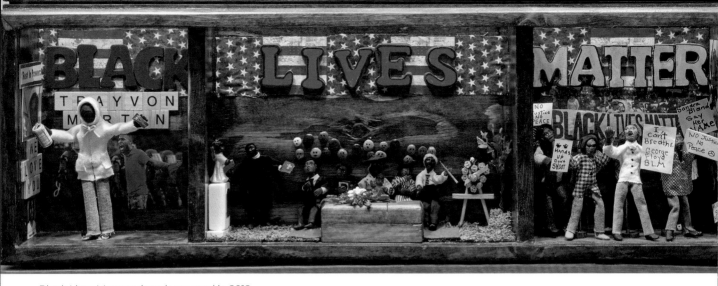

Black Lives Matter triptych, created in 2018.

Karen Collins and Eddie Lewis in their living room, which doubles as Karen's workshop.

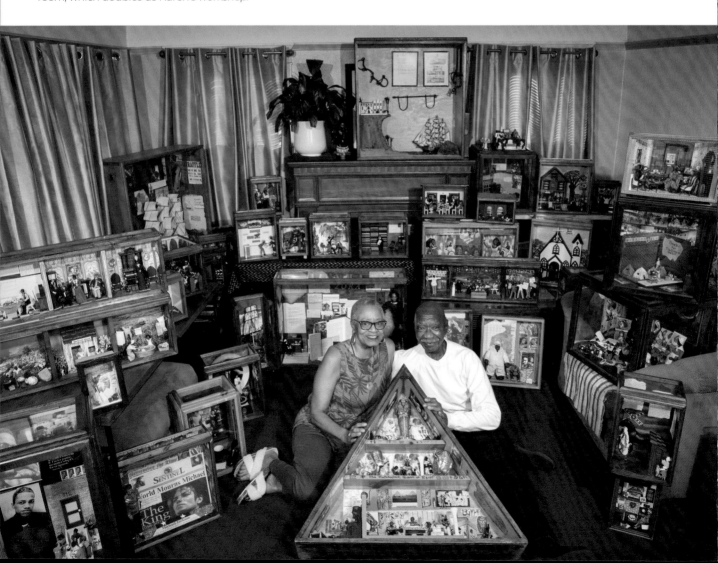

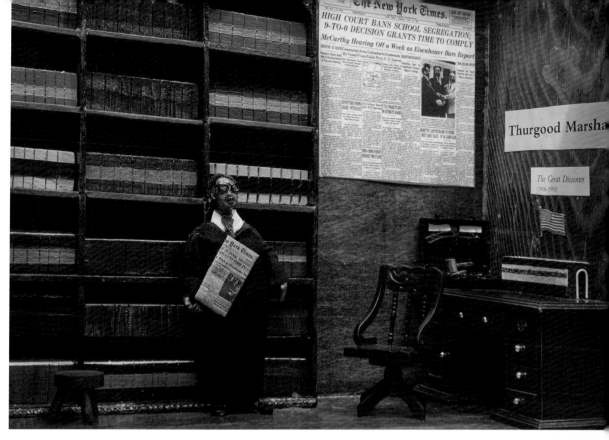

Supreme Court Justice Thurgood Marshall.

authentic slave shackles Collins acquired from a dealer, further highlighting the historical traumas that she has never shied away from in her interpretations.

In recent years, Collins has found increased appreciation for her project through grants and awards, media features, and high-profile commissions, such as a homemade "Doodle" for the Google homepage to kick off Black History Month in 2020, commemorating the sixtieth anniversary of the Greensboro lunch counter sit-in that helped launch the Civil Rights Movement. As of this writing, the best place to see part of the collection is at the Autry Museum, in its freshly reconceived permanent exhibition, *Imagined Wests.* For that eclectic and highly engaging show, Collins was commissioned to create scenes relating to Black figures in the American West, including the Exodusters, the name given to Black migrants to Kansas post Reconstruction, and Bill Pickett, the rodeo pioneer for whom the contemporary touring Black rodeo is named.

Before long, it will no longer be manageable for Collins to lug the boxes around to each special showing or event, and the museum's ultimate fate is uncertain. It is her greatest wish that the museum will find a place where it can be displayed and enjoyed by kids and families in perpetuity. She even has one diorama that does not depict any historic personages or situations, but looks hopefully to the future: it's of the museum itself, in its own dedicated building, with ample space for craft activities and a library. Time will tell whether and how subsequent generations get to be inspired by the dedication and love imbued in each scene, but regardless, the lessons these pieces hold will be carried forward by the countless students and visitors whose lives she has already touched.

La Historia Museum
El Monte

For half a century starting around 1915, a twenty-two acre plot of land just beyond the borders of the city of El Monte and adjacent to the Rio Hondo was home to generations of Mexican migrant families. With a population that exceeded a thousand by the 1930s, it came to be known as Hicks Camp, the largest of several such barrios in the vicinity, and one of countless segregated encampments housing the agricultural labor force throughout California. Often described as a shantytown, the barrio's houses were built using scrap lumber from railroad boxcars, streets were dirt and riddled with potholes, and running water was by no means guaranteed, and yet it is remembered fondly as a vibrant and community-minded place. For decades, even more prosperous residents of Hicks Camp were barred from moving into El Monte proper due to racist housing covenants, but this started changing after World War II, thanks to societal shifts prompted by a nationwide activist movement. Families slowly moved up and out, and the final dozens of homes were razed by 1973 and replaced with suburban and industrial development, as the area transitioned away from agriculture almost entirely.

The city of El Monte's official historical museum, situated in a striking Spanish-style, WPA-built structure that originally served as the library, houses an impressive array of artifacts pertaining to early residents, community events, and local businesses. The exhibits include the legendary nearby attraction, Gay's Lion Farm, which operated from 1925 to 1942 and raised several of the lions that are featured roaring at the start of MGM movies from that era. But, as entertaining and informative as the historical museum is, information relating to Hicks Camp and the Mexican American community has always been in notably short supply. By the 1990s, well after the city's demographics shifted to a majority identifying as Hispanic or Latino, people who had grown up in Hicks Camp and the surrounding barrios started having reunions in nearby parks and meetings at the historical museum itself; they even put up an early exhibit there. They soon felt, however, that they needed their own space to best represent their community. A core group organized in 1998 under a new banner as La Historia Society, opening their *museo* two years later in a small, city-owned building just a block north of the historical society's established museum.

A quarter-century on, La Historia Museum continues to collect and preserve photos, objects, and oral histories documenting the barrio communities, and partners with the Kizh-Gabrieleño Band of Mission Indians to honor the region's Indigenous forebears and traditional caretakers. A case holds tools used in the harvesting of grapes, walnuts, and oranges placed atop the iconic rallying flag of the United Farm Workers, and a nearby display honors veterans of color from the community. Group photos from the segregated schools in the area show classes

The museo's freeway-adjacent digs are maintained with pride.

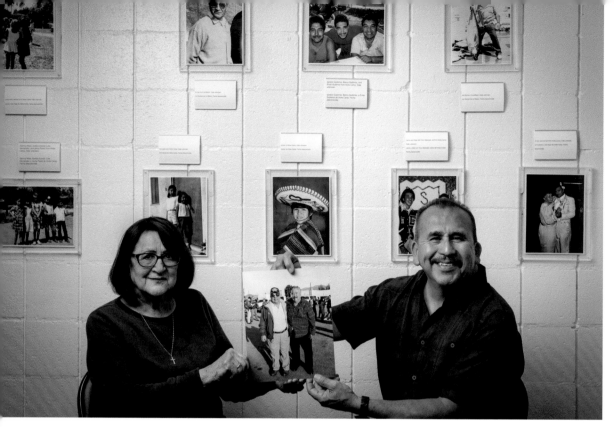

Irene Bautista and her son Adrian hold a photo of Irene's late husband, Bob (left), with former El Monte Mayor and La Historia Society Co-Founder, Ernie Gutierrez. The photo on the wall behind them shows Adrian as a young boy, with his serape and sombrero.

comprised entirely of Mexican and Japanese American students, at least until the 1942 class, at which point all children from the latter group had been rounded up and shipped off to "relocation centers" (concentration camps) such as Manzanar, a haunting National Historic Site in the Eastern Sierra.

Local media has seemingly overplayed the rift between the El Monte Historical Museum and La Historia, but it is true that they have resisted calls to come together under one roof. It's notable that this debate is happening at all, since it not only calls attention to, but also brings the conversation toward a more nuanced understanding of a community's history than nearly any single museum can convey on its own.

Many of La Historia's founding members have now passed or are unable to continue volunteering on a regular basis, but it is sustained by a small and passionate group, assisted by a cast of young historians and archivists from UCLA, all under the leadership of the longtime, dedicated president, Rosa Peña. As for the site of Hicks Camp, part of it now forms the Rio Vista Park, where a bird's-eye map of the old barrio is inscribed on the pavement, and interpretive signs feature grainy photos of children joyously playing in the river, courtesy of the collection of La Historia Museum.

Displays recognize local businesses as well as veterans from the community.

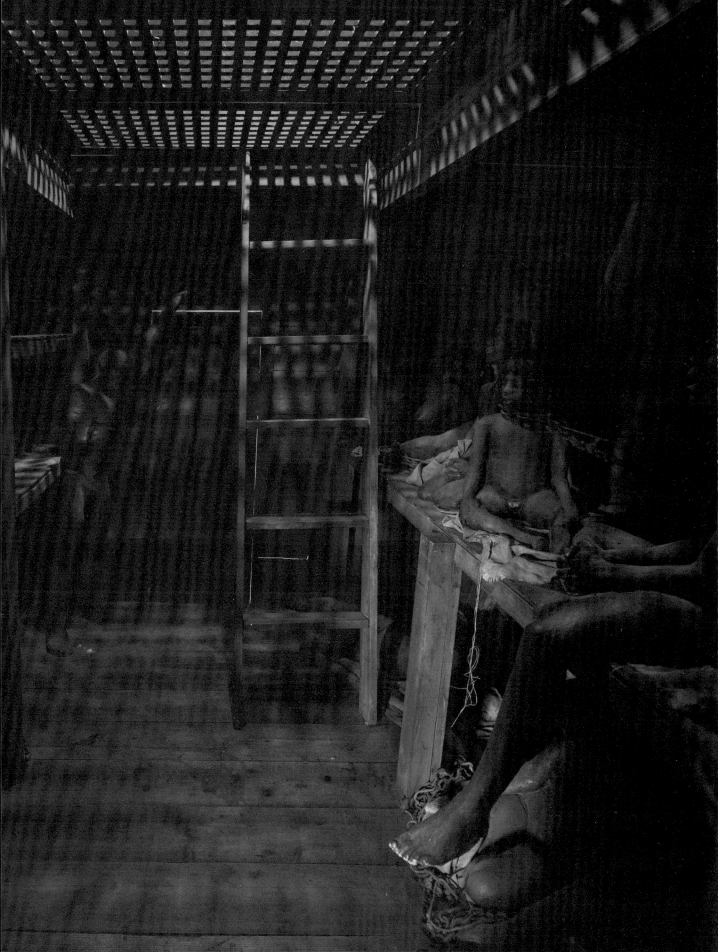

Civil Rights Museum, Watts Labor Community Action Committee (WLCAC)

Watts

One of the most active and admirable community service organizations in Los Angeles is also home to a criminally underappreciated and surprisingly powerful museum. The Watts Labor Community Action Committee (WLCAC) offers so many critical services and programs at their sprawling seven-acre campus on 109th Street and South Central Avenue, it's easy to see why they're not mostly known for their immersive and effective exhibits. Still, the on-site Civil Rights Museum is a hidden gem that helps fulfill the parent organization's tried and true motto: "Don't move...improve!"

The late founder and community organizer Ted Watkins is a legend in the Watts community, responsible for launching a range of projects from workforce development to providing access to affordable housing and public health resources. He started WLCAC in 1965 and helped literally rebuild the neighborhood following the destructive and deadly civil unrest later that year. Despite the progress of the program over the years, the nonprofit's facilities were burned to the ground in the 1992 uprising, and they were tasked with rebuilding again. Fortunately, given their established track record, they were up to the challenge. Though the elder Watkins wouldn't see the new campus buildings (including the aptly named Phoenix Hall) completed before his death in 1993, his son, Timothy Watkins, took the reins and is still the president and CEO of WLCAC today.

Shortly after the new facilities were completed in 1994, WLCAC hosted a Martin Luther King Jr. exhibit by photographer Benedict Fernandez as part of their multi-prong mission, in this case providing opportunities for cultural enrichment. Judging from the overwhelming reception, WLCAC realized there was a need, and doubled down to create permanent exhibits that would engage and inform the community: the museum was born. Sharing the 45,000-square-foot Phoenix Hall building with performance and event spaces, including a ninety-nine-seat black box theater, the series of environments and galleries that make up the museum are the fruits of a wide range of artists and craftspeoples' labor.

No time is wasted on the guided Civil Rights Tour, as visitors are first led below deck onto a simulated slave ship—part of which was donated from the set of the Steven Spielberg film, *Amistad*—depicting the horrific Middle Passage. Shackled and naked, life-size human figures created by noted community-based artist Charles Dickson are crammed into bare wooden bunks and are felt as much

The gut-wrenching first stop on the tour: a scene below the decks of a ship carrying shackled slaves on the Middle Passage.

*Timothy Watkins, WLCAC President & CEO, in the walk-through
environment representing Reconstruction-era Meridian, Mississippi.*

as seen in the hold's dim lighting; the effect is nothing if not haunting. After a
sobering start, the next stop is behind a curtain that reveals a walk-through scene
of a Reconstruction Era dirt road in Ted Watkins' hometown of Meridian, Mississippi.
A typical shotgun house is flanked by rusted antiques and creeping foliage, and
a noose hangs from a tree next to an abandoned, crashed period vehicle. Meant
to show what life was like in the rural South before the civil rights movement,
the remarkable immersion of the space belies the limited budget and lends the
feeling of an amusement park environment, but with a lot more soul.

 The tour continues with a room that is split in half: on one side a brightly
lit Sunday school scene and on the other a segregated lunch counter, where
a vintage sign that hangs above the cash register reads, "NO Dogs, Negroes,
Mexicans." This prepares the visitor for the next display in the Hall of Shame—a
substantial collection of pop culture artifacts featuring racist stereotypes, from
Sambo toys and mammy food products to Uncle Remus sheet music and,
most sickeningly, souvenirs themed around alligators devouring Black babies.
After all this darkness, the tour ends with more uplifting displays, including

an exhibition of Howard Bingham's 1968 photographs of the Black Panther Party, and a variety of artworks and sculpture depicting civil rights leaders from Malcolm X to Cesar Chavez.

Though not officially part of the tour, the last space one might see is a small side room where dozens of awards and resolutions hang, recognizing WLCAC for their many years providing needed programs and services—and they are not slowing down. Recent initiatives include the acquisition of a vacant 2.5-acre plot nearby, where the staff and community members have built an urban garden and education center called MudTown Farms. While the work continues and many of the neighborhood's challenges persist, the Civil Rights Museum provides critical historical context and ample space for cultural expression, honoring the legacies of those who came before, and undoubtedly inspiring the next generation of artists, activists, and changemakers.

A Black Panther Party-themed meeting room is set amidst the museum galleries.

A noose hanging from a tree sets the tone of the pre-Civil Rights era rural southern town.

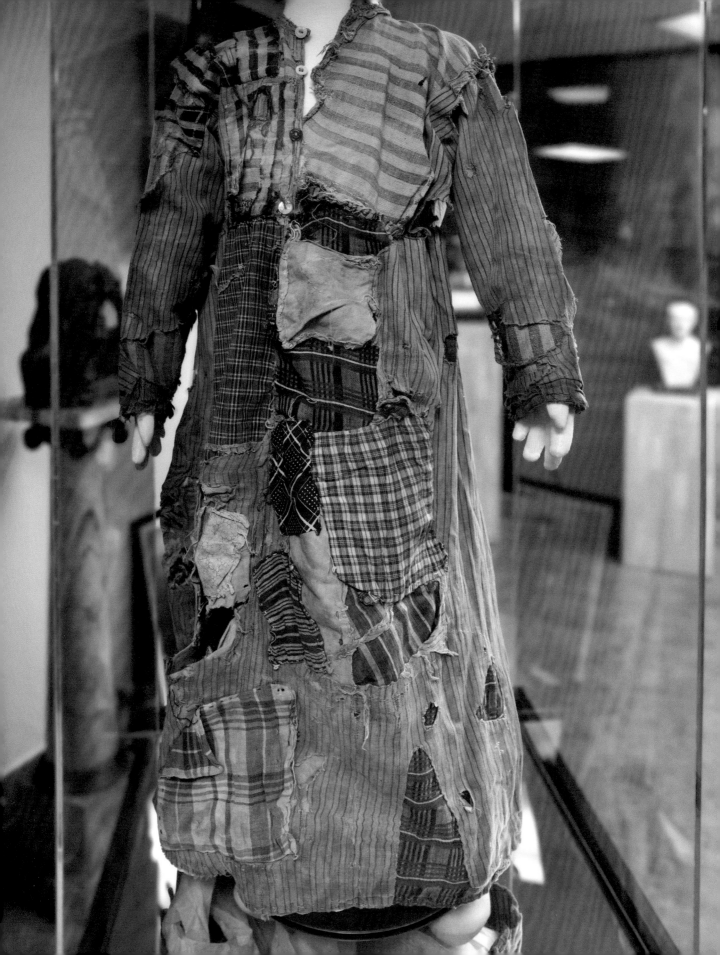

Ararat-Eskijian Museum
Mission Hills

Long before the buzz began for the multi-million dollar Armenian American Museum in the heart of Glendale, a much smaller institution a few miles up the freeway has been doing the work of uplifting the diaspora and celebrating its cultural impact for more than a quarter century, albeit on a more intimate scale. Even after the anticipated opening of the gleaming new museum in Glendale, the Ararat-Eskijian Museum on the northern edge of the San Fernando Valley will remain a worthy stop for its particular setting and the unique and important works on display.

The museum sits at the intersection of the 5 and 405 freeways, on the campus of the Ararat Home of Los Angeles, named for the spiritually and historically significant Mount Ararat in the motherland. This senior care facility opened in 1949, when seven refugee survivors of the Armenian Genocide moved into a West Adams mansion purchased from movie star Mary Pickford for $12,000. In the decades since, they've grown by leaps and bounds: today the Mission Hills complex occupies more than twenty acres, with housing and care provided for around four hundred seniors of Armenian heritage.

The "Eskijian" in the name comes from the founder (and architect) of the museum itself, Luther Eskijian. Also a survivor, Eskijian immigrated with his brother and their widowed mother through Ellis Island at age seven in 1920. After moving to Southern California, he became an architect before he was enlisted to serve in World War II. His skills were put to work in General Patton's army, following the war front through Europe and helping to convert large buildings seized from the Nazis into hospitals. It was during his tour of duty that he began collecting for his future museum, which he had always envisioned as a space to study and commemorate the genocide of 1915 in the Ottoman Empire, and to preserve and share Armenian culture more broadly. After the war, Eskijian enjoyed a long and successful career as an architect and engineer before setting to work (pro bono) in his retirement on the design for the Sheen Memorial Chapel, which included space for the museum on the bottom level. The building was completed in 1994, and the museum opened with fanfare two years later.

By the late 1990s, Maggie Mangassarian-Goschin was getting more involved in the museum, and remains the director and leading ambassador to this day. Eskijian's original collections included much military memorabilia and other things related to his personal interests, but since his passing in 2007, the museum has shifted to focus more intentionally and specifically on Armenian culture. A tour through the exhibits today—jewelry, folk costumes, embroidery, metalwork, ancient and medieval coins, contemporary artworks and musical instruments, all of which demonstrate a high level of craftsmanship and a great

The patchwork dress of a child from an orphanage in Hadjin.

depth of tradition—provides a crash course in the culture and makes for an enlightening as well as sobering experience.

Artifacts range from an ancient Sumerian cuneiform seal (ca. 2100 BC) that presents an "administrative account of barley," to a 1954 painting of a mother and her child by Jirayr Zorthian, the acclaimed artist known as much for his paintings and sculpture as for the bohemian bacchanals he hosted at his Zorthian Ranch compound in Altadena. Then there is a wonderful miniature wooden model of an Armenian church by artist Hovannes Guedelekian (two more of which are in the chapel upstairs) and a series of intricate paintings by renowned Persian-Armenian artist André "Darvish" Sevrugian. Many of the craft items were recent donations, and they continue to encourage contributions as the younger generations often don't want or can't keep the heirlooms that are passed down to them.

Among the most powerful objects on view are a tattered patchwork dress from an orphanage in the town of Hadjin, as well as a large, spectacular rug from the same orphanage that was made by the children there to raise badly needed funds. But the most chilling display sits in a memorial niche in the chapel: human bone fragments from unknown dead, salvaged from the concentration camps in

The museum is on the ground floor of the Sheen Memorial Chapel, built in traditional Armenian style.

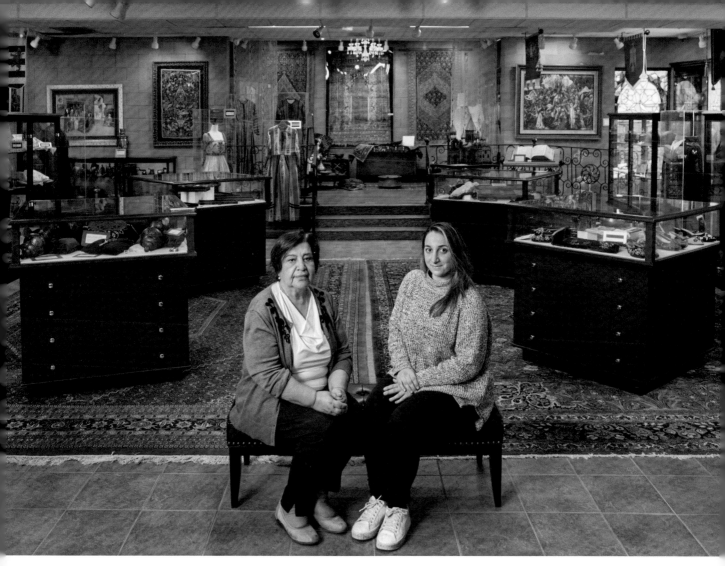

Director Maggie Mangassarian-Goschin (left), in the main
gallery with museum volunteer and educator Sedda Antekelian.

Der Zor (modern day Syria), where many thousands of Armenians were marched to their death during the genocide campaign.

The museum regularly hosts scholarly and cultural lectures, performances, and symposia in collaboration with other Armenian institutions around the world, and it is the sister museum to the Armenian Genocide Museum-Institute in Yerevan. They maintain a significant archive and three distinct research libraries holding journals, films, periodicals, and other primary resources, including a library dedicated explicitly to the Armenian Genocide. But one doesn't need a special research topic, or even time for a deep dive, to appreciate the richness and beauty of the culture in this lovingly curated space. In addition to the art-filled history lesson for outsiders, it should undoubtedly make the whole diaspora proud.

Installation view of the museum's inaugural exhibition, Sons Like Me, *by Compton artist Anthony Lee Pittman.*

Compton Art & History Museum
Compton

"Because I'm from Compton, I know what it's like to have second-hand things," Abigail Lopez-Byrd said, describing why she and co-founder/husband Marquell Byrd wanted to make sure everything they do in the community is first-rate, or *museum quality*. After growing up in the city, Lopez-Byrd went to study sociology, art, and education at UC Santa Cruz. Even when she went away to school and then to live in New York, she always knew that she would be back, subscribing to the "Don't move... improve!" motto of Ted Watkins in neighboring Watts (see page 33). She had long dreamed of opening a museum in her hometown, and when Marquell had a similar vision in the summer of 2022, they knew they had to make it a reality, opening the Compton Art & History Museum in short order, just in time for Black History Month in 2023.

Prior to the museum, the couple had launched Color Compton in 2019, a nonprofit offering internships for local teens to pick up skills in arts and storytelling media, also creating a collaborative community archive. Their programs investigate the social and emotional benefits of art-making, and include visits to museums, galleries, and libraries around the city to see what resonates with participants, and to consider whose stories they do and do not find represented. They've even brought a group of youth to attend a conference of archivists, and always compensate them for participation since most of the young people they engage with can't afford not to work.

When a space downstairs in the same strip mall as Color Compton became available, it was the last in a series of signs pointing Abigail and Marquell towards the realization of their latest and greatest dream. They did much of the renovation themselves, laying new flooring, building gallery walls, and fixing the space up so well in just a few months that some visitors admit their surprise at seeing a "real" museum in the neighborhood. The inaugural offering was a solo show by Compton native and artist/activist Anthony Lee Pittman, featuring his bold paintings, tapestries, floral arrangements, and two altars: one honoring his late Mexican grandparents, and the other an homage to African American artists, including the poet Essex Hemphill, whose poem "In the Life" inspired the show's title, *Sons Like Me*.

In its first year, the Compton Art & History Museum had already mounted three changing exhibitions including work by women of color exploring ideas of liberation and freedom, and another on the city's legendary hip hop legacy in light of the fiftieth anniversary of the movement. True to the historical side of the operation, the museum borrows and showcases archival photos and other ephemera from nearby California State University Dominguez Hills, as well as Cal

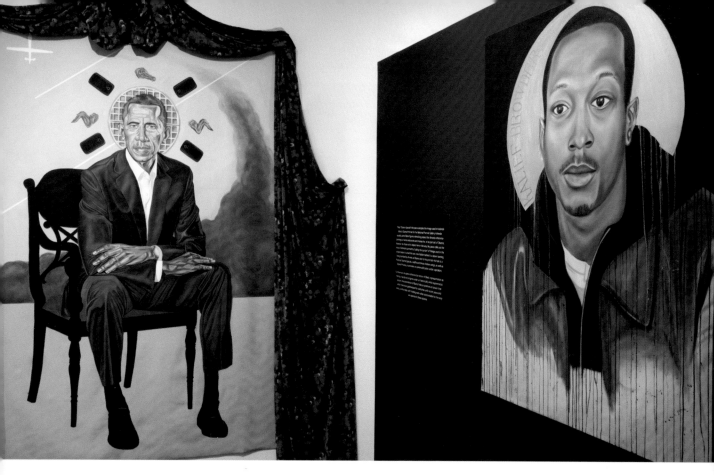

Works by Anthony Lee Pittman.

State Los Angeles, like the latter's archive from the Compton Communicative Arts Academy, documenting the Black Arts Movement of the 1960s and '70s. Some of the other archives in the city have holdings predominantly representing the older, whiter Compton, but the museum wants to highlight stories from living memory that center the majority Black era and the now majority Latino voices of the community they serve.

The logos of both Color Compton and the Compton Museum include a design with four pillars that rise up like a mountain and represent art, history, identity, and community, inspired by the Martin Luther King, Jr. memorial sculpture in the civic center plaza across the street. With these tenets in mind, Abigail and Marquell are full of ideas for the future, with a planned project on local businesses and community spaces, and another about the agricultural side of the community; not only does the city have a large swath of land zoned for agriculture going back to its incorporation in 1888, but just down the street are the stables of the now-iconic local cowboys. Even those who miss the latter exhibition might still find a copy of Walter Thompson-Hernandez's bestselling book, *The Compton Cowboys,* alongside custom gifts and merch available in the small museum shop.

A large part of what prompted Abigail and Marquell to start a museum was the verifiable fact that Compton, along with South LA broadly, is a museum desert.

Prior to their opening, the only brick and mortar museum of any kind within city limits was Tomorrow's Aeronautical Museum at Compton/Woodley Airport, and while that is a highly worthy program in its own right, it didn't quite fill the void of spaces dedicated to sharing the art, culture, and history of the community. In the future, they hope to have their own building with permanent and changing galleries, classrooms, and a coffee shop, and given their demonstrated hustle and drive, that may well come to pass. For now, what they've built is a much needed space for reflection, joy, and empowerment that the city of Compton, globally famous for cultural exports, can be proud to keep close to home.

Museum founders Marquell Byrd and Abigail Lopez-Byrd, with Adalia, Azariah, and Amayah.

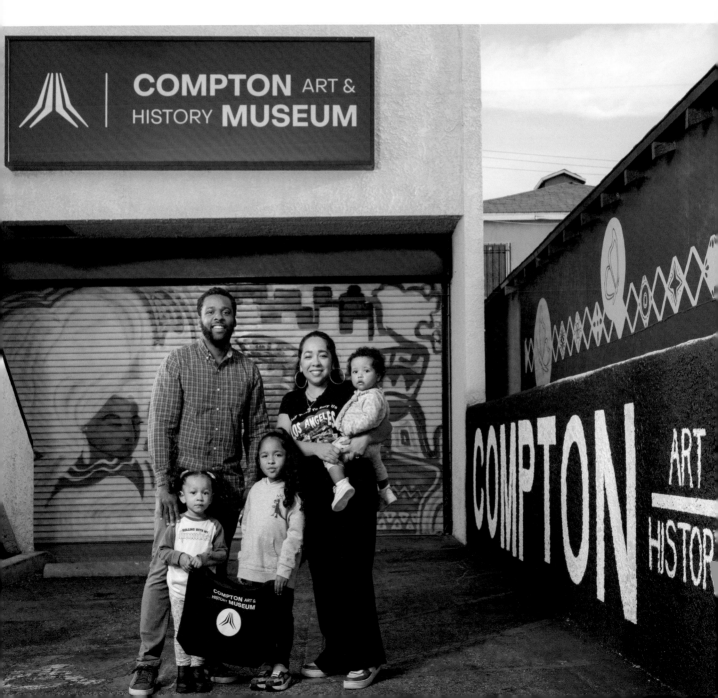

Skid Row History Museum & Archive
LA Poverty Department
Downtown LA

Those who might question the power of art to provide spiritual and emotional sustenance have not spoken to the members and performers of the Los Angeles Poverty Department, the *other* LAPD. As the first theater company in the country (and likely the world) comprised of people experiencing homelessness, this LAPD, founder and director John Malpede suggests, is the municipal department that the city forgot to set up, so he has been running it for them since 1985. Now operating out of their Skid Row History Museum & Archive, in a storefront on Broadway in downtown's Historic Core, the actions undertaken by this group defy pernicious stereotypes about the community and celebrate those within it who are working towards positive change. Most importantly, they have fun doing it.

When Malpede, a performance artist from New York City, came to Los Angeles in 1984 while working on a project about homelessness, he attended a Los Angeles County Board of Supervisors meeting and heard residents of Skid Row testifying about the deplorable conditions of the hotels they were being placed in as the Summer Olympics loomed large. He was so inspired by their activism that he joined the cause, and has never left. Before long, the nonprofit Inner City Law Center made him an artist-in-residence, allowing him to hold performances in the offices at night after the lawyers went home, and within a few years the LAPD became its own nonprofit. By the year 2000 he was joined by co-director Henriëtte Brouwers (they're also married), an international experimental theater director and performer originally from the Netherlands.

With the official boundaries of Skid Row delineated in a 1976 "Containment Plan," many outsiders and politicos don't consider it to be a residential neighborhood, even though some people have lived there for more than twenty years. In 2002, LAPD launched a project entitled, "Is There History in Skid Row?", after debates of that nature. Later, they created an exhibition at The Box gallery in 2008 that they called the *Skid Row History Museum,* with flyers, objects, and ephemera they had collected, a Skid Row timeline, and programmed activations in the gallery. When former City Councilman Jose Huizar launched his Bringing Back Broadway initiative that promised to upscale the neighborhood, LAPD decided to do their own civic duty and take

The museum gallery doubles as an event and performance/ workshop space, with the archive occupying the rear loft.

their new museum concept to that very street. Originally in a mall a few blocks down, the current space opened in 2017 with artist Rosten Woo's installation, *The Back 9*, an actual mini-golf course which explored how LA's zoning laws and regulations affect Skid Row ("Try and get your ball into the social service hybrid industrial zone!")—one of the most brilliantly effective contemporary art shows in recent memory.

In addition to temporary exhibitions and events, the museum maintains an archive of LAPD's activities since the beginning (photos, videos, programs, and original research) as well as donated collections such as that of Alice Callaghan, who started both the Skid Row Housing Trust and Las Familias del Pueblo community center and daycare. Other holdings represent the LA Community Action Network, with files representing lawsuits on tenants' rights and residence ordinances. A dedicated team of volunteers and archivist interns have created searchable online finding aids for the collection. The archive also hosts researchers and scholars in residence, whose work informs LAPD's organizing and advocacy, including on issues such as increasing access to parks and sanitation services, adding housing that will support children and families, and creating a new district council to ensure self-representation. One of LAPD's signature programs, which is well represented in their archives, is Walk the Talk, a biannual festival and parade which honors Skid Row leaders, artists, advocates, and others who make up the fabric of the community. The "fun, funky, and festive" parade is led by a New Orleans-style second line brass band and features artist-commissioned portraits of that year's honorees, as well as stops at locations along the route significant to each honoree for performances that highlight their work and accomplishments.

LAPD believes in confusing and blurring the categories of creative intervention and grass-roots advocacy and activism. In the introduction to the book, *Agents & Assets,* documenting a series of events they produced about the War on Drugs (and on communities, they emphasize), Malpede writes, "If we do it right, our main product is confusion. Confusion begets insight. Insight plus strategy begets change." And when asked his hope and vision for the future of their organization: "Just keep responding to reality...and support low-income people in the neighborhood."

With the staggering epidemic of homelessness continuing to plague the city, any effort to preserve the stories and amplify the voices of the victims of society's greatest inequities cannot be given sufficiently high praise. Those of us who are fortunate not to be faced with such devastating challenges in our own lives can act in a number of ways to help address it collectively, but certainly one of them is to bear witness to these stories, honor the creative work with our attention and gratitude, and acknowledge our shared humanity with humility and joy.

LA Poverty Department performers and staff. Back row from left: Franny Alfaro, Scott Clapson, Zachary Rutland, Iron Donato, associate director Henriëtte Brouwers, Tom Grode, Asher Davis, founding director John Malpede. Middle row: Ruben Garcia, Leyla Martinez, Lorraine Morland, Lee Maupin, Stephanie Bell, Rixt Bilker. Front row: Keith "Prime Minister Footie" Johnson, Emily Benoff.

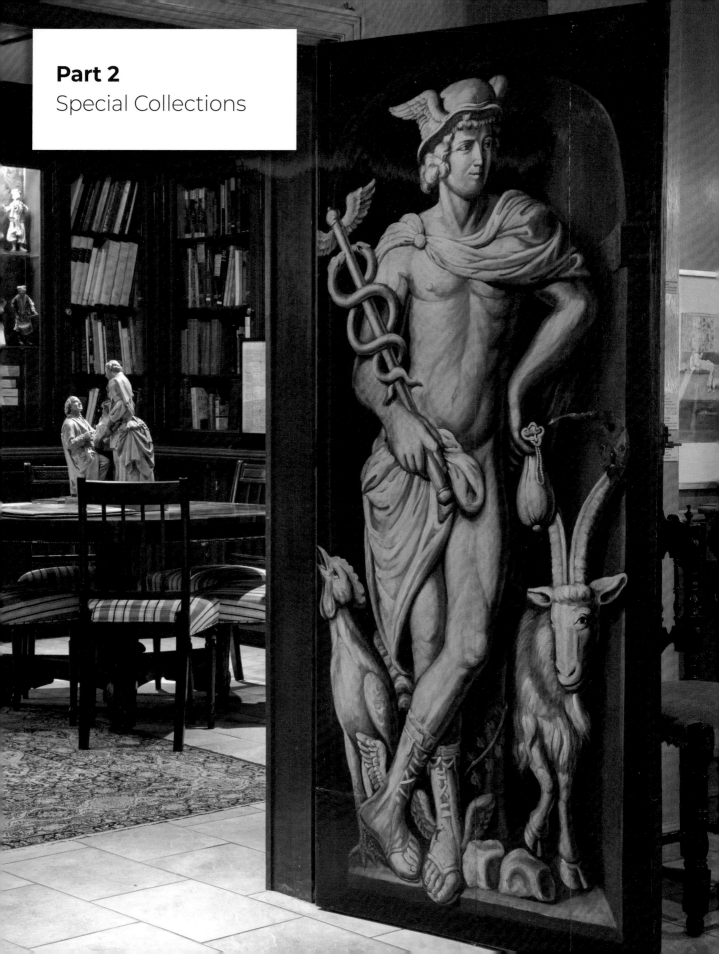

Edward-Dean Museum & Gardens
Cherry Valley

Cherry Valley is a small exurban community at the far eastern end of the Inland Empire's sprawl, where a constant stream of cars are mostly just blowing through the San Gorgonio Pass on their way to the desert, or winding their way up the foothills to the u-pick apple orchards of nearby Oak Glen. Regardless of which direction one is headed, the Edward-Dean Museum & Gardens, an unexpected trove of decorative arts and design, is a worthy stop.

Co-founder J. Edward Eberle discovered his passion for antiques as a child in the early 1900s, while visiting art auctions in Denver with his grandmother. Before long, the family relocated to Southern California, and he took a job as a bank employee while pursuing his interest in art and antiques on the side. Looking to explore the source of his beloved decorative arts, he soon responded to an ad seeking a chauffeur for a wealthy handicapped patron going on a European Grand Tour, but that adventure was cut short by the onset of World War II. He spent the war as a sergeant in the Army Air Corps, where he met his future business (and, by all appearances, life) partner, Dean Stout; together they would set up a showroom on "Antiques Row" on La Cienega Boulevard after returning to civilian life in 1945.

After about a decade running their successful business and building up their personal collections, Edward and Dean would move their operation to the present location, which was a convenient stopover for their clients and friends on their way from Los Angeles or Orange County to Palm Springs. In 1957, they began construction on a dedicated building, designed by architect Ben Rabe in the style of an Italian villa and set up as a private decorative arts museum to display the more unique and valuable pieces in their collection. Eberle took charge of curating the museum and its displays, while Stout set to work designing Italian and French gardens throughout the grounds.

After just a few years, running the museum turned out to be more work than they bargained for, and Eberle began to search for a new steward. He first attempted to deed the museum, its contents, and grounds to the University of Redlands, but the offer was ultimately declined since the university lacked an endowment to support ongoing operations. He next approached the staff of the Huntington Library, but they wouldn't promise to keep everything in the collection, which was also a dealbreaker for Eberle. After a few more offers fell through due to Eberle's general inflexibility, the museum's contents were all finally transferred to Riverside County in 1964. Stout died at age fifty-five in 1967 in Newport Beach, and Eberle moved to Laguna Beach, remaining active on the museum board and nonprofit support group. He would give lengthy—and one imagines, highly entertaining—docent trainings from his lavishly decorated beachside home until his death in 1980.

A painting of Roman god Mercury on an eighteenth-century Dutch door, at the entrance to the research library.

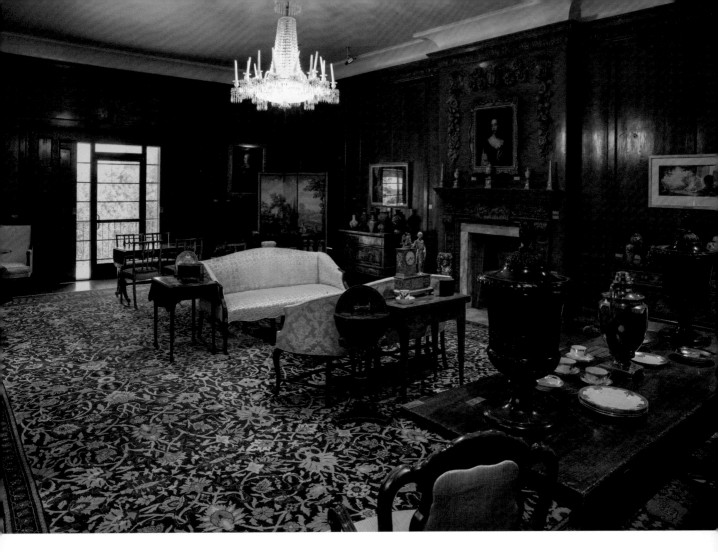

The Pine Room, with seventeenth-century Norwegian pine wall paneling.

It's easy to think of the museum in terms of the cabinets of curiosity that evolved into the modern Western museum and were characterized by the wealthy elite's collections of art and objects from around the world, densely curated in broad themes or by region, often in their homes, to show off to their friends. Specialists and aficionados who visit will be duly impressed by many of the sixteenth-to-nineteenth century European and Asian sculptures, paintings, and other decorative pieces, and the list of artists (see Joshua Reynolds, J.M.W. Turner, and George Lambert in the picture gallery) no doubt carries weight in certain circles. But one of the more unique conditions Eberle imposed is that the new stewards would maintain in perpetuity the general spirit of the 1964 "appearance and contents" of the rooms, effectively leaving limited room to move or substantially change anything.

Entering the permanent exhibits, the first and most prominent gallery is the Pine Room, with walls covered by intricate panels of Norwegian pine. Created by famed seventeenth-century woodcarver Grinling Gibbons, and said to have come from the home of the Earl of Essex, the paneling was brought to Southern California, like so much grand European architectural salvage, by William Randolph Hearst, who Eberle had helped with the acquisition of Persian

rugs for the castle at San Simeon. When the Santa Monica mansion Hearst built for actress Marion Davies was demolished, Eberle purchased the paneling, even revising construction plans to accommodate this new, integral acquisition.

After the Pine Room, visitors continue through a series of rooms, including one highlighting Asian art, the aforementioned picture gallery, and the Blue Room, an eighteenth-to-nineteenth century salon with crystal chandeliers, a pianoforte of the classical era, and unique printed linen window shades that came from a café in New Orleans. The basement contains a rare book collection that is made available for research and reference through the Riverside County Library system.

While the museum is still making occasional acquisitions, somewhere around ninety to ninety-five percent of the collections are from the original bequest. The curators do try to keep things fresh for a changing museum landscape with things like QR codes and special tours, and temporary exhibits in an ancillary side gallery. Visitors coming on Fridays or as part of a school group may even get a private performance from one of the volunteer musicians. And although it is a hidden gem, the county has been able to diversify their revenue thanks to the sixteen acres of rolling lawns, rose and flower gardens dotted with statues, and a picturesque koi pond that make it a popular wedding and event venue. As the surrounding Inland Empire communities have seen a boom in development, the museum stands as a monument to the hope that some things will not soon change.

The Blue Room,
with printed linen
window shades.

Valley Relics Museum
Van Nuys

Across greater Los Angeles, there are about fifteen museums situated at airports large and small. For obvious reasons, these are typically devoted to aviation (see, for example, the Flight Path Museum at LAX on page 125). At the airport in Van Nuys, there is one major exception, and while aviation is not entirely beyond the scope of the Valley Relics Museum, there's a broader through line for the plethora of artifacts on view. Situated in two vast corrugated metal airplane hangars, even this space may prove to be insufficient to contain the range of stories relating to the valley—or The Valley—that are the object of museum founder and director Tommy Gelinas's obsession.

Gelinas is a family man with rockstar vibes and a compulsive sense of nostalgia that has resulted in one of the fastest-growing independent museums throughout the region. The San Fernando Valley, where he was born and raised, has served as the inspiration for his collecting and preservation work over the past several decades, and it's fair to say that the subject has evolved from an area of interest to his all-consuming life's work. It's long been fashionable to paint the Valley as either vapid or quaint, and Gelinas has set out to counter that image by celebrating its history and fostering an uncomplicated sense of local pride. Beyond that, he is determined to highlight how some Valley exports have become globally recognizable hallmarks of American culture.

It all started with social media posts featuring old Valley photos and postcards Gelinas had collected. He found that his audience responded more positively to vintage fast food ephemera, such as that from the Pioneer Chicken chain, as opposed to the older history of the nineteenth-and-early-twentieth century "pioneers" after whom many of the prominent neighborhoods and streets are named. He honed his interest in the pop culture side of Valley lore, and as his online presence gained traction, people started sending him things. Objects began to fill the conference room, parking lot, and offices of the t-shirt printing company he ran with his wife, Staci. As the project began to attract media attention, he decided to move everything to a dedicated warehouse location in Chatsworth, opening the space as a museum in 2013. Within the first year, they had already outgrown this cavernous space, and subsequently moved to the present location at the Van Nuys Airport, where they've managed to fill up their twin hangars and then some.

If the collection seems somewhat hodgepodge, it's partially because Gelinas takes things as they come, often with a sense of urgency in cases where it's him versus the wrecking ball. Anyone who has visited or even seen a picture of the Valley Relics interior will quickly note one of their hallmarks: large

The door from the childhood bedroom of Eve Plumb, who played Jan in The Brady Bunch.

street signs of iconic and fondly recalled restaurants and businesses that have closed, especially those rendered in brilliant neon. High ceilings have allowed for oversize signs to tower above visitors much as when they still graced the roadside, though of course with a much greater density than out in the wild. It makes for a highly photogenic scene, and is thus a sought-after location for filming as well as for birthday parties and bar/bat mitzvahs.

Beyond the oversize neon signs, there are a number of exhibits created with the assistance of volunteers and guest curators. One popular artifact is a retro sticker-filled door from the childhood bedroom of Eve Plumb, better known as Jan from *The Brady Bunch*. Another highlight is the display relating to Nudie Cohn, the famed Ukrainian-American "Rodeo Tailor" who bedazzled and embroidered custom suits that were *de rigueur* for country western megastars of the 1960s and '70s and have recently come back in style. The "Nudie Mobile" parked in the gallery is a prized relic; this is one of several white Pontiac Bonnevilles that Cohn customized beyond logic or reason, with longhorn steer horns on the grill, Native American motifs painted on the steering wheel and upholstery, and pistols and silver horseshoes affixed inside and out. Amongst the other vehicles on rotating display is the original VW bus from *Fast Times at Ridgemont High,* one of countless movie props the museum has inherited.

Recent acquisitions include a collection of dragon and wizard figurines from the late heavy metal singer Ronnie James Dio, the sales counter and cash register from a former Licorice Pizza record store, and a fiberglass family from atop the roof of an old A&W root beer stand. Perhaps most surprisingly, Gelinas has also expanded beyond his original San Fernando Valley scope, and has now retrieved signs from shuttered businesses as far away as the Whittier location of Chris' & Pitt's BBQ, and a neon Tower Records sign from Brea, in northern Orange County. It's a move that seems confounding at first, but the pop culture preservation bug has taken hold, and while it may seem that the drive to save everything has overpowered his geographic loyalty, the Valley pride is still strong enough that I don't foresee a name change any time soon.

Didactic text is relatively light throughout the museum, though many of the objects require no explanation, and an immersive nostalgic experience, unique to each visitor, is generally favored over an authoritative (read: pedantic) narrative that many museums might feel pressured to overlay. Most objects are in cases or behind velvet ropes, but not so for the restored games from the Family Fun Arcade in Granada Hills that fill a long wall; they are all set to free play, with some visitors coming exclusively for this perk.

Now that the museum has gained substantial visibility, thanks in part to visits by celebrities and influencers, it is increasingly the place people turn when there is a piece of Valley (or other) history that they'd like to see saved. Gelinas even keeps a crane operator and sign mechanic on the team. It's a model that can't possibly continue in perpetuity, though the museum shows no signs of stopping. And as

TV wall from the home of Jack Webb of Dragnet *fame; used to survey the competition.*

the collection expands to represent significant places like Oil Can Harry's, the legendary Studio City roadhouse and LBGTQ safe space that closed in 2021 after more than fifty years, it could bring more people and even politicians around to the importance of keeping the collection intact long term. No matter what the future holds, it remains for the time being an ideal place to bask in the neon glow, pause in front of one of the exhibits and say, "I remember that!"

Overleaf: Museum founder Tommy Gelinas in his element

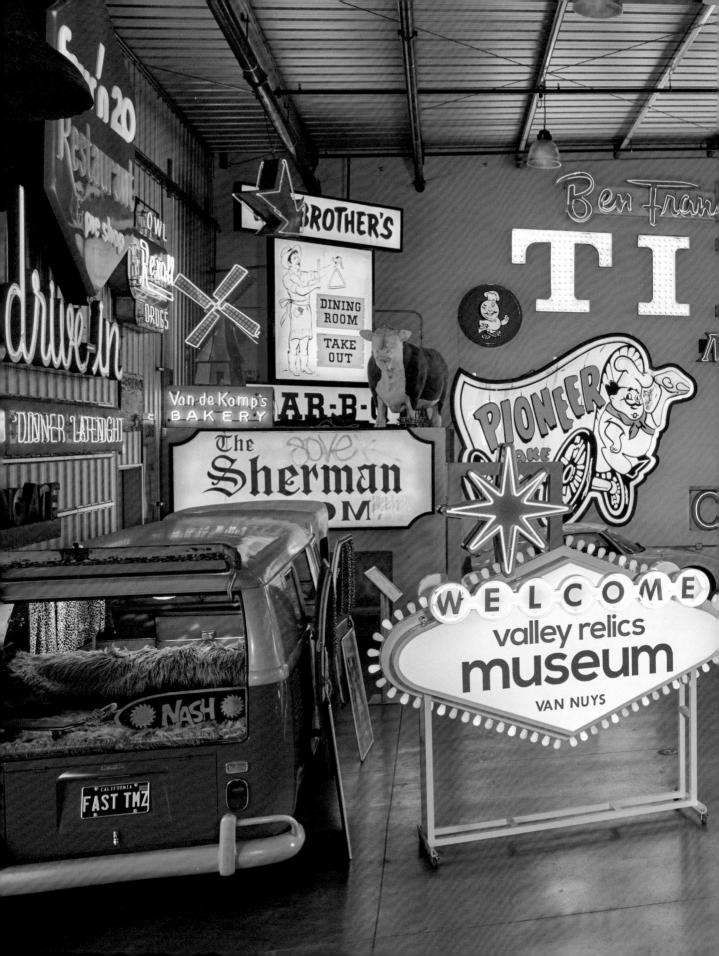

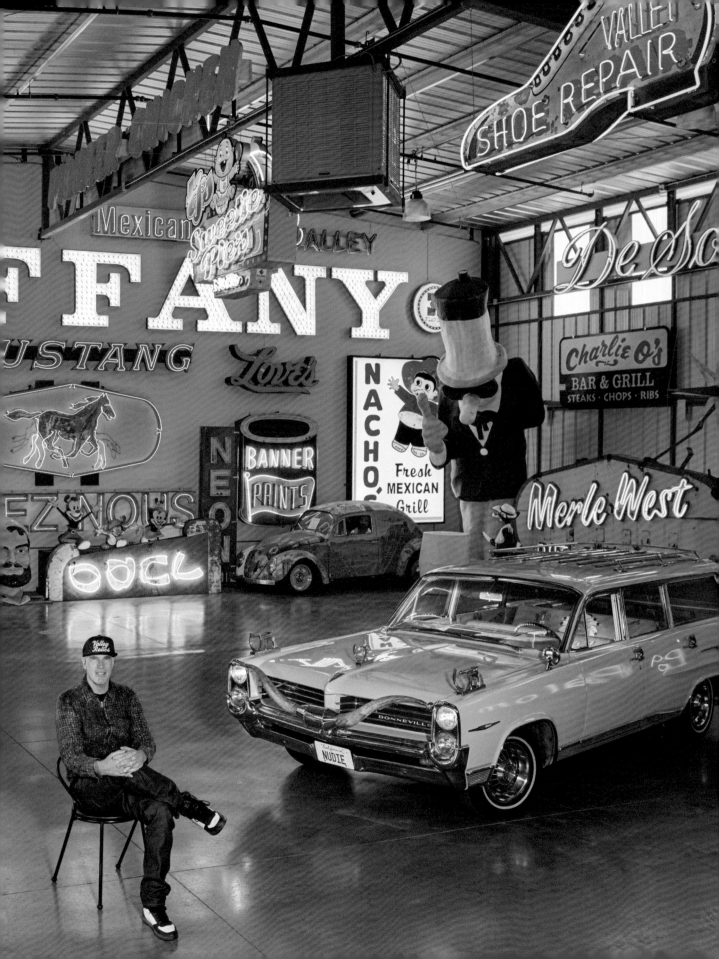

First Original McDonald's Museum
San Bernardino

Albert Okura attributed many of the significant developments in his life to *destiny,* though he also admitted that his compulsive ambition didn't hurt. Either way, it's certainly not everyone who ends up the founder of a rotisserie chicken fast food chain that operates a few dozen locations (Juan Pollo, located mainly in the Inland Empire), or the purchaser and "mayor" of a Mojave desert ghost town (Amboy on old Route 66), let alone the creator of an unsanctioned museum devoted to a multinational corporation—the First Original McDonald's Museum—at the site of the San Bernardino store that started it all.

Okura was *Sansei,* a third-generation Japanese American whose parents were imprisoned in internment camps during World War II, though he certainly wasn't as vocal about his ancestral heritage as he was about honoring the post-war American, automobile-driven culture in which he was raised. A junior college dropout, he was working as a manager at Burger King when he decided to strike out on his own and create Juan Pollo—with the help of some family, including brother-in-law and business partner, Armando Parra, who helped perfect the rotisserie chicken based on recipes from his native Chihuahua, Mexico.

The second Juan Pollo opened in San Bernardino in 1986, and shortly thereafter Okura learned about the early history of McDonald's. Ray "The Founder" Kroc was his personal hero, but he knew little of the real McDonald brothers' story, and was shocked to discover that the company actually started just a few blocks away from his new restaurant. When the building at that hallowed site went up for sale following a foreclosure in 1998, he felt destined, naturally, to purchase the property. He originally had no firm plans for the nondescript building on 14th and E Street; the original McDonald's was long gone, the only evidence being two small sections of terrazzo floor tile outside the entrance. He figured he could move his corporate offices in, if nothing else.

When a local newspaper falsely reported that he would be opening a museum dedicated to the Golden Arches, people started calling to inquire about when they could visit. He decided to allow the prophecy to be self-fulfilling, and the museum would open before the year was out. He learned that December 12, 1998 was the fiftieth anniversary of the opening of the original McDonald's, so he cobbled together enough old photos and several artifacts to host his own unveiling on that date. It's worth mentioning that the anecdote about the newspaper's museum prophecy is given some additional context by a confession in his self-published 2015 autobiography, itself a work of outsider art in the field of corporate CEO memoirs, entitled *The Chicken Man With a 50 Year Plan:*

An early "Evil Grimace" costume, from the character's more nefarious era.

Whenever I talk to reporters I make sure I keep talking and throw out many ideas, plans, or theories and most of all, never be boring or predictable. Reporters need to write and editors need to edit. The bigger the article starts off the longer it will end up in print...I also realized that you can't believe everything you read in the newspapers because reporters can only write what is told to them and they can't research every fact.

Over the years, members of the public have continued to donate items, and these contributions (along with a Polaroid of each donor) make up some majority of the displays. Rows of cases are stuffed with old merchandise, packaging, collectibles, and Happy Meal boxes and toys arranged in chronological order or by nation of origin. Even for sworn enemies of the brand who wouldn't touch a Big Mac with a ten foot pole, it may still be an enjoyable stroll for the vintage advertising and graphic design, curious international marketing tactics, and general quirkiness and delight of the set-up. There is even some real food—actual McDonald's burgers, pies, and breakfast items preserved through an experimental process by which each of the components of the sandwiches were dried and lacquered separately to keep them from rotting.

Other highlights include a costume of the purple Grimace character looking particularly deranged, and a variety of retro play area sculptures dotting the property. The exterior of the building is covered by an epic panoramic painting of SoCal people and places done by artist Phil Yeh (and

PlayPlace sculptures and a wraparound mural sporting an unverifiable superlative claim.

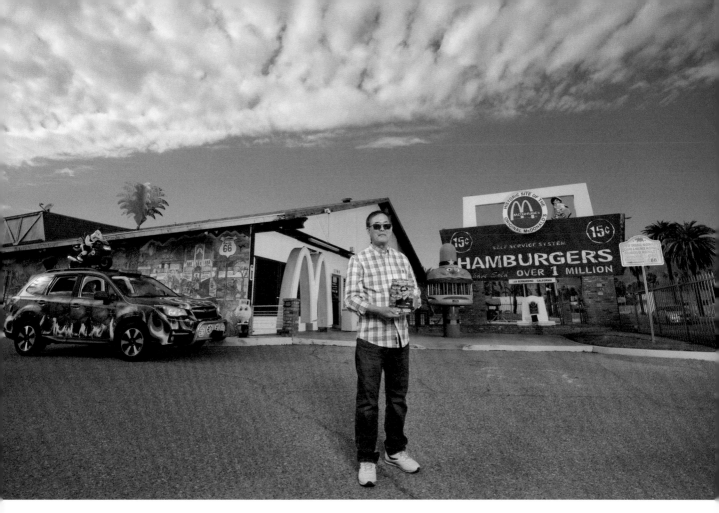

Albert Okura, the late museum founder, entrepreneur, and self-described Chicken Man, holding a copy of his 2015 memoir.

friends); it's billed as the World's Most Detailed Mural, and when pressed on the likelihood of this being true or even measurable, Okura shrugged and said, "Someone's got to have that distinction."

Okura died suddenly in early 2023, putting some plans on hiatus, including a twenty-fifth birthday party for the museum, scheduled for later that year, that would have coincided with the centennial of the original McDonald's. Sadly, one can no longer see Okura manning the rotisserie station on a slow Sunday night, nor watch him rolling in a parade in one of his characteristically outlandish vehicles. But one can at least revel in his maverick spirit through the unreasonably spicy hot sauce sold at his restaurants (now managed by his sons, Kyle and Aaron), admire the restored road sign for Roy's service station in Amboy, and of course, kneel at the altar of the hamburger and the marketing thereof at the unofficial and unauthorized First Original McDonald's Museum. With a new memorial sign out front honoring Okura and highlighting his belief that it was his destiny to sell more chicken than anyone in the world, the site now serves as a shrine to not one, but two larger-than-life founders.

Street Light Museum, Bureau of Street Lighting
Downtown LA

Many observers have remarked that it is unusual for a city the size of Los Angeles not to have a major, official museum dedicated broadly to its development and culture. The Natural History Museum of Los Angeles County (which opened in 1913 as the Museum of History, Science, and Art) comes closest, though after the art department split off in 1963 to create LACMA and the NHM's mission was codified around *natural* history, the human history department was effectively demoted. But LA does have at least one official, city-run museum that seeks to bring to life the history and character of this place, even if it is decidedly niche in scope, and that is the museum at the century-old Bureau of Street Lighting.

The idea might seem curious at first, but street lights have a distinguished place in the public imagination. After all, these majestic bits of infrastructure have been used as the medium for two landmark public art installations in the city. Most famous of course is *Urban Light,* Chris Burden's iconic glowing grid that has served as a backdrop for countless engagement, graduation, and general "bucket list" photos since being installed on LACMA's doorstep in 2008. Then there's *Vermonica,* artist Sheila Klein's "urban candelabra," a survey of LA lights that predates *Urban Light* by fifteen years and long graced a shopping mall parking lot in East Hollywood at Vermont Avenue and Santa Monica Boulevard (hence the name). Klein's piece was relocated in 2020 to the Bureau of Street Lighting's nearby field office, a facility that had already been serving as a private proto-museum, with hulking scraps of the department's own history preserved. When the official museum was dedicated downtown in 2015, the field office collection was a key source for the exhibited pieces.

Situated in an office building that serves as Department of Public Works (DPW) headquarters, the Street Lighting Museum occupies a second-floor suite accessible only via escort, past a maze of public servants' cubicles. The museum room is outfitted with cork tile floors and a drop ceiling that necessitated the decapitation of the light fixtures, leaving the pole section of most lights to the imagination. The shining specimens sit behind velvet ropes, all arranged counterclockwise chronologically by decade of installation. This unnatural setting provides a special opportunity to see the range of styles in all their detailed glory at a more intimate level than in their usual habitat. Small brass plaques indicate the model, date range, and location within the city where they were originally installed (and can often still be found). Many of the model names read like the menu at a civic-minded sandwich shop: South LA Classic, Van Nuys Special, Lynwood Single, Downtown Double....

Some of the earlier models on display; the square aluminum lantern is a rare example from Bronson Ave circa 1915.

As far as public lighting is concerned, we've come a long way since the first forty-three gas lamps were lit on Main Street in 1867, followed by the first electric lights in 1882 that towered above downtown on 150-foot tall poles. Throughout the early- to mid-twentieth century, new street lightings were often massive events that drew a star-studded crowd to celebrate the modernization of the urban landscape, and by 1956, amidst the postwar population boom, the city began to require that all new housing developments include streetlights. Due in part to demand for a fresh look for every new boulevard, bridge, and tunnel, more than four hundred unique designs can be found throughout Los Angeles today (more than any other city in the country), with over 223,000 lights that manage to illuminate just two-thirds of the city's streets.

Plenty of classical and vernacular forms are on view in this one-room museum, with shepherd-crook arms next to modern "cobra" fixtures, streamline designs featuring anonymous topless ladies (still found along Wilshire Boulevard)

A five-star luminaire "Hollywood Special" from 1960, along with classic examples from Olympic Boulevard (circa 1932) and contemporary Chinatown.

or stylized dragons (as on the Chinatown Special), plus fluted shafts and finials galore, all rendered in metal, concrete, and glass. There is an aluminum square lantern, one of only five in the city, that can be found on redwood poles along Bronson Avenue. Propped in a corner is the Hollywood Special, with its rows of stars on the side that nod to the Walk of Fame, that graced Hollywood and Vine from 1960 to 2005. On the floor nearby is an octagonal base from Westwood that reps the UCLA colors of blue and gold, replicas of which still stand near the old Fox Theatre, where even the municipal garbage receptacles are painted in alignment with the school spirit. A framed display of actual bulbs traces their evolution from incandescents with a tungsten filament to mercury vapor, metal halide, high-pressure sodium vapor, and finally LED, to which nearly all the lights still in use have been converted in the last fifteen years.

The bureau no doubt knew there was an audience for this when it opened to the public. As sometimes happens with historical elements of the built environment, there is a small but dedicated community of people who take to the internet to track the locations of particular street light models, research their history, and share moments of beauty and intrigue through

their sightings. These amateur enthusiasts, including a few who have gone borderline professional and even written books on the subject, are onto something: slowing down and paying attention to our surroundings deepens our appreciation for the layered stories our city contains.

The museum was launched around the bureau's ninetieth anniversary and shines a light on their historical hardware up to that point, but one hopes resources might be allocated to expand its scope to include forward-looking developments as well, including the city's first ever streetlight design contest from 2020. Miguel Sangalang took over as general manager of the bureau in 2021 with big ambitions, including a proposal to leverage the existing streetlight network to deliver technology, such as internet access, to create a more equitable Los Angeles. As it stands, while it might not yet be a required visit for school field trips and those wishing to better understand the city's complex past, the museum does serve as a delightful point of entry to thinking about where and how we want our civic memory to be preserved.

Bureau general manager Miguel Sangalang in the museum.

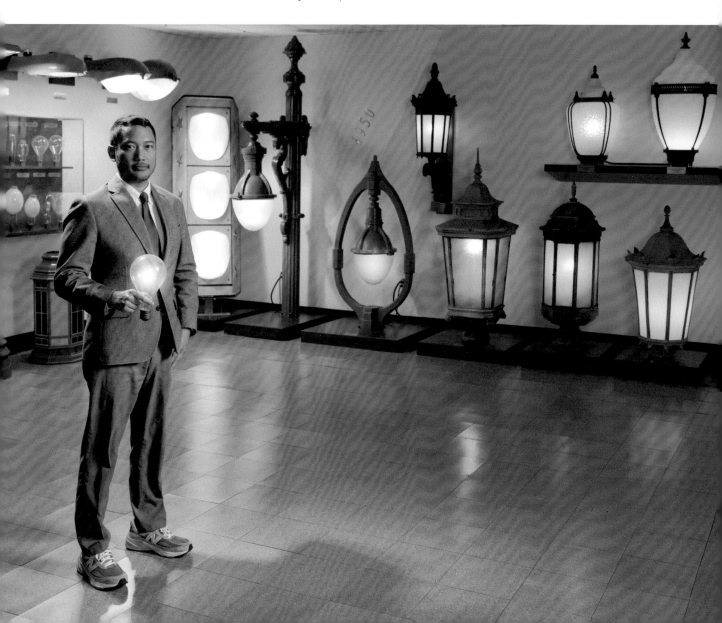

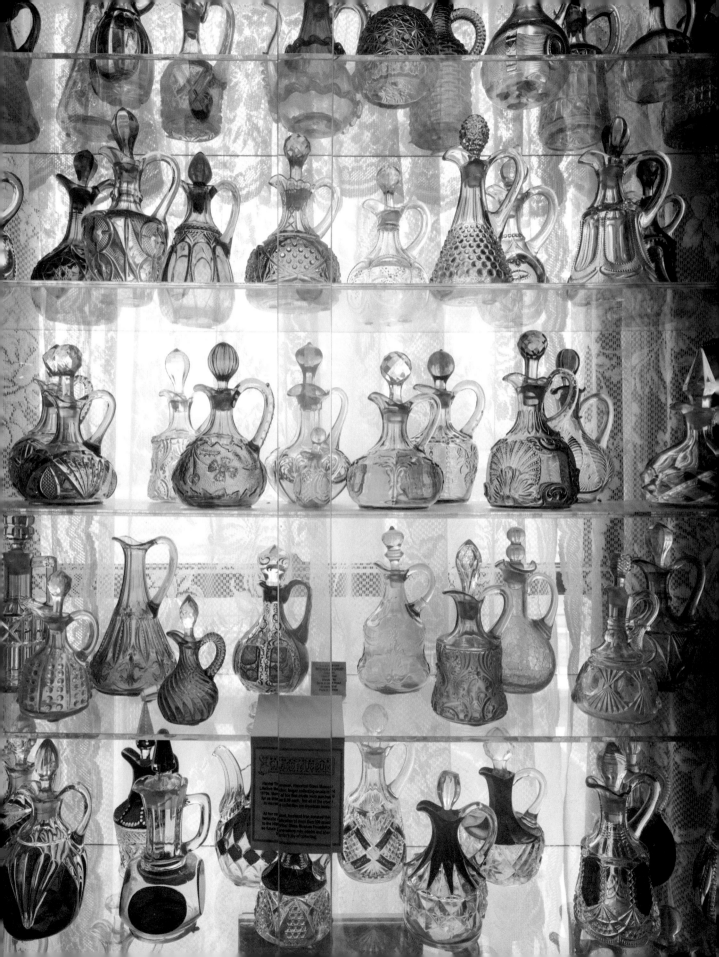

Historical Glass Museum
Redlands

If you have enough of the same type of nearly anything in one space, the results are bound to be interesting, sometimes surprisingly so. The Historical Glass Museum in Redlands, dedicated to, and overflowing with, American glass from the nineteenth and twentieth centuries, is an incontrovertible case in point. It's the only museum of its kind west of the Rockies, perhaps in part because the vast majority of pieces were produced in states back East, such as Ohio and the Virginias. The museum occupies a quaint Victorian home that was built in 1903 by woodworker, architect, and East Coast transplant, Jerome Seymour, whose handiwork is still in evidence in the doors throughout the house—even if many have been removed from their hinges and put in storage to ease the flow between packed rooms. In 1976, Dixie Huckabee founded the museum along with her friends and they purchased the home shortly thereafter, though it took years of fundraising to rehabilitate the space before it could open as a public museum in 1985.

Anyone who thinks collecting antique American glass is a niche hobby should first check their family's cabinets, and also know that there are even more specific clubs out there, such as the Early American Pattern Glass Society or the Paperweight Collectors Association (both of which would be in heaven here). And while there are a number of museums around dedicated to collections of like things—for example, Altadena's now-legendary Bunny Museum, or Darlene Lacey's online Candy Wrapper Museum, based out of her home in La Verne—they are often the result of an individual's passion rather than the kind of communal effort that the Historical Glass Museum represents.

There were at one time more than five hundred glass manufacturers active across the country, which explains why there is so much stock to go around. Community members with large private collections have bequeathed many of the items on view, including a substantial number of perfume bottles from Pearl and Leo Cogen, and Harriet Thomason's 312 cruets for oil or vinegar, arranged by color and beautifully backlit by natural light. Each room is organized by type, from Victorian Art Glass (1885–1900) to Early American Pattern Glass (EAPG to those in the know; 1850–1920) to Depression Glass (1922–44) and American Elegant Glass (1925–55).

The Depression Glass room includes green "jadeite" and iridescent "carnival glass," along with an assortment of pressed "milk glass" dishes with lids in the shape of birds, foxes, dogs, and rabbits. The Pattern Glass room includes an intriguing spoon-holder that might have been served with dessert at a Victorian dinner party; this example is topped with a figure of Jumbo, the elephant from P.T. Barnum's circus. The kitchen contains hollow glass rolling pins into which

A rainbow of vinegar cruets, part of the collection donated by Harriet Thomason.

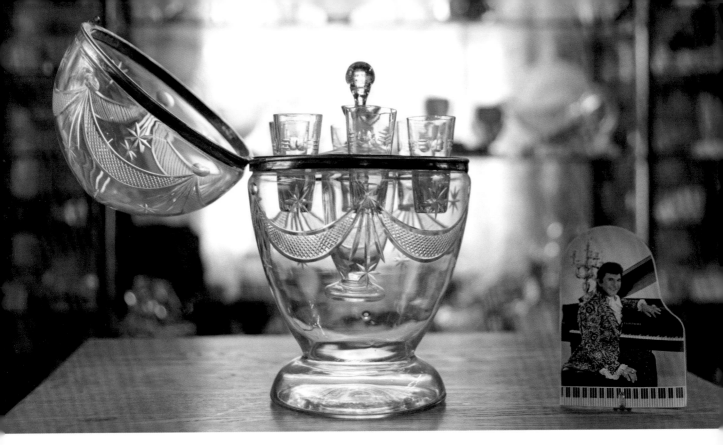

A brilliant cut glass liqueur set, one of the prized artifacts from Liberace's Hollywood penthouse.

enterprising chefs could deposit ice (to the benefit of the pie crust they were rolling) and an electric iron with a glass body, made during World War II when strict metal rations were in force.

A few styles are defined by the specific chemical ingredients or process that resulted in a unique color and finish, such as cranberry glass or amberina. And then there's an entire case full of automobile "bud vases" (sized to fit a single rosebud). These come from the earliest days of the automobile, when it was customary to have flowers as an air freshener inside one's car, a widespread trend that faded by the 1930s as both air conditioning and improved car batteries were developed.

One of the more objectively extravagant acquisitions was of a few pieces of "brilliant cut glass" from Liberace's Hollywood penthouse, including a liqueur set with decanter and glasses encased within an egg-shaped orb. Museum founders Dixie Huckabee and Stella Stubbe were able to purchase these at the estate auction in 1988, from which they've also framed their souvenir bidding paddle in the shape of a grand piano.

Many donations are deemed redundant or otherwise unworthy of long-term exhibition and instead sold to benefit operations; any visitor looking to start their own collection won't need to go far, as the gift shop is overflowing with glass that is priced to sell. And for a deeper dive, the museum hosts regular seminars, such as "Hobnail Glass, from Hobbs Brockunier in 1885 until Fenton in 1965."

What about earthquakes? As Stella Stubbe told Huell Howser when he cautiously inquired about them during his segment on the museum, "We just pray a lot." Of course, visitors can do their part by watching their step and leaving the selfie sticks at home. Photos don't do it justice anyway, as the real pleasure comes from strolling through the maze-like displays, marveling at the range and sheer quantity of fascinating and attractive items, and absorbing a bit of the joy that this hobby clearly brings to those whose devotion to it keeps the doors open year after year.

The 1903 Victorian structure is lovingly maintained by volunteers.

Outer Limits Tattoo and Museum
Long Beach

Cruising down busy Ocean Boulevard, amidst the high rise offices and apartments of downtown Long Beach, one is unlikely to notice that they're passing by an important address, unless they know to look. Down the steep grade via Chestnut Place, a green neon sign announces "Outer Limits Tattoo and Museum" on a storefront space in the back corner of an older building. The awning notes this business was established in 1927, but what is not obvious until stepping inside is that this nearly century-old establishment is therefore the longest continuously operating tattoo shop in the country, and among the oldest in the world (a title claimed by both Razzouk Tattoo in Jerusalem and Tattoo Ole in Copenhagen). Once part of Long Beach's legendary seaside amusement park known as the Pike, the shop is now the last remnant of that sprawling entertainment destination.

At its mid-century height, the Pike was one of the largest attractions of its kind in the country, with more than two hundred sundry amusements including midway games, lunch counters, rides, a bath house, carousel, fortune tellers, and more than a handful of tattoo parlors. In addition to civilian thrill-seekers and sweethearts, the Long Beach Naval Shipyard at nearby Terminal Island provided a constant stream of eager customers, for the tattoo parlors in particular, most notably on Navy pay days. This made the Pike a mecca for tattoo artists nationwide. Eventually, however, the Pike's seedy reputation, mixed with increased competition from the newly opened and more family-friendly Disneyland, as well as the *Queen Mary* docked a stone's throw away, meant a steady decline that eventually led to its demolition starting in 1979.

Sordid conditions are not typically a deal breaker in the tattoo business, and the shop kept buzzing along during the waning years and through the ensuing decades of redevelopment, especially with the name of legendary tattooist Bert Grimm attached to it. Grimm was a raconteur and shameless self-promoter who claimed to have inked Bonnie and Clyde before leaving St. Louis, and purportedly spent a season tattooing with Buffalo Bill's Wild West Show when he was sixteen. He helped popularize the sailor-influenced American traditional style (think anchors and daggers), and of the multiple parlors in which he set up shop, he is most closely associated with this location. After Grimm's departure, it was taken over by his nephew and understudy, Bob Shaw, and later by Shaw's sons. But when the Navy shut down the Terminal Island facility in 1997, the steady traffic from enlistees on shore leave dried up completely, and the writing was on the wall.

Flash art relics and tattoo machines used by artists at the Pike amusement zone.

Enter Kari Barba, herself something of a celebrity in the tattoo community, who, over more than four decades in the field, has prioritized the hiring and apprenticeship of female tattoo artists, and has personally fought an uphill battle for recognition in a male-dominated (and hypermasculine) subculture

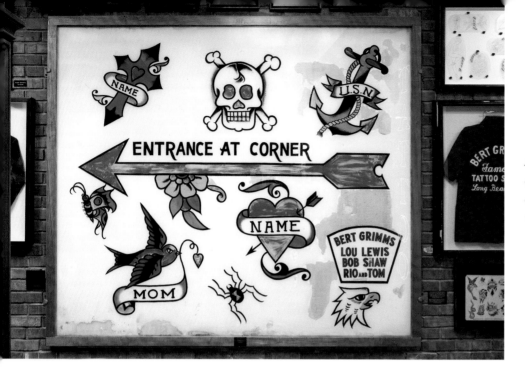

A large window displaying historic flash art, discovered behind a wall during renovations.

and industry. Among her notable achievements is the fact that she pioneered safety and hygiene protocols that are thankfully now industry-wide standards, such as sterilizing needles between clients and simply wearing gloves. Barba purchased the shop in 2002 to prevent it from being converted into a dentistry or law office, keeping it true to its roots as a new outpost of her established Outer Limits business. Already a trailblazer, Barba can now add historical preservationist to her resumé; in addition to maintaining the shop, she also serves on the board of the Tattoo Heritage Project, which is in the midst of a campaign to open a more comprehensive National Tattoo Art Museum in Long Beach. But with that project likely years from opening, Outer Limits is presently the only brick and mortar tattoo history game in town.

It took several years of hard work alongside a few partners, with Barba even selling her home, to bring this legendary shop up to code and back into service. Given its pride of place in the annals of commercial tattooing, it was natural that in its new incarnation it should double as a museum. Appointments are required for those looking to get inked, but walk-ins are welcome for those more interested in the history. In addition to some artifacts discovered during renovation, Barba conducted research at the Historical Society of Long Beach to find old stories and photos of the shop, many of which are now framed on the walls. In a tall display case, several shelves hold a variety of tattoo machines (don't call them guns) dating back to the 1930s, used and in some cases built by artists at the Pike. There are multiple frames with acetate stencils from the time when designs were applied that way, featuring Grim Reapers, Harley Davidson logos, nude pin-up girls, and geishas.

Arguably the centerpiece is a large, hand-painted storefront window directing visitors to the corner entrance and showcasing original flash (samples of an artist's style and available designs) from the Bert Grimm era. It is believed

to date to the late 1950s or early '60s and depicts then-popular designs, including several that incorporate a banner where the client could put their name, that of a romantic partner, or the obligatory "MOM." This was one of three windows hidden behind a false wall that was discovered during renovations, though the other two were sadly unsalvageable. A large safe was also found behind the wall which Barba plans to crack open for their centennial celebration in 2027, even though she expects it to be empty. Rounding out the gallery is a red velvet bomber jacket with stylized green dragons and "Bert Grimm's Famous Tattoo Studio" in gold embroidery, and some original black-and-white photographs of happy customers, mostly young sailors with patriotic chest pieces, all taken by Grimm himself.

Vestiges of Pike history continue to fade; 2022 saw the closure of Looff's Lite-A-Line, a unique pinball-like casino game, which had relocated and continued to operate with a small museum dedicated to the Pike and the Looff carousel dynasty on the perimeter of the game room. With that loss, the old tattoo shop at 22 S. Chestnut Pl. is now the only living relic of the iconic amusement zone. And Barba, as a master of indelible marks, is intent on leaving another kind of permanent impression, this time in the Long Beach and tattoo world's history books.

Kari Barba, museum/shop proprietor and tattoo pioneer.

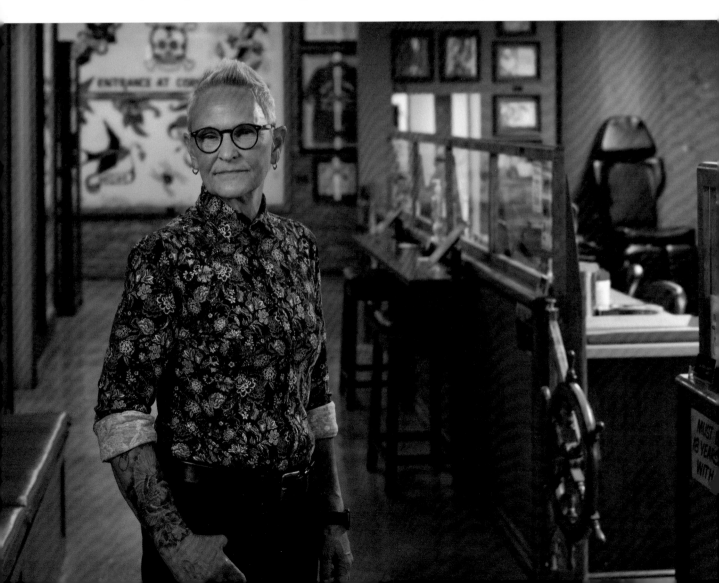

Kendo Shinai

The art of Kendo performs with a dried bamboo weapon called a shinai. Made to represent an actual samurai sword, an additional small shinai can also be used. These shinai came to America in the 1930s and are nearly 100 years old.

Japanese Kendo Uniform

The Japanese art of Kendo opened its doors on American soil in 1920. This is one of the original outfits worn by the first group of Kendo students: Joseph Yoshio Odegiri.

Uniform worn by Joseph Yoshio Odegiri, donated by Carolyn Yano

Morihei Ueshiba
(Dec. 14, 1883 – April 26, 1969)

Aikido is a modern Japanese martial art created by Morihei Ueshiba. History reveals that Ueshiba was a weak and sickly child. To encourage his son in physical exercises, his father enrolled him in sumo wrestling, swimming and more. A turning point came in Ueshiba's life when he witnessed his father, who was very politically active, attacked by followers of a competing politician. In response, Ueshiba set out to make himself strong and be able to protect himself.

He devoted himself to years of physical conditioning and to the practice of martial arts. In spite of the impressive fighting abilities he developed, he felt very dissatisfied. He began delving into philosophy and religion in the hope of finding a deeper significance to his life. During his spiritual quest, Ueshiba believed that all the peoples of the world should unite in a spirit of love and harmony. It is this spirit that he drew on when creating the modern martial art of aikido in the 1920s.

Aikido is not so much a system of combat but rather a means of self-cultivation and improvement. The goal of aikido is on the defeat of others but the defeat of the negative elements of one's own mind and spirit. It utilizes various holds and throws from the jiu-jitsu art. Proper performance of aikido techniques is rooted in a belief in "universal energy" that all things possess. In practice of aikido, attacks are redirected and neutralized using circular, flowing movements. The art was officially named aikido in 1942.

Jigoro Kano
(Oct. 28, 1860 – May 4, 1938)

Judo, translated as "gentle way," is a modern martial art combat sport created in 1882 by Jigoro Kano. Its most prominent feature is its competitive element, where the object is to either throw or takedown one's opponent to the ground, or to otherwise subdue one's opponent with a grappling maneuver.

As an accomplished instructor in the Japanese art of jiu-jitsu, Kano felt that he could increase the art by using a set of principles that would allow him to use the maximum amount of efficiency by using a minimum amount of effort. In short, resisting a move from an opponent the weaker one could be easily thrown, however, by making certain adjustments by letting the attack in a way that would cause the opponent to lose his balance, the weaker could take advantage of the situation and defeat his opponent, making it possible for weaker opponents to defeat significantly stronger ones. As a result, Kano created a new style he called judo.

Judo was the first martial art to gain widespread international recognition by becoming an official Olympic sport. Kano was also a pioneer of international sports, being the first Asian member of the International Olympic Committee that served from 1909 until his death. He officially represented Japan at most of the Olympic Games held between 1912 and 1936.

Martial Arts History Museum
Glendale

The Martial Arts History Museum, devoted to the history and global cultural impact of the full range of martial arts, is perhaps the only museum of its kind in the world. This might seem like a surprise given the general proliferation of judo, karate, Muay Thai, jiu-jitsu, Krav Maga, and others via countless gyms and studios, and in contemporary popular culture more broadly. But when one sees what it took the proprietor to pull it all together, it's no wonder there isn't any competition. Anyone who visits is likely to be greeted by founding director Michael Matsuda, who is also an author, magazine publisher, historian, designer, curator, producer, entrepreneur, and indefatigable optimist with an infectious enthusiasm for his life's work.

As a kid in the San Fernando Valley, Michael's parents compelled him to take judo classes. He hated this experience (that day of the week was known to him as "Nightmare Night"), but an altercation with a school bully demonstrated the value of self-defense. He tried a range of other martial arts but says that the newly available kung fu class he took on September 15, 1973 changed his life forever. He got so invested that by high school, he helped form a martial arts club and soon converted more than thirty classmates into his disciples. He would become the last teacher of monkey-style kung fu in America and a sixth generation grandmaster of the art.

Matsuda started his career writing articles for magazines and eventually founded *Martial Art Magazine*. Though he sold that business in 1987, he has continued publishing and is now the author of more than fifteen books, including one on the story of the museum itself. He attended a staggering array of local colleges and universities—UCLA, USC, CSUN, AFI, LATTC, Mission College, LA Valley College, College of the Canyons—taking eleven years to learn all the various subjects that might prove useful in running a museum and creating its displays, from marketing and PR to journalism, business, graphic design, filmmaking, and editing.

The museum itself began as a pop-up at martial arts tournaments and gatherings. After years of failed attempts to garner official support in finding an affordable location from the City of Los Angeles and other surrounding cities, and following a short stint in Santa Clarita, Michael and his wife Karen decided to sell their home in 2010 in order to buy a place in Burbank, on a stretch of Magnolia Boulevard between Italian delis and year-round Halloween stores. The museum would operate there until late 2023, when they put that building back on the market, moving to a sprawling basement space in Glendale that would quadruple the footprint, making it possible to display more of the collection and finally be able to accommodate school field trips. After a feverish build out,

A century-old Japanese kendo uniform, one of many significant uniforms on view.

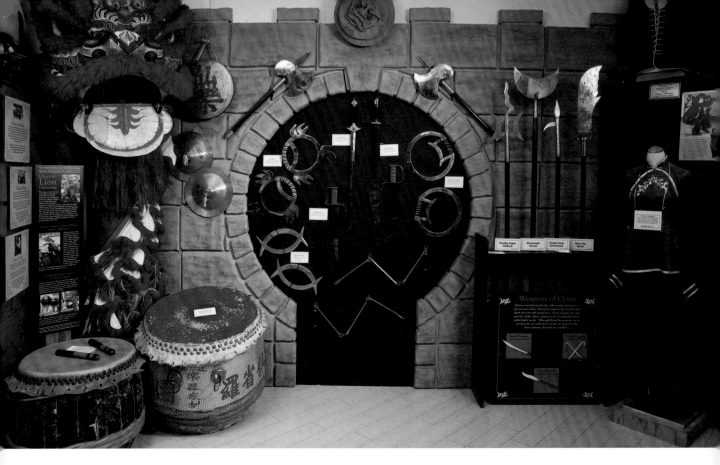

An exhibit dedicated to Chinese martial arts and culture at the former Burbank location.

the museum reopened in April 2024 in its vastly expanded digs, just off bustling Brand Boulevard and with the Americana shopping mall in close range, which Matsuda counts on to produce increased foot traffic.

Inside the museum, after passing under a faux-stone arch, visitors are guided through a series of themed exhibits contextualizing some of the more than five hundred artifacts in their collections, starting with a section on Chinese martial arts that includes masks, tai chi uniforms, a history of kung fu, and a moon gate façade supporting a variety of hand weapons. Next, three imposing suits of samurai armor guard a wall of swords in the Japanese section. Other areas showcase Hawaiian, Thai, Filipino, and Korean martial arts, and the effects of martial arts on American history and culture (including the racism and resistance that met early pioneers who immigrated to the US). Another display features movie props like a bandana from *Karate Kid Part II* (1986), a shield from *Mortal Kombat* (1995), a set of "gopher chucks" from the comedy *Kung Pow! Enter the Fist* (2002), and the "flying guillotine" prop from *Samurai Cop 2* (2015).

Additional objects put on view after the move include "Judo" Gene LeBell's judo gi uniform in his signature pink (dyed after a laundry mishap), as well as the uniform of the pioneering Black kickboxer Cecil Peoples. Separate rooms are dedicated to women in the martial arts and Armenian and Persian traditions and practitioners. Matsuda also branches off into other areas of Asian pop culture, including an overview of anime. The exit (and entrance) is through the gift shop, which offers a variety of clothing and merchandise including Matsuda's many

publications, under a stylized tree (concealing a structural beam) that he had always wanted to create and still hopes to populate with animatronic birds.

Behind the exhibit area is a 120-seat theater, set up for events such as movie premieres, book signings, and lectures. The signature program, which actually predates the museum itself, is the Martial Arts Hall of Fame ceremony, honoring individuals based on historical achievements rather than the number of championships or prior awards won. Inductees receive a Sammy, a trophy in the form of a samurai sculpted by Matsuda's neighbor, Richard Wade.

Matsuda, always punching above his weight, still considers this space a stepping stone, and dreams of a larger standalone location complete with classrooms, a restaurant, and space for conventions and tournaments. Regardless, he emphasizes that the museum would never have been possible without the support of the diverse martial arts community. And since the LA area is home to so many pioneers of the various art forms, he believes that it could have only happened here.

Michael Matsuda, demonstrating monkey-style kung fu in the samurai section.

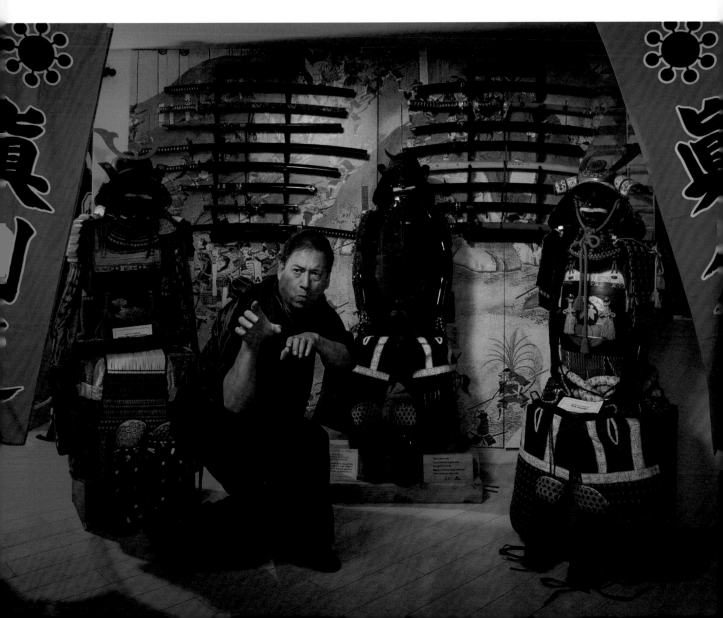

Part 3
Technology and Science

NASA Jet Propulsion Laboratory (JPL)
Pasadena/La Cañada-Flintridge

" **W** *ELCOME to our universe..."*

...So proclaims a prominent sign on the guard booth under a jetwing-esque canopy at the main entrance to the Jet Propulsion Laboratory (JPL), NASA's premiere purveyor of interplanetary craft. The first stop of any visitor to this esteemed 168-acre campus is the badging office, making it possibly the only museum in the region that requires special security clearance. It does add a sense of excitement, as though one might come into contact with secret technology not yet approved for civilian consumption, and even if that's not in the cards, the buzz of activity mixed with the historic spaces and iconic equipment that visitors will encounter is enough to make one think they hear a piped-in, uplifting orchestral theme song playing across the quad. In truth, this working facility doesn't accommodate nearly enough visitors to warrant such Disneyfication, even though it is nominally open to the public and especially to school groups. It certainly doesn't qualify as obscure or unheralded in the popular imagination, as is the focus of this book, but then when has it ever been listed among the local museums or sites to check out, and how many Angelenos not in grade school can say they've been?

The actual museum/visitor center and adjacent auditorium are named after Theodore Von Kármán, the Hungarian-American aerospace engineer and administrator largely responsible for the founding of JPL. But no didactics go into the lab's wild origin story; no placards outline the early reckless rocket fuel tests of the so-called Suicide Squad (including the controversial sex-magick occultist, Jack Parsons), or the McCarthyist persecution of much of the pioneering team, or the lab's long association with the US military. It is primarily the modern exploratory era that is proudly showcased in the displays, as in 1958, shortly after the establishment of the National Aeronautics and Space

A sample block of aerogel, a silica-based solid that is 99.8 percent air.

The Jet Propulsion Laboratory's 168-acre campus, tucked against the San Gabriel Mountains. A thirty-foot-tall NASA logo is visible on the side of the Spacecraft Assembly Facility.

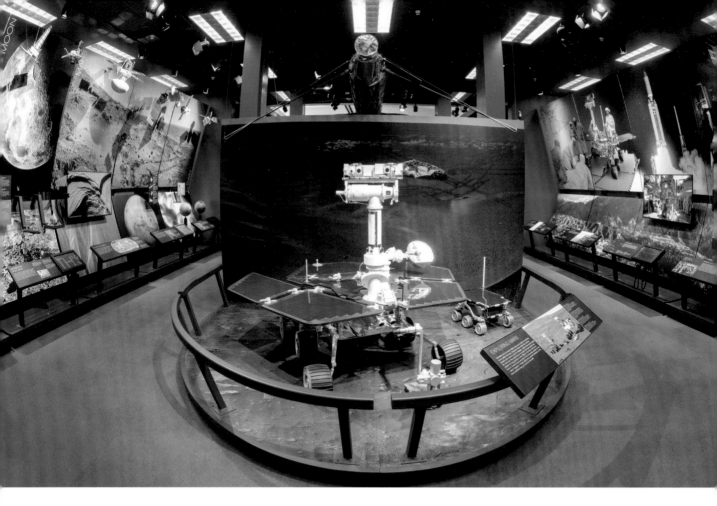

Administration, JPL was transferred from Army sponsorship to that of NASA (albeit still administered by nearby Caltech even today).

Entering the museum, one is greeted by life-size models of Mars rovers, including *Sojourner*, the first to land on the Red Planet and explore its surface in 1997. Other achievements featured along the gallery's perimeter include intricate miniature models of satellites like the *Mariner 10* that was sent off towards Mercury, an authentic moon rock retrieved on the Apollo 16 mission and encased within a clear resin pyramid, and a sample block of aerogel, a ghostly silicon-based material that is 99.8 percent air and has been used to insulate electronics on Mars rovers and trap comet particles on the *Stardust* probe. The most commanding object is the room-size replica of the black and gold *Galileo* spacecraft, which was launched in 1989 to scope out the gas giant Jupiter and its moons and send back invaluable data before intentionally plunging into the planet's atmosphere in 2003. The collection continues into the auditorium, with more models such as the 1977 *Voyager* spacecraft, complete with a copy of the famed golden record that was meant to serve as a capsule of Earthly culture, along with its needlessly arcane diagram instructing advanced space beings on how to decode its audio and visual contents.

The tour continues across campus to several captivating spaces that are in active use, like the Space Flight Operations Facility, better known as Mission Control,

The visitor center/ museum gallery, with a full-scale model of twin Mars rovers Spirit *and* Opportunity *at center.*

which is satisfyingly consistent with film depictions and is thrilling to see, even if no one is working there that day. Looking in from a balcony, the staff's nerdy sense of humor shows on the desk belonging to the Ace for the *Cassini* Mission: someone has casually left a book with a photoshopped cover that reads, "Flying the *Cassini* Spacecraft for Dummies." Out in the foyer, one can also see a jar of "lucky peanuts," consumed before important missions as a hallowed ritual. From there, it's a short stroll to a unique stop with a great name: Mars Yard, a small field of dirt and rocks meant to simulate the surface of Mars and which functions basically as a sandbox to see how best to navigate the rovers' "Earth Twins" (exact replicas) over and around obstacles. In the "clean room," part of the Spacecraft Assembly Facility, one entire wall is made up of HEPA filters, and anyone entering must wear a white full-body "bunny suit." Peering down into this sterile, dust-free room from an elevated (and isolated) observation deck, one can often see inscrutable tasks being performed, presumably towards the assembly of actual spacecraft.

The impulse to attach cheeky hidden messages onto multi-billion dollar pieces of equipment being launched into space would seem irresistible: the *Curiosity* rover's rolling track has a footprint that leaves "J-P-L" in Morse code on Mars's rusty ground, and the parachute of *Perseverance* is cryptically encoded with a pattern that translates to the GPS coordinates of JPL along with their semi-official slogan, "Dare Mighty Things." These Easter eggs can be understood not just as inside jokes by engineers who don't get out much, but as a calculated attempt to engage a wider public and bring viral interest to a given mission. Indeed, broad support is needed to ensure sustained funding for the space program, and seeing firsthand how this futuristic sausage is made is a great way to foster a lifelong enthusiasm for the seemingly impossible things they have in the past and will yet accomplish.

A moon rock, brought back by Apollo 16 astronauts in 1972.

Pennypickle's Workshop
(Temecula Children's Museum)
Temecula

Across the vast and diverse museum-scape, children's museums are a different animal compared to adult-centric (or even family-friendly) museums of art, science, history, or culture. They tend not to care for collections or exhibit any artifacts, foregoing didactic labels with lengthy interpretive texts. They are instead more like structured playgrounds, with environments and installations that promote education and social development through participatory experiences. Simulated, scaled-down grocery stores and firehouses are common at the dozen or so children's museums throughout the greater LA region, as are straightforward jungle gyms and art-making stations. But there is one institution which takes the themed-environment strategy to another level, with results that are totally delightful even to someone with no little ones in tow (never mind that entry without a child at such venues, this one included, is typically forbidden). Pennypickle's Workshop in Old Town Temecula stands out, since those who visit will find that they are not merely patrons of a museum, but also guests in the home and workshop of a zany inventor and mad scientist, Professor Phineas T. Pennypickle, PhD.

Professor Pennypickle is the alter-ego of creator Pat Comerchero, who conceived and designed the museum's unique layout and storyline. Growing up, Comerchero's family owned toy stores and a children's clothing store in San Diego, and she spent the early part of her career as a toy sales rep, which gave her direct experience with places peddling youth engagement, and with the business side of wonder. While home-schooling her children, and later grandchildren, she saw firsthand that kids are natural tinkerers and scientists, and that often the most effective way for them to learn new concepts was through experimentation and play. She began promoting the idea within her home city of Temecula, along with her husband (and former mayor and city councilmember) Jeff, that they needed a public children's museum to bring this kind of homespun, experimental, and educational fun to the broader community. Over the last twenty years, their advocacy has paid off.

The building housing the museum was formerly an antique store with small rooms carved out for different vendors, and after sitting vacant for a few years, the city purchased it and leased it to the nonprofit Friends of the Temecula Children's Museum. Comerchero knew she didn't want cookie-cutter displays, also recognizing that signage means nothing to children, who just want to press buttons and try things. She tends to look at an everyday object and probe its potential to engage and inspire, resulting in a space where every wall of every room is covered with a mind-bogglingly vast array of found materials, science

The library is appropriately also the time travel portal.

and art experiments, optical illusions, and interactive games and mazes. With a surface aesthetic of steampunk assemblage, activities are organized more or less by concept and set within rooms of the imaginary inventor's abode. Past the bric-a-brac-covered entry gate, it's a free-for-all of chaotic, exploratory play—all tying back (at least loosely) to the central plot.

The professor is never seen and is always out time-traveling; Comerchero didn't want a fixed image to represent Pennypickle, so his appearance is left up to kids' imaginations (and therefore, might look like them). The museum's less evasive mascot is the professor's fieldmouse assistant, Beaker (full name Beakerham Bettermouse IV), who watches over the house while the professor is away. Upon entering the museum, one first encounters the professor's library, dedicated to time & travel, where sitting in a metal chair (perhaps taken from a jet plane) triggers an audiovisual time-warp sequence. Flashing lights beckon one to escape by crawling into the fireplace, which ends up being a maze leading further into the fantasy.

The hot air balloon basket appears to have crash landed through the ceiling.

In a central area dedicated to aviation and flight sits a hot air balloon basket—on brand in a region known for balloon rides over wineries, though Pennypickle's basket is of course outfitted with atypical accouterments. The bathroom doubles as the water resources room, with activities relating to hydraulics and hydroelectric power generation. A mirror carries instructions to make a funny face, and it doesn't take long for kids to figure out that you can see straight through this mirror from the other side by stepping into the full-size wardrobe in the adjoining bedroom. Other spaces are dedicated to perception and illusion (the bedroom), chemistry and physics (the kitchen), and power and electricity (the dining room).

There are so many interactive elements sprinkled throughout that it's difficult to know which buttons will do something; it doesn't even matter if some of them happen to be inoperable, because it's natural to just keep moving and try the next one. Some of the more intentional demonstrations are clearly indicated by an oversized penny and a pickle screwed to the wall in close proximity to the prompt, such as a pile of tube televisions where kids can move large magnets in front of the screens and watch the distortion of the images, or

a door with a porthole window through which the hallway appears infinitely long. The sheer number of objects makes exploration a joy for the curious and results in a surprisingly intimate experience, allowing each child to feel as though they've personally discovered Pennypickle's secrets.

The museum has been receiving awards since it opened in 2004, and is purportedly the first fully themed children's museum in the country (appropriate for a downtown area which itself adheres to an Old West concept). Comerchero hopes that kids who spend time here might be inspired to go into STEAM-related fields (science, tech, engineering, arts, and math), and the museum has now been around long enough that some of their earliest visitors can start to bring their own children. The creativity and care that went into this place makes it beloved in the community and admired by museum professionals far and wide. But the main concern for the average guest is to pull, crank, climb, and crawl their way around, finding joy through discovery, and learning something new along the way.

Pennypickle's bathroom is crowded with water-related experiments.

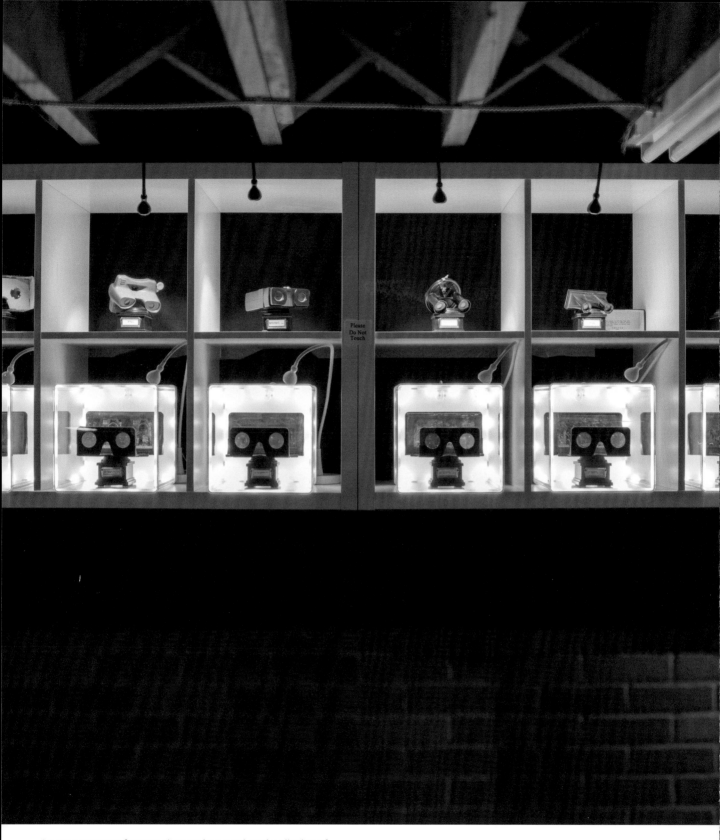

An assortment of stereo viewers (top row) and a display of nineteenth century French diableries, macabre scenes of the underworld that can be lit from behind to switch from day to night.

3-D SPACE
Echo Park

Considering that most people see the world in three dimensions, why is it that 3-D media and technology is so captivating? The question is worth pondering, but Eric Kurland can at least recall the exact time in his childhood that his interest in all things 3-D was first sparked. From around five years old, he would always close his weaker eye when looking into a View-Master, that iconic retro object of immersion, thereby constraining the images to flat two-dimensionality. When he was seven or eight years old, he just happened to open both eyes when viewing a slide featuring Popeye and Olive Oyl with little hearts floating in space above them; Popeye popped out, and Eric's mind was blown. He promptly ran around the house checking every available slide to be sure they all did the same thing, and it set him on a lifelong quest to educate and inspire in others the appreciation of this special perceptual effect.

In the years since that revelation, Kurland has carved a career out of various technical and advisory positions to bring stereo visual effects to movies and new media. Beyond professional gigs, he served for five years as president of the LA 3-D Club (the most robust of its kind in the country), and is director of the LA 3-D Movie Festival. Most recently, his resumé has expanded to include founding director of 3-D Space, a museum and educational center dedicated to the art, science, and history of all things stereoscopic.

An early seed of the museum was planted in 2012 through a confluence of LA characters. Kurland and his mentor, Ray Zone—a film historian, "3-D King of Hollywood," and namesake of Howlin' Ray's hot chicken restaurant where his son is founder and head chef—recovered three truckloads of objects and ephemera from the estate of filmmaker and collector Dan Symmes. George DiCaprio (father of Leonardo) was helping administer the sale and remembered Zone from when they were neighbors and used to publish comics together; he made them promise they would do something with these fascinating and, in some cases irreplaceable, artifacts. Just a few months later, Zone himself died and Kurland became the keeper of his collections as well. By the time the Portland, Oregon-based 3D Center of Art and Photography folded in the face of dire economic straits and shipped all their stuff Kurland's way, the vision of starting a museum was fully formed.

After a lengthy search for a location, the owner of the building storing Kurland's artifacts mentioned that he was clearing an adjacent basement space that he planned to rent. Kurland jumped at the chance to launch a starter version of his museum there, directly below the former Echo Park Film Center. Officially opened in 2018, you can find 3-D Space down a short alleyway, past a cinderblock wall topped with razor wire and dotted with

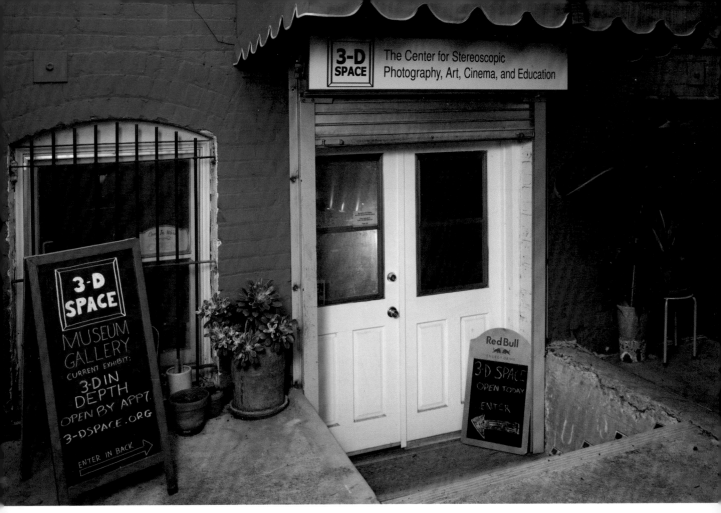

The museum is accessed down a narrow alley, just off busy Alvarado Street.

spray-painted icons of anaglyph 3-D glasses (the kind with one red and one blue lens) that seem to jump out from the graffiti.

3-D Space hosts changing exhibits with imaginative and informative themes, typically some combination of antique, modern, and futuristic devices. Among these are stereoscopes, holograms, View-Masters, VR goggles, 3-D books and movies, digital art and photography, and multiple generations of equipment and 3-D cameras, including one that looks to be ready for a 1980s family vacation but for the fact that it's stretched comically wide and features twelve lenses in a row that allow it to make lenticular images. One of Kurland's particularly prized pieces is the exceedingly rare Terryscope, a homemade prototype, arcade-style kiosk with stereoscopic *Mighty Mouse* film clips that play for a dime (he'll loan you one). This 1955 invention by Terrytoons creator Paul Terry was meant to be installed at shopping plazas next to gumball machines and mechanical horse rides, but it never took off; this model with a classic Formica countertop viewing panel and spray-painted stencil text is one of only four known to exist.

While Kurland remains busy scheduling programming, curating exhibits, and giving tours, he still hopes to move to a bigger location where he can have a full screening room, library, and expanded gallery space to further showcase advancements in related technology. Until then, this clandestine basement bunker is as good a place as any to peer in on a diverse range of innovative media and consider our brain's ability to convey the perception of depth—and dwell on just how cool that is.

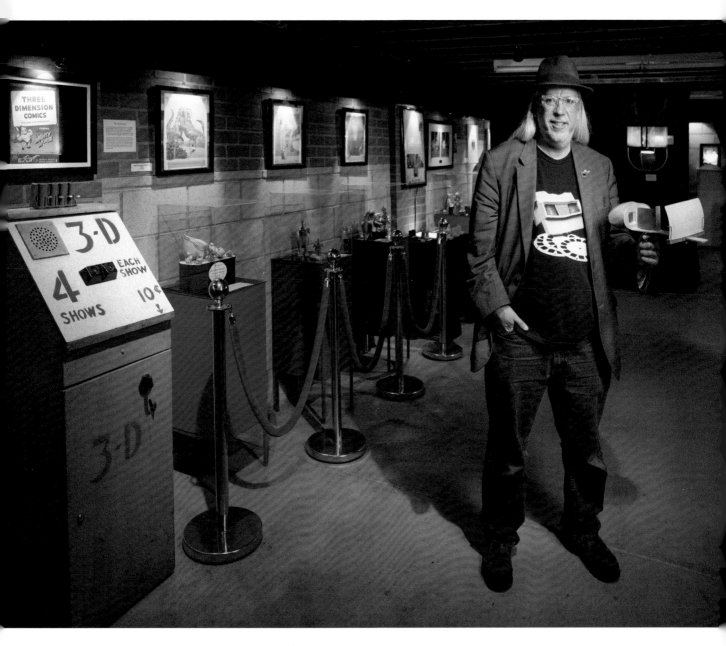

Museum founder and director Eric Kurland stands in the gallery holding a Victorian-era stereoscope, with the rare Terryscope prototype at left.

Paul Gray Personal Computing Museum
Claremont

If one tried to look up the Paul Gray PC Museum in 2017, one would have found scant information available online beyond a memorial tribute to the late Claremont Graduate University (CGU) Professor Gray, and a single Yelp review alerting would-be visitors that the "PC" here has nothing to do with political correctness. Upon arrival, one might also find it difficult to physically access without a student ID badge. Though it remains decidedly under the radar, occupying a handful of display cases tucked into niches of the Academic Computing Building atrium, it has since undergone a meaningful revival, now serving in a more relevant and dynamic capacity than the most casual passersby (on their way to class, perhaps) might assume.

Paul Gray was a pioneer in the field of information sciences, and was author of more than a dozen related books and countless articles. Gray came to CGU in 1983 to serve as founding chair of the Center for Information Systems and Technology (CISAT), a program which he would lead for the next eighteen years. He was most interested in the impact technology has had on each of us as individuals, focusing deliberately on the *personal* angle of personal computing. By the time advancements in computer technology brought the physical size, user interface, and price point of the machines down to a reasonable scale for individual consumers (as opposed to the earlier, room-sized mainframes well established amongst corporate and government entities), Paul Gray was already in on the ground and keeping close tabs on these developments.

Soon after retiring in 2001, Gray founded the museum, donating his collection of already ancient machines along with their original user manuals, and facilitating donations of devices that would help fill the gaps. The museum became largely dormant after Gray's passing in 2012, but in recent years has been re-engaged by the school's Museum Studies program, led by Professor Joshua Goode in collaboration with Professor Emeritus Lorne Olfman, who also served as head of the CISAT program and had worked closely with Professor Gray. The most unique aspect of the revival is the leadership structure that emerged: a series of student executive directors are given the proverbial keys, and are invited to apply their own interests and skills to further the museum's mission. This provides direct experience in museum management, with a sense of responsibility and a perspective beyond that of any more traditional internship or entry level position they might hope to find (not to mention the relatively low stakes if something doesn't go as planned, or when the student in charge graduates and moves on).

The inaugural student ED, Kiera Peacock, developed new exhibits and worked on conservation. Her successor, Allison Koehler, developed lesson

Museum advisors and student directors, from left: Allison Koehler, Terri Childs, Bailey Westerhoff, Joshua Goode, Lorne Olfman, Kiera Peacock.

plans and educational programming, including the *Decoding the Past* virtual discussion series, produced with the assistance of museum board member and Paul Gray's daughter, Terri Childs. The third director, Bailey Westerhoff, took a particular interest in development and fundraising. Perhaps unsurprisingly, the museum still fields calls from people who can't find another obvious use or home for their old equipment, and is still actively collecting, provided it's something on its wishlist.

Focusing primarily on earlier models, a majority of the pieces hit the market prior to 1990. In one case are "clamshell" devices, clunky by today's standards, including Hewlett Packard's first laptop, the 110 model from 1984. Also on view are an Apple II from 1977, the first PC with color graphics; IBM's 5150 from 1981, their first foray into personal computing; and a Commodore 64 from 1982, which still holds the distinction as the highest selling computer model of all time due to

A typical display case showing early personal computers, from left: Tandy/RadioShack TRS-80 (1977), IBM 5150 (1981), and Apple Macintosh Plus (1986).

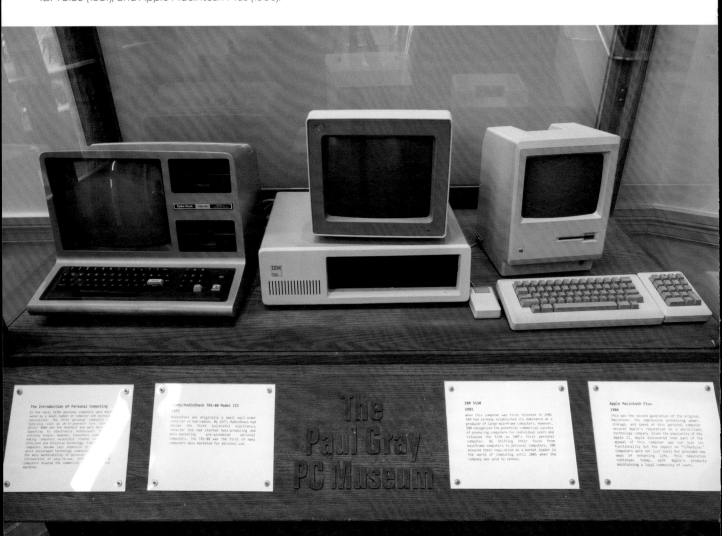

The twenty-six pound Osborne I (1981), the
first portable (luggable) computer model.

its affordability and utility for video games. And don't forget the Altair 8800 from 1971, which likely took its name from *Star Trek* and couldn't do a whole lot, but struck a definite chord amongst radio and rocket hobbyists of the era.

The future of the museum likely holds more tactile and interactive experiences, and partnerships with area schools to engage younger kids, but its activities will also be guided by the talents and priorities of incoming student directors. The featured machines seem to convey an optimism about the promises of new technology, compared to the way it's played out in the decades since. As the effects technology has on our personal lives are more extreme (and in some ways more dystopian) today than ever before, it's not only nostalgic but also necessary to reflect on this legacy of progress, and as Professor Gray would no doubt encourage, be critical and intentional about where we will allow it to lead us next.

International Printing Museum
Carson

"THE black hole vortex of all things printing..."

...That is how Executive Director Mark Barbour describes the collecting policy of the International Printing Museum. This is not an unfair characterization, considering the museum requires more than one off-site warehouse and numerous tractor trailers to store the presses not currently on view, and continues acquiring new machines, type, artwork, and printed matter from around the country on a regular basis. Just recently, a large donation came in from the Smithsonian, which deemed the International Printing Museum a better-fitting caretaker for Victorian type in various fonts. So far, the small but mighty museum's claim to having the world's largest collection of *working* antique printing presses goes unchallenged, and yet, the dynamic institution located near the intersection of the 110 and 405 freeways remains something of a hidden gem.

As of this publication, Barbour is pushing sixty, and is quick to point out that he has been running printing museums for roughly forty of those years (though he can't recommend that others attempt the same career path). He started as a student at Cal Poly San Luis Obispo, where he quickly got involved with the Shakespeare Press Museum, an active letterpress studio in the basement of the Graphic Communication building. This gig got him connected with Ernest A. Lindner, a Los Angeles-based printer, dealer, and world explorer who hired Barbour fresh out of college in 1988 to help open a museum with his massive collection, originally in Buena Park.

After a few years at their Orange County location and just as the support of a benefactor (or "sugar daddy," as Barbour puts it) was drawing to a close, Caltrans seized the building by eminent domain for an express lane expansion of the 91 freeway, and the state was therefore obliged to invest in the museum's relocation. They landed in their present venue in the city of Carson in 1997. Though Ernie passed away in 2001, the Lindner Collection forms the heart of the museum, around which much has been built in the intervening decades.

Visits to the museum are always interactive, sometimes theatrical. Even casual and seemingly uninterested visitors are compelled to join a tour/demonstration, as the staff are not about to allow anyone to leave the building without seeing some of these fascinating machines operating, let alone ignorant of the many ways the printed word changed the course of world history. It's a rare and multisensory treat, with the Rube Goldberg-like linotype machines producing a symphonic clatter that melds nicely with the smell of freshly inked and sometimes homemade paper. The truly infectious enthusiasm of Barbour, his small team of staff, and his large cohort

The Unitype once met the typesetting needs of small town printers, but in time the Linotype machine won out.

Guided tours start in a set dressed as Benjamin Franklin's printing shop; Franklin himself makes an appearance for school groups.

of volunteers—the majority of whom have professional ties to the printing industry—doesn't hurt.

Specialized tours include a historic overview of printing innovations, and their ever-popular Benjamin Franklin presentation (speaking of theater). School kids are compelled to debate with Franklin about what should be included in the Declaration of Independence, after which they learn how to use a period press to make reproductions of this founding document that they can all take home. Benjamin Franklin himself, and his printing shop, are also set up as a program on wheels, with a trailer-based mobile museum that unfolds to bring a host of experiments and demonstrations on the Colonial-era printing press to schools and community events. Conceived during the time when the museum was in temporary storage pending a move, the museum on wheels now goes as far as the Bay Area and Arizona, and has worked with more than 800,000 students to date.

Other signature annual events include the LA Printer's Fair, a community-building convention and participatory art fair, as well as the Letterpress

Wayzgoose, based on an old, traditional happening in the letterpress trade. They've also recently built out a new space as the Book Arts Institute, dedicated to classes and workshops including bookbinding, paper marbling, screenprinting, and letterpressing as well as dedicated Merit Badge and Patch Days for Scouts.

As a source of needed income, the museum puts its globally significant stock of fully functioning and aesthetically striking antique machinery to work, renting equipment all over the country and even internationally for TV and film shoots. Any time there is old-fashioned printing equipment used in a scene, there is a good chance it came from the International Printing Museum, including the Victorian-era print shop that appeared in HBO's *The Gilded Age,* for which it shipped a five-thousand-pound Prouty "Grasshopper" newspaper press all the way out to the Lyndhurst Mansion in Tarrytown, New York. Not surprisingly, Barbour couldn't help but load a few new acquisitions onto the truck for the ride back home.

Museum director Mark Barbour in the main gallery; a large wooden recreation of the 1440 Gutenberg Press is at right.

ASTRONOMICAL MUSEUM

Mt. Wilson Observatory
Angeles National Forest

At just over 5,700 feet above sea level, Mt. Wilson Observatory has (or is, depending on how you look at it) the highest elevation museum in Los Angeles County. Driving up the winding highway rising through the pines above Pasadena and the LA Basin, it's also one of the most exciting to get to, particularly after the unfortunate closure of the charming hike-in visitor center at Henninger Flats a few miles down the trail. But its mountaintop location is only a small part of what makes a visit so rewarding, as the palpable and epic history, active science, and incredible structures and stories make it clear that despite its legendary status in the world of astronomy, it remains underappreciated more broadly.

Mt. Wilson Observatory was established in 1904 through a campaign led by George Ellery Hale, the well-connected son of a Chicago elevator magnate, who was successful in coaxing steel baron and philanthropist Andrew Carnegie into creating a new division of his Carnegie Institution of Washington to support modern astronomical research. Hale would ultimately lobby to construct four telescopes that were each the largest in the world when built; the second and third are the pride of Mt. Wilson: the 60-inch, built in 1908, and the Hooker 100-inch, which saw its "first light" (as they so romantically say in the field) on November 1, 1917. The inches refer to the diameter of the concave reflecting mirror that collects distant light, and the massive 100-inch scope had the power to discern a single candle's flame from a distance of 9,600 miles.

Several fundamental discoveries were made at Mt. Wilson that would reshape astronomy as we know it and significantly alter our understanding of the universe and our place in it. Harlow Shapley used the 60-inch telescope to locate Earth within the Milky Way...on the outskirts, that is, and not the center of the galaxy as humans had typically preferred to believe. Edwin Hubble was working on the 100-inch in 1924 when he observed (aided by the pioneering work of Henrietta Swan Leavitt) that we were not the only galaxy in the universe, and showed that the universe itself is expanding. Given this history-making research, it's clear how the entire property can be understood as a museum, especially since nearly all of the historical facilities are preserved as time capsules, though there are actually two areas of the campus intentionally dedicated as museums proper.

The on-site astronomical museum was established in 1937 in a utilitarian, A-frame structure, where many of the original lightbox photos of spiral nebulae, sunspots, and moon craters remain on view. It was updated sixty years later with new labels adjacent to the historic displays, for example, to confirm that the anticipated 1986 return of Halley's Comet did occur on schedule. Other lightboxes have been revamped more recently to tell the history of the observatory itself. A diorama of the grounds sits in the middle of the room alongside a large disc

The A-frame Astronomical Museum is itself historic; the Snow solar telescope is visible in the mirror.

covered in a grid of resinous nodules that was used for polishing the telescope mirrors. A table case contains documents and letters from the archives, including those written to Hale from the likes of Albert Einstein (who visited the observatory on several occasions), Nikola Tesla, and Herbert Hoover. But to see the fanciful and sometimes conspiratorial letters sent to the celebrity scientists by over-enthusiastic civilians from around the world, one has to go back down the hill to the Museum of Jurassic Technology in Culver City (see page 275), which has produced an exhibit and publication of exactly that.

Over on the ground floor of the 100-inch telescope dome is the nascent Museum of Photon Technology, initiated just before the pandemic and showcasing instruments used to analyze light. Alongside various specialized spectrographs and a blink comparator (used to capture an area of the sky at different times and quickly flip or blink between them to more easily note if anything has moved or changed), there is a vacuum chamber for aluminizing mirrors up to forty inches, and a clock drive mechanism that regulated the dome's rotation speed prior to the upgrade to computer-controlled motors. There is also a large metal trough in which to bathe the telescope's nine-thousand-pound mirror in hydrochloric acid as part of the intricate, twelve-day cleaning process that it must undergo every four years or so. Standing under the colossal telescope dome today, it's shocking to imagine that nearly all of the materials and supplies used to build these state of the art facilities and labs were brought up a steep and rocky trail by pack mules, and later by custom trucks.

Mt. Wilson was the first observatory in the world built in a location chosen specifically for "good seeing"—exceptional atmospheric viewing conditions, that is, with the region having possibly the least turbulent air of any place in North America. Nevertheless, Carnegie Observatories (still based in Pasadena) shut down Mt. Wilson in 1985, as it was becoming increasingly less useful for science

Inside the Museum of Photon Technology; the tank at center is a vacuum chamber for aluminizing telescope mirrors.

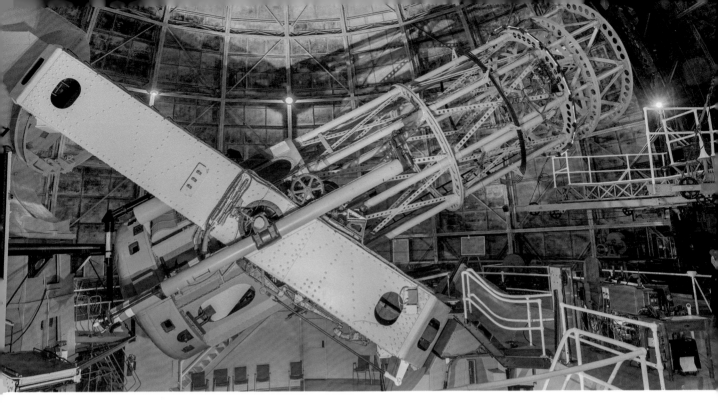

The massive 100-inch Hooker telescope.

due to the encroaching light pollution. Carnegie had already opened the Las Campanas Observatory in Chile's Atacama Desert in 1969, and it continues to put its eggs in that dry, clear, and much more remote basket. Within a few years of the closure, former staff and other eager supporters established the Mount Wilson Institute and reopened the facility to provide access to the public and outside researchers. The California Air Resources Board and the US Geological Survey are among the entities that have ongoing work here, but the most substantial leaseholder is Georgia State University and their CHARA Array, which looks for sunspots on stars other than the Earth's sun. The atmospheric stability remains ideal, and CHARA's infrared detection system is unaffected by visible light pollution, pernicious though it may be.

The terms of the agreement to build and operate Mt. Wilson Observatory on federal property stipulated that if it ever closed down, they would need to remove or destroy everything and restore the land. Though even if they ever do fall on the hardest luck, it's unlikely the will (or the budget) could be found to carry out the dismantling of such a significant site. For now, the primary fight, aside from fundraising, is to ensure it remains all mirrors and no smoke. The observatory narrowly escaped destruction in the 2009 Station Fire (the largest in LA County's recorded history) and had an even closer call during the Bobcat Fire in 2020.

The admirable work of the Mount Wilson Institute volunteers has not only resulted in the preservation of the scientific and historic integrity of the property, but has begun to enshrine it as a unique cultural destination as well through public programs, art shows, concerts, and star parties. Regardless of the occasion or time of day (or night), the power of this place is quietly profound. It imparts a sense of wonder and awe that most museums only aspire to, but which is for many of us a natural result of the contemplation of the universe and our existence within it.

Part 4
Movement and Transit

Southern California Railway Museum
Perris

Given this book's emphasis on many of the smaller institutions throughout the region, sticklers may protest the inclusion of this, one of the largest museums in Southern California by area, with a one-hundred-plus-acre campus converted from a former potato field in a rapidly developing section of the Inland Empire. But it remains an underappreciated gem, considering its deep connection to the development of Los Angeles and environs, the dynamic range of experiences and events on offer, the scope of incredible and fascinating collection items, and the staggering commitment of those who keep it all running.

Yes, the Huntington in San Marino has the Southern California Railway Museum (SCRM) beat in the size of their endowment, annual attendance, and even in terms of acreage, but the SCRM holds a big piece of Huntington heritage that even they cannot claim. Any casual student of Los Angeles history knows something about Henry Huntington's old Pacific Electric Red Car trolleys—which constituted the world's largest electric railway transit system in the 1920s—and about their eventual demise as the automobile swiftly rose to dominance. Today, the best place to see an original working Red Car is the SCRM, which holds the largest extant collection, all thanks to the vision and efforts of some young enthusiasts who couldn't accept the total disappearance of this legacy on their watch.

It all started in 1956 with a core group of fourteen founders, most in their teens or early twenties. The underage railfans even had to wait for one slightly older co-founder to come back from the Navy on leave just to sign the nonprofit articles of incorporation. They began purchasing decommissioned trolleys and streetcars that were destined for the scrapheap for pennies on the dollar, and arranged by a handshake agreement to move them to a section of Griffith Park that would later become established as Travel Town, a children's birthday party destination and respectable railroading museum in its own right. After about a dozen years, the City of Los Angeles gave notice that the site would soon be penned in by the construction of the 5 freeway, making it difficult, if not impossible, for them to ever move; the search for a location where they could operate a larger museum and actually run the cars kicked into high gear. In 1969, they moved to their current location on the outskirts of the old railroad town of Perris.

In the early years, the founding group was quickly joined by many more volunteers, who would head out to the property straight from work on Friday and post up in a makeshift bunkhouse, working to build out their vision straight through until Sunday evening, when they would head home and report back to their day jobs the next morning. Today, the museum has twelve hundred members, including roughly fifty core volunteers who can be found most every

Santa Fe Railway Post Office Car No. 60

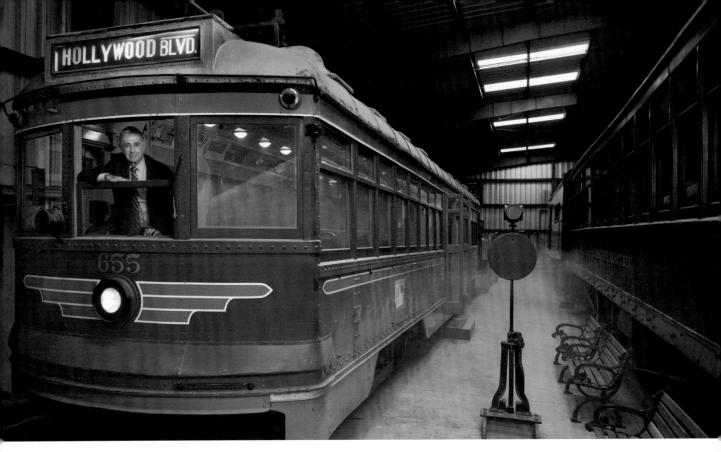

Chuck Painter, museum board member and dedicated volunteer, shows off Pacific Electric Red Car 655, which was plucked off a pile of scrapped cars at Terminal Island and restored.

Saturday, hard at work on a wide range of projects. Harvey Laner, who was one of the fourteen founding members, is still volunteering nearly seventy years later.

Weekends are indeed the best time to visit, when several of those streetcars and trolleys offer rides around the track circling the property, and larger trains operate on the main line that runs along an easement straight into town towards the historic Perris depot and back. A few times a year, they host large-scale special events, perhaps with a Polar Express theme, or featuring a certain blue celebrity tank engine. In addition to their ongoing fundraising initiatives, crowd-funding campaigns support specific projects such as the restoration of the steam locomotive, which finds easy support amongst enthusiasts, even internationally. David Althaus, the foreman of Diesel Services, writes up regular progress reports for their community of supporters far and wide. Althaus and his team once spent eighteen years on a single restoration project, and as of 2024, he has been contributing his time and expertise for thirty-eight of his eighty-two years.

It's not possible here to list all the specific trolleys, trains, and assorted rolling stock that fill the numerous oversized car barns, but it's worth mentioning a few that stand out even for a non-specialist. One would do well not to miss the car from the Santa Fe Railway that functioned as a rolling post office, or the 1909 Funeral Car "Descanso" from Los Angeles Railway (or LARy, famous for their Yellow Cars), which includes a side-loading compartment fitted for a casket. The Grizzly Flats collection

features the narrow gauge steam locomotive from a Hawaiian sugar plantation that Disney animator Ward Kimball ran in his San Gabriel backyard. And of the many Pacific Electric Red Cars, they have the one which was analyzed precisely by the production team of the 1988 film, *Who Framed Roger Rabbit;* a replica was used in the film (it was actually a bus), but the sounds it makes are authentic and were recorded from yet another Red Car in the museum's collection.

For the niche museum-obsessed, there are two smaller museums-within-the-museum hosted on the grounds. The first is the Middleton Collection, after Ivan Middleton, who had operated a train shop at Knott's Berry Farm until they decided to fence in the park property and start charging admission in 1968. Middleton then purchased two Denver Rio Grande train cars with his brother and parked them at SCRM. This collection of "smalls" includes a unique set of miniature streetcars fashioned from manila file folders by a California Highway Patrol officer stationed at the top of the Grapevine pass, who reportedly would get bored whenever it wasn't snowing. The other mini-museum is the Harvey Girls Historical Society's Fred Harvey Museum, preserving the history of the famous Harvey House restaurants at Santa Fe railroad depots across the West (including at LA's Union Station, the last of its kind to be built), and of the Harvey Girls who ran them. In a dedicated building that opened in 2015, an all-women volunteer group shares the stories of what at the time was one of the few paying jobs available to women in America, providing a rare opportunity for financial independence and upward mobility.

In Southern California, like most places, there is no shortage of railfans, and while a typical "foamer" (yes, people do self-identify as such) is most often seen posted up trackside with train schedule in hand, the dedicated volunteers at this museum are in a class of their own. Whether part of this community or not, one thing visitors can appreciate is the sense of accomplishment those involved derive from completing a near impossible restoration project that will allow these machines, officially retired decades ago, to continue providing joy and rolling long and far into the future.

Ken Schwartz, volunteer lead of the Grizzly Flats (Ward Kimball Collection) restoration, inside the 1896 business car known as Esmeralda.

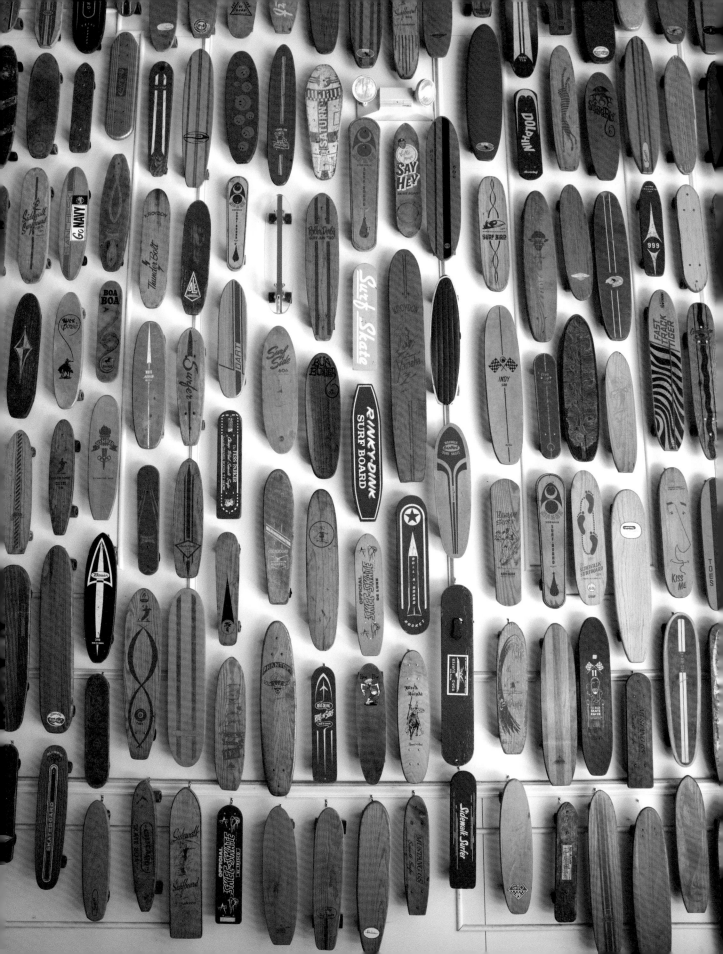

Skateboarding Hall of Fame and Museum
Simi Valley

One must admit, for a museum dedicated to skateboarding, a space in an outdoor shopping mall, directly across from a Vans store, would seem to be an appropriate setting. Actually, museums within malls are something of a Southern California tradition, starting with the Museum of African American Art at the Baldwin Hills Crenshaw Plaza, which occupies a third-floor space accessed through a larger area meant for an anchor department store (it's now outlived two such tenants, with the closure of Macy's in 2023). The Skateboarding Hall of Fame and Museum is situated in a cavernous storefront formerly occupied by a furniture retailer at the Simi Valley Town Center (just a few stores down from a VFW-sponsored military museum), and is the first and largest of its kind. Anyone who rolls up is likely to meet Todd Huber, the founder and driving force behind the collection and museum, with the infectious enthusiasm of a kid in a candy factory, even if his role is more like that of Wonka himself.

In 1989, when Huber was twenty-four years old, he was ready to give up his heavy smoking habit. After seeing a hypnotist, he was compelled to calculate how much he could save each year by not spending money on cigarettes; a friend suggested he could buy skateboards with the money instead. Huber soon picked up a little red board, branded as "Surf-N-Suzi," for $20 at the local Ventura County Fairgrounds flea market, and the compulsion to start collecting took hold. In the decades since, Huber has traveled far and wide in search of rare boards, even spending four days traveling up the approximately seven-hundred-mile "World's Longest Yard Sale" from Alabama to Michigan, with a prominent sign on the front of his vehicle reading, "WE BUY SKATEBOARDS." He also trades with collectors around the world, including with a skateboard museum in Belarus that has sent him a good number of Soviet decks that are otherwise not easy to come by in the States.

Huber now has something like five thousand skateboards and a plethora of related artifacts. Actually, he confesses that he hasn't bothered to count, and he's been giving that figure long enough, while still collecting, that the real number is perhaps quite a bit larger by now; regardless, there are no challenges so far to his claim that this collection is the world's largest. But the drive to collect has begun to abate; as the online market has picked up, some of the thrill of the hunt has worn off, and as skateboarding has become even more mainstream, especially with its recent admission into the Olympics, it's moved farther away from the homespun counter-culture that has so inspired him. Fortunately, his commitment to preserving the history and origins of this sport and cultural phenomenon is not at risk of waning.

Boards from the early years of commercialization, mostly the 1960s.

The museum was originally housed at Simi Valley's premiere indoor skatepark, Skatelab, which Huber co-founded in 1997 with Scott Radinsky, a former Major League Baseball pitcher and punk rock singer for the bands Pulley, Ten Foot Pole, and Scared Straight. Skatelab achieved legendary status, and was also home to numerous film shoots, like the music video for Limp Bizkit's disturbing anthem, "Break Stuff." As free public skateparks began to proliferate, the paying customer base for an indoor park, particularly in sunny SoCal, took a slow motion face plant. In 2018, Skatelab announced its imminent closure, and Huber went independent with his part of the institution, taking it just a few miles down the road and reopening in the mall after swiftly renovating and installing his collection from floor to ceiling.

While the bulk of the space is given over to a skate shop and mini skatepark, with a halfpipe and a few other ramps and rails where kids can come practice or take skating lessons, the museum itself is primarily on the walls. The rough chronology starts with the earliest homemade boards and scooters, and tapers off after the section covered with wide, Technicolor, graphic-heavy boards from the 1980s, mostly because the style that evolved next looked pretty much like the popsicle shape that is still most prevalent today. Huber has found that boards from the 1960s are easier to track down than those from the '80s, simply because they weren't easily skate-able and tended to get thrown in the closet, whereas the improved and more versatile models were kickflipped into oblivion. Almost every board he owns has been well loved, and though the museum is light on didactic labels, Huber will be happy to point out how they chart the trends not just in board design, but also the advent of grip tape, kick tails, precision bearings, and the evolution of wheels from steel to clay to urethane. Most boards are American, but there are also British, Canadian, and Czech boards, as well as some from Australia, like one called Surfa Sam.

One section of the space is carved out for a substantial skateboarding library that contains nearly every issue of *Thrasher* and *Transworld* magazines amongst many other volumes; those interested in skate videos can have a proper marathon with the six hundred or so that are available. The Hall of Fame part of the name can be traced back to 2009, after Huber stumbled across the Water Ski Hall of Fame in Florida and felt that skateboarding should have something similar; there are features celebrating many of those who have been honored at the annual ceremony he puts on. Having filled the public space, a back room is similarly overflowing with piles of boards and bins full of ephemera such as uniforms, signed posters, and lunch boxes.

Many collectors are most interested in the commercial models—including those from the early 1960s that predate any consensus of what to call them, when they were marketed as sidewalk surfboards, skee-skates, or road surfers—but Huber has a remarkable collection of even earlier examples, when the only way to get a skateboard was to make it yourself, often by nailing an old roller skate to a piece of wood. The exhibit showcases the innovation and charm of so many of the homemade creations that he likens to folk art, with a variety of custom details. A

few are even carpeted. It is notable that the development of skateboarding, now a juggernaut industry, can be traced to kids and teens who were compelled to create their own fun with limited resources.

When Gene Simmons visited the museum, he reportedly asked, "What are you doing out here in God's country?" Huber grew up in the area (his father was former mayor of Simi Valley as well as Ventura County supervisor) and argues that it's an appropriate place to pay tribute to skateboarding, with a number of hometown heroes in the scene. But he does hold that the cultural impact of the sport deserves to be shared with as many people as possible, a belief which might someday land him in Los Angeles or one of the South Bay or Orange County beach cities, perhaps in time for the 2028 Olympics. In the meantime, he's loaned pieces out for temporary exhibitions, most recently at the Great Park Gallery in Irvine as well as a retrospective at the Design Museum in London, which also borrowed the idea of installing a skateable half-pipe within the gallery. The legacy of skateboarding is not exactly at risk, with even the Smithsonian taking an interest in collecting relevant artifacts, but Huber's unrivaled collection represents a critical and underappreciated angle on its DIY origins, making it a delight to behold and ensuring that visitors won't regret dropping in.

Todd Huber's shirt bears the Skateboarding Hall of Fame motto: KEEP ON PUSHING.

Overleaf: '80s boards showcase the pop culture and famous skaters of the day.

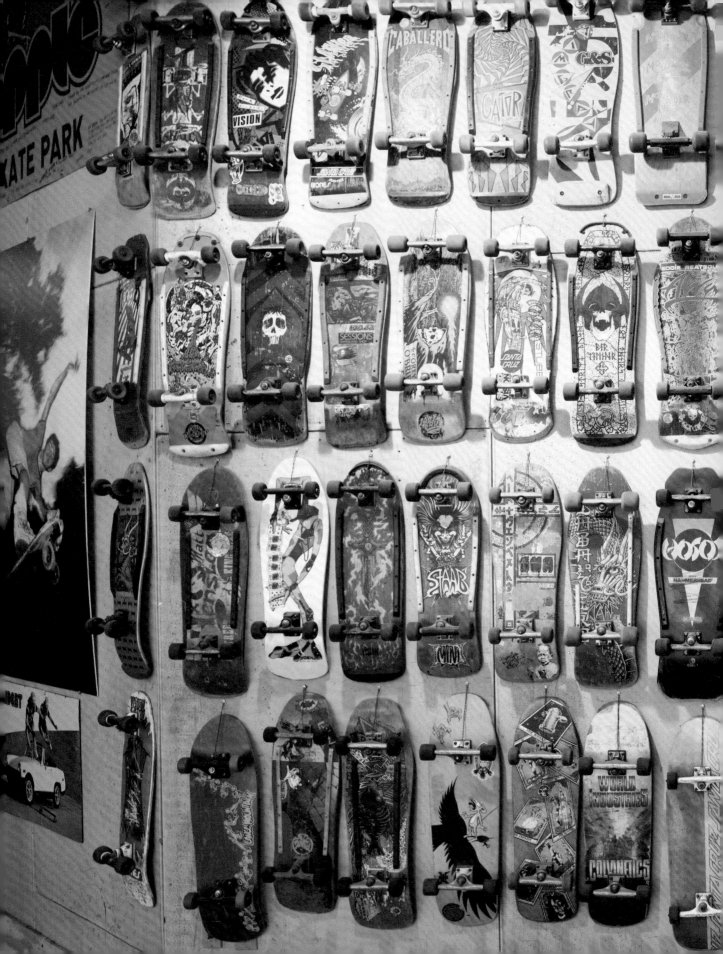

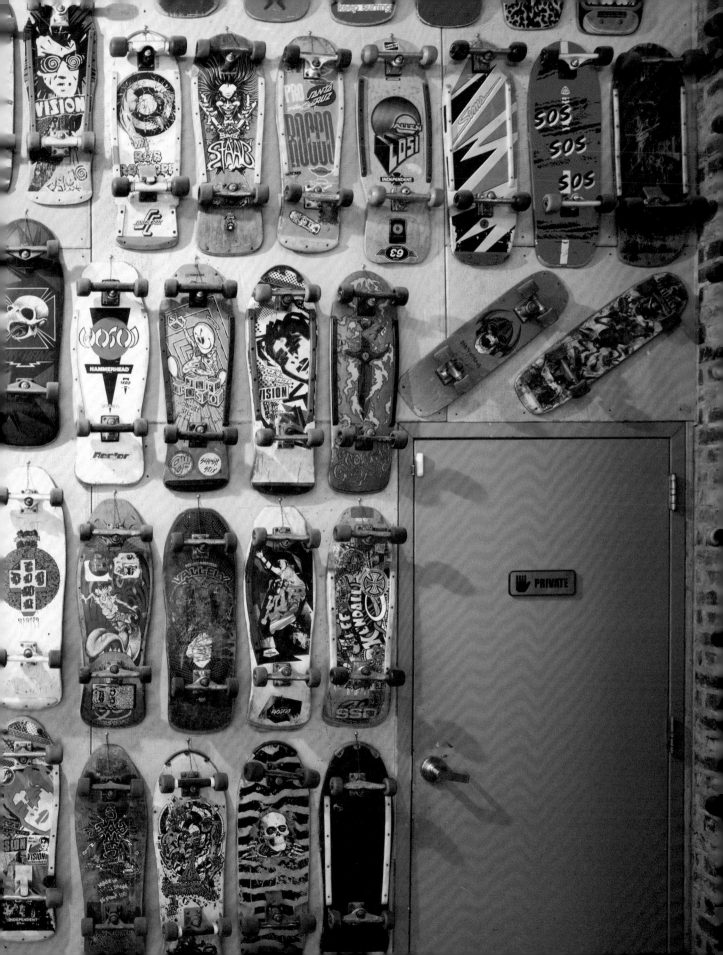

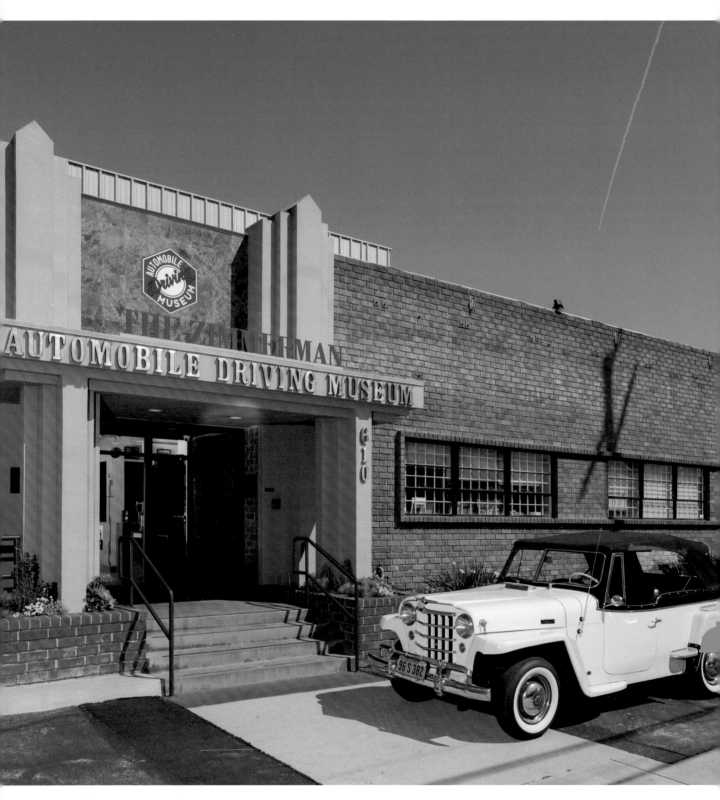

A 1950 Willys Jeepster, one of many cars in the rotation for Sunday rides.

Zimmerman Automobile Driving Museum (ADM)
El Segundo

There are around fifteen public car museums in greater Los Angeles, not to mention the countless private garages where collectors have created nostalgic environments in which to park their prized sets of wheels. But of all the opportunities to admire rare vehicles and roving works of art, the Zimmerman Automobile Driving Museum (ADM) in El Segundo has found a niche that makes them an especially beloved destination: the chance to touch, sit in, and even ride in many of the cars on display.

The tactile and multisensory experience offered at the ADM is of course unheard of at other auto museums around the region, and perhaps around the country as well; anyone who bristles at do-not-touch signs will feel most welcome. Even at a car show where a proud owner might hold open the door for visitors to take a closer look, one can bet that they will maintain hawkish oversight until they've secured the perimeter. This might sound like a small thing, but it's amazing how vastly different it is to look in through a car window versus actually sitting in the driver's seat and pulling the heavy door closed with a satisfying thud. Many of the cars have a distinct smell, perhaps a mix of motor oil with decades-old upholstery, that's something like an olfactory patina.

Stanley Zimmerman, a successful mortgage broker and lifelong car enthusiast, founded the museum (along with friend and architect Earl Rubenstein) with the express purpose of allowing the public, young kids in particular, the opportunity to engage with their grandparents' cars in the "petting zoo" setting for which they're now known. The ADM opened in 2002 in the semi-underground garage of a preschool in West LA; staff would park a few cars on the street during open hours just to let passersby know they were there. After a few years, it moved to the present location just south of LAX. The operative word in their title is *driving,* and not only does everything run, but their specialty is offering Sunday rides using a rotating selection of their classic cars. The slow cruise through this industrial office park, which is otherwise a ghost town during weekend ride days, is as close as most people will ever get to the open road in one of these rare old machines.

The main museum hall contains around half of their 130 vehicles, and visitors ages eleven and older are allowed to climb into all of them under docent supervision (unless otherwise noted, and provided they don't try to start the car or force any latch or control). Walking along a winding highway painted on the floor, visitors trace a roughly chronological path, starting with the most basic engine-driven buggies of the late nineteenth and early twentieth century and ending with some futuristic prototypes and the obligatory DeLorean (sans time machine) with gull-wing door left wide open. In addition to the vehicles

A 1949 Crosley station wagon woodie, ready for a road trip, even if it reportedly struggled to hit fifty miles per hour on the open road.

themselves, there is also a 1920s-style Packard showroom, an ice cream parlor, and themed areas including a 1929 service station and a retro mechanic's shop. A favorite is probably the petite and rather cramped 1949 Crosley station wagon woodie, which is road-trip ready with suitcases and a thermos in the trunk and skis and fishing rods strapped to the luggage rack. The stylishly asymmetrical 1963 Studebaker Avanti, the elegant silver 1936 Packard Phaeton reputedly owned by Stalin and driven in the Rose Parade twice, and the unpretentious 1988 Plymouth Voyager passenger van are all pretty fun to climb inside as well.

Partnering with a nearby science and engineering-oriented high school, the ADM offers an auto shop class that has allowed students to work on a total restoration of a 1955 GMC pickup, when most schools have eliminated even basic auto electives. The museum also maintains a relationship with Mattel, whose global headquarters are right down the street: in addition to sponsoring (and heavily branding) a children's play area in one corner of the museum, the

company leases storage on the property—the Garage of Legends—for some of the most iconic, IP-oriented vehicles in the corporate fleet. These are not viewable during normal operations, though for special events they will occasionally bring out the skeleton-themed Bone Shaker or other life size Hot Wheels supercars.

Zimmerman, the museum's founder, namesake, and primary benefactor died unexpectedly during the pandemic. After an uncertain period, it appears the museum will be able to keep the headlights on after all. And even if they don't have the largest or most valuable collection compared to stiff local competition, one hopes they will long keep both the museum and car doors open, so that visitors can continue not only to show up, but also to hop in.

The hot rod speed shop, one of several period dioramas.

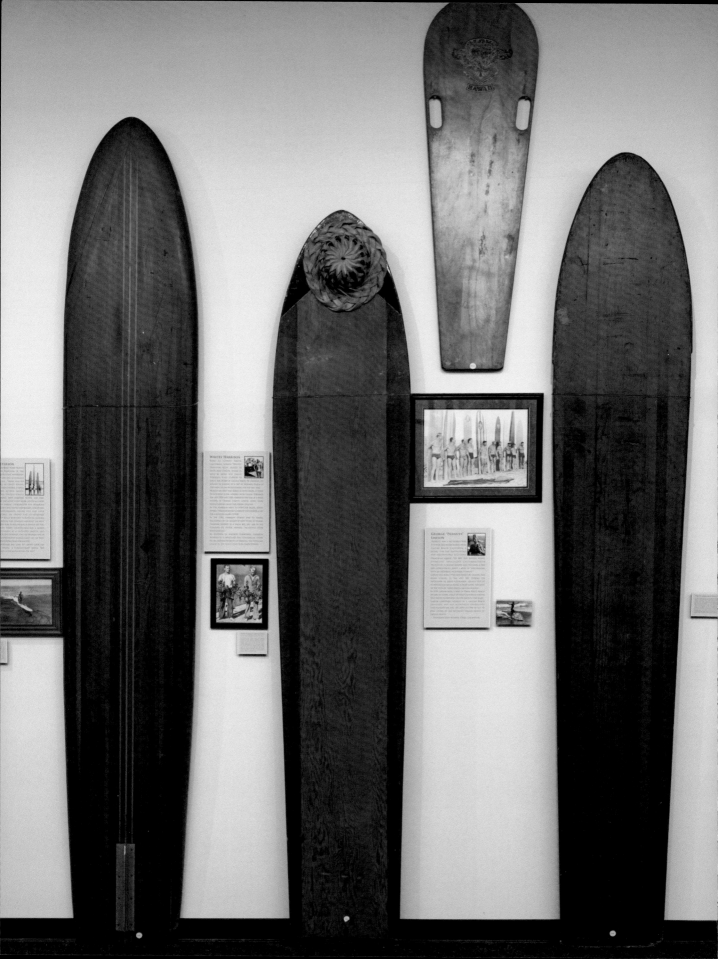

Surfing Heritage and Culture Center (SHACC)
San Clemente

Though their target audience might at first seem obvious, it would be a mistake to assume that the Surfing Heritage and Culture Center (SHACC) in San Clemente would not appeal to someone who has never even tried riding a wave. Indeed, strolling through the gallery, even the ocean averse can't help but be fascinated and amazed by the history the museum preserves and interprets, and witnessing other visitors lose their minds over what they're seeing really helps reinforce how the "stoke"—which SHACC is dedicated to sharing—can be contagious, even indoors.

With all due respect to the smaller surfing museums up and down the California coast (in Huntington Beach, Oceanside, and Santa Cruz), it was admittedly not unfair when a news outlet referred to SHACC as the "Smithsonian of Surfing." They weren't about to argue, as the museum's mandate calls for a thorough exploration of the subject's history and global impact, including what is likely the most comprehensive research library and archive of surfing photos, periodicals, videos, oral histories, and memorabilia, not to mention their unrivaled *quiver;* that is, their massive collection of boards. It's also true that they've advised the actual Smithsonian Institution, loaning and donating significant boards; and while our nation's most esteemed (and the world's largest) museum complex may have one of the seven known boards that were ridden or shaped (designed and built) by Duke Kahanamoku—the native Hawaiian swimming champion who is credited with popularizing surfing beyond its island origins—SHACC has four.

Dick Metz, the nonagenarian museum founder, has lived to experience almost the entire arc of modern surf history. Growing up in Laguna Beach during the Great Depression, he started surfing when homemade, one-hundred-pound solid redwood boards—too heavy not to just leave on the beach—were still the norm. Later, his friends would shape balsa wood boards in their dad's machine shop or on the beach under a pier, and could only sell one if they weren't already out surfing. When Metz was in his early twenties, in partnership with his friend, legendary surfing and sailing pioneer Hobie Alter, he opened a retail surf shop on Oahu, and would go on to operate more than twenty Hobie Surf Shops in California, Hawaii, and Florida. For decades, when his friends were finished with their old boards, he would trade them for a t-shirt, and save them a trip to the dump, so he would have something to display in the ceiling rafters above the merchandise. He enjoyed sharing the stories of each board with visitors and customers, but when he attended one of the first surfboard auctions in the 1980s, he was shocked to discover that they possessed real value to collectors.

Metz founded SHACC in partnership with collector Spencer Croul, and they opened in an otherwise unremarkable business park (unless you're looking for collectible tiki mugs) on the southern edge of Orange County in 2005. The

Some of the early redwood boards were so heavy no one bothered to drag them home after surfing, opting to leave them on the beach until they returned.

core exhibition traces all of the significant developments in surfboard design and technology in chronological order: the introduction of the fin, which facilitated turning and made it possible to get inside the wave's tube; the earliest experiments adding protective layers of fiberglass, as scraps of it were becoming available as castoffs from the military and aerospace industries following World War II; the homegrown chemistry experiments seeking the perfect recipe for shapeable foam that would set evenly with no air bubbles or irregularities; and the so-called shortboard revolution. Interspersed with artwork and examples of swim trunk fashion, the timeline concludes with high-performance modern boards ridden by some of the biggest contemporary champions, including Brazilian surfer Ítalo Ferreira, the first Olympic gold medalist in the men's competition when surfing debuted at the Tokyo 2020 games.

One unique installation, and perhaps the most elaborate, is the recreated *shape shack* of iconic surfboard manufacturer Dale Velzy, who grew up in a family of woodworkers and cabinetmakers and is considered the first person to sell surfboards commercially. The shack is an homage to all the shapers of the 1940s

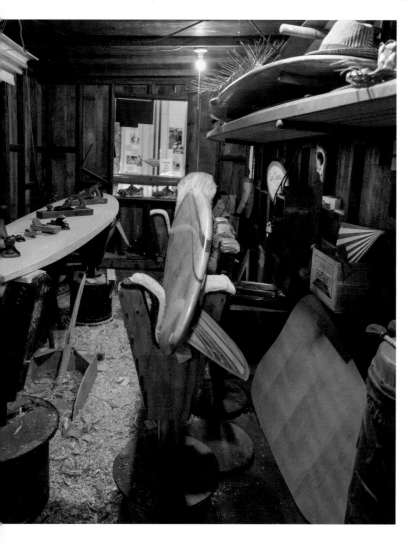

Recreation of Dale Velzy's shape shack, with his tools and unfinished boards.

and '50s, and includes many of Velzy's tools, molds, and some of the boards he was working on when he passed in 2005. There is also a pair of sneakers covered with a thick, colorful concretion, built up a drip at a time over years of glassing boards (sealing them with fiberglass and resin). Another central exhibit space features rotating shows on subjects ranging from surfing in cinema, to surf-inspired '60s music and design, to women surfers. A highlight of the latter is the first board named after a woman, designed by Hobie Alter and signed by its namesake, the pioneer surfer and local legend, Joyce Hoffman.

It's too bad that not every visit can be enlivened by hours of stories from Metz, who has a remarkably sharp recollection of his own explorations and exploits. For instance, legend has it that the connections formed and tales recounted

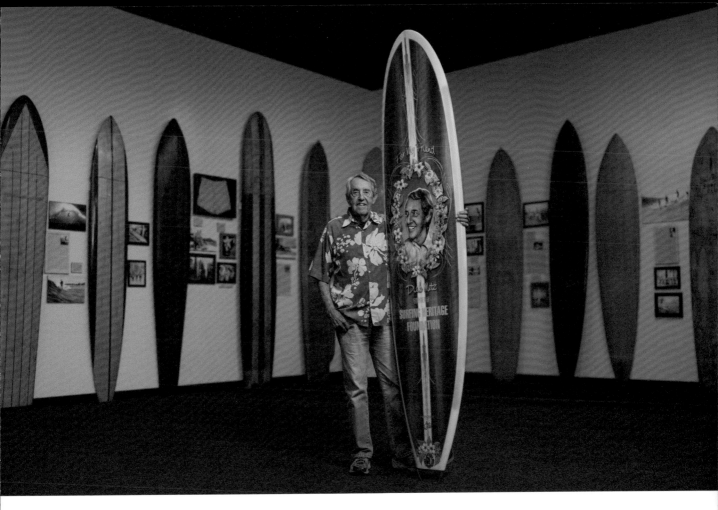

Museum founder Dick Metz at age ninety-four.

following his three-year journey around the globe starting in 1958—funded by the sale of his family's liquor license to then-new Disneyland—helped influence his friend Bruce Brown's 1966 film, *The Endless Summer,* a surprise cult sensation that brought in $20 million at the box office and helped propel surf culture into the international zeitgeist. On display amongst related ephemera, SHAAC has the camera that Brown used to film this cultural touchstone.

 SHACC will always be more than a hall of fame or simply a great collection, as a key aspect of its mission is in the name: culture. The staff emphasize that surfing has left a lasting impression on popular culture in America and globally, and make a compelling case for how we can understand and appreciate the sense of freedom and adventure that defines its spirit. It makes for a meaningful visit, even for someone who prefers just to look at the ocean, and for the countless surfers of the world, from gremmies (novices) to experts and elders, it's a chance to pay respect to those who paved the way and reflect on the importance of this activity in their life, whether it's their hobby, profession, community, or part of their identity.

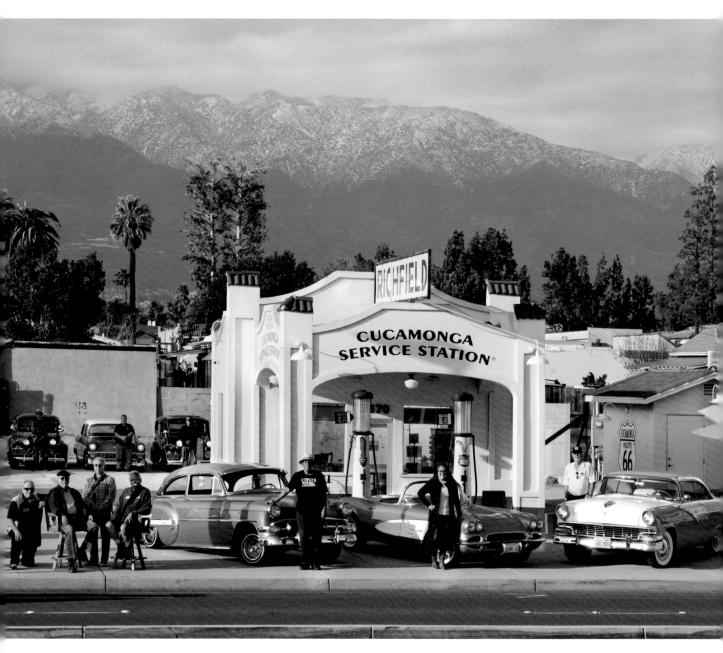

Route 66 IECA members, front row from left: Ron Demler, President Anthony Gonzalez, Jeff Mittman, Alan Ryan, Steve Duena, Lani Martinez, and Ed Hildebrand. Rear: Thomas J. Richardson, Steve Marquez, and Albert Gutierrez

Cucamonga Service Station Museum
Rancho Cucamonga

In the early 1900s, gasoline-powered cars were just gaining dominance over electric and steam-powered models (a whole story unto itself), and in the early days, fuel was sold in cans at hardware and general stores. As demand began to increase, there were many places (Los Angeles included) where gasoline was being dispensed directly from above-ground tanks, some even carried through the city on a horse-drawn trailer. In the 1910s and especially the '20s and '30s, the massive population increase in Southern California, which coincided with a sharp rise in automobile use, led to the proliferation of more permanent service stations. Across LA, a handful of early gas stations still stand, though few serve in their original capacity: they have been repurposed as a Starbucks in Hollywood, a vendor of lobster rolls on the edge of Koreatown, and a tiny art gallery in Glendale's Adams Square Park. But the Cucamonga Service Station, a little yellow jewel box of the Inland Empire, has more history than all the others, and these days serves nothing but history itself.

When this station opened in 1915, Rancho Cucamonga was still a sparsely populated and largely agricultural community. The garage served as a focal point and community center of sorts, and would even make gas deliveries to the nearby grape vineyards and citrus groves. By the time Route 66 was established in 1926, including this stretch of Foothill Boulevard as part of its cross-country ramble, the station had already been in operation for more than a decade. The rise of the interstate highway system beginning in the 1950s resulted in the eventual decommissioning of Route 66 as a federally maintained roadway, not to mention the slow death of countless bypassed attractions and services along the famed route. The Cucamonga Service Station closed for good in the early 1970s, though unlike so many businesses on the so-called Mother Road, the building was left standing long enough to receive a breath of new life.

By the early 2000s, the derelict property was in the hands of a billboard company, and their bid to bulldoze the historic structure met opposition and a city landmark designation in 2009 that restricted redevelopment. In 2012, a passionate group of locals formed a nonprofit (Route 66 Inland Empire California, or Route 66 IECA) to take over the deed as a write-off for the corporate slumlord, with the condition that the eyesore sign must stay. Route 66 IECA president Anthony Gonzalez had gotten experience in the restoration

of historic properties while he was head of El Pueblo de Los Angeles Historical Monument and was charged with shoring up the buildings on Olvera Street following the 1994 Northridge earthquake, work that certainly came in handy for rallying the community behind this new effort. When Route 66 IECA took over, the building was in need of a complete overhaul, and the group's years of hard work is in evidence in the site's almost too-pristine appearance today.

The museum's grand opening was in 2015, in time for the station's centennial year. The one-room, Mission-style building is all that's left of what was once a more extensive operation with arched driveways and a multi-bay garage in the back. The signature bright yellow paint matches the original color scheme of the Richfield Oil Corporation (predecessor to ARCO), which was revealed after scraping off the layers during restoration. The large Richfield sign gracing the top of the building is much like the original and was installed after being found at an antique warehouse in Northern California; the bullet holes in it are hardly noticeable from the ground.

A vintage uniform, amongst the Richfield Oil ephemera.

The structure itself and the antique pumps outside make up the lion's share of the museum experience, though cases inside also hold antique car repair tools, Route 66 memorabilia, and information about the Negro Motorist Green Book that has thankfully garnered wide attention in recent years, reminding us that traveling on this iconic byway was not the symbol of freedom and carefree adventure for all communities. There is also a variety of Richfield company keepsakes, including postcards, maps, ashtrays, souvenir wildflower seed packets, and a hair protector cap from the hydrofoil boat ride they put on at SeaWorld San Diego starting in 1965. Though modest in scope, the museum's primary long-term goal is to rebuild the larger garage behind the station, which will serve as a space for meetings and expanded exhibits.

In 2023, the City of Rancho Cucamonga was an early adopter of a policy dictating that a percentage of stalls at any newly built fueling stations must dispense a renewable alternative energy such as electric charging or hydrogen. Of course, this trend is picking

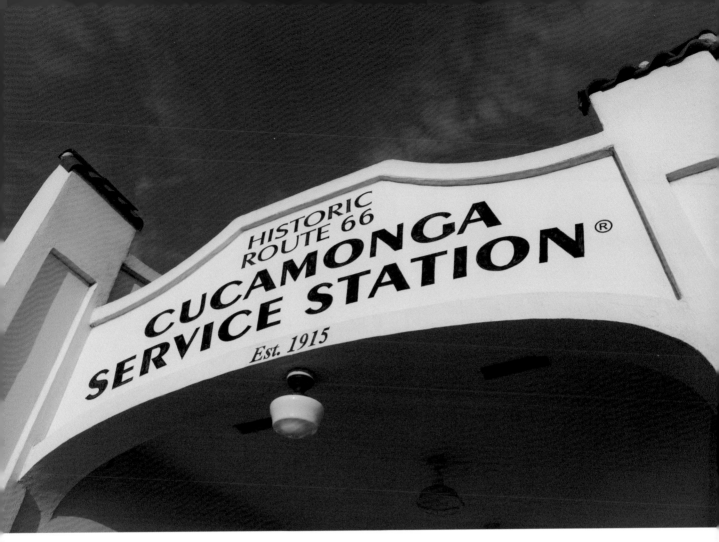

*Built in 1915, this is perhaps
the oldest remaining service
station in California.*

up steam, and the State of California is scheduled to phase out the sale of new gas-fueled cars by 2035, making it increasingly possible that people alive today will see petroleum-powered vehicles become practically obsolete. In addition to any environmental benefits, this may also be good news for the value of collectibles in the *petroliana* category, not to mention the Route 66 nostalgia factor which is already through the roof, if the popularity of Disney's *Cars* franchise is any evidence. But for those seeking the real deal, local options are somewhat limited, and the Cucamonga Service Station has quickly become a lively hub and well-loved point of interest for those who are compelled to seek out the traces of what was once widely regarded as America's Main Street.

Flight Path Museum LAX
Westchester

The sign on a refurbished awning greets visitors to a former passenger terminal building at the southern edge of the sprawling LAX tarmac with an enthusiastic "Welcome Aboard!" Entering via the mid-century pattern block breezeway, one gets a hint of the casual style and absence of post-9/11 security, not to mention the easy parking, that was typical of the "golden age" of air travel when this terminal opened for charter flights in the 1960s. It's been out of commission for a quarter century, as the airport has outgrown it by leaps and bounds, but its present use as a museum and learning center provides a much more engaging and even delightful visit to LAX than any actual passenger in recent memory is likely to report.

The Flight Path Learning Center was established as a nonprofit in 1995 by a committee that included the Aero Club of Southern California, and the Southern California Historical Aircraft Association. Their founding mission was to recognize the importance of aviation and aerospace to the culture and economy of the region, and to inspire youth to pursue careers in related fields. The inaugural project, the original Flight Path, is a walk of fame in the Westchester neighborhood, honoring pioneers in aviation and aerospace with plaques spanning several blocks of the sidewalk along Sepulveda, starting near the In-N-Out-adjacent lawn that's an established planespotter haunt.

In 2002, the Los Angeles Board of Airport Commissioners approached Flight Path and invited them to turn the defunct Imperial Terminal into a museum in time for a gala the following year for the seventy-fifth anniversary of LAX and the centennial of the Wright brothers' maiden flight, with much of the initial support provided by Los Angeles World Airports (LAWA), the agency that operates and manages the airport complex and grounds. With a focus on the history of LAX and commercial flight more broadly, the museum has also maintained its educational mandate, particularly through a series of flight simulation classes for young aspiring aviators taught by commercial airline pilots. Its location right on the edge of the airfield obviously makes it a prime viewing location for airport activity today, and this end of the tarmac is still in use by private and cargo jets; some enthusiasts as well as many young children might be as content looking out the windows as at any of the curated displays, though they would stand to miss quite a bit if that's all they did here.

In the main gallery, cases filled with model airplanes and all manner of memorabilia and souvenirs—playing cards, ashtrays, in-flight china, swizzle sticks—are organized by airline. A timeline on the wall gives an overview of aviation history in Southern California as well as that of the airport itself, originally called Mines Field and then the LA Municipal Airport before going International and taking the LAX designation in 1950. But the real distinguishing feature

Katie Rampen models the 1944 TWA flight attendant "cut-out" wool uniform by Hollywood fashion designer Howard Greer.

A vintage display showcasing model planes from the Flying Tiger cargo line.

of their collections are the more than six hundred flight attendant uniforms, representing sixty-eight airlines and counting, with styles indicative of the lion's share of the official attire worn throughout commercial flight history.

Many of the outfits are modeled by mannequins or hung throughout the galleries, but hundreds more are kept in a dedicated vintage uniform room, where they hang on racks sorted by airline, era, and then by size. Some designs are groovy, others wild, but most are typical of the popular fashion of the day. A few were done by celebrity designers, such as the smart Pan Am uniform designed by Hollywood legend Edith Head in 1975, and a good number play on cultural tropes of the airline's country of origin, like the green kimono with a stylized cherry blossom pattern from Japan Airlines. One United Airlines uniform from 1930–32 is billed as the first ever stewardess uniform, worn by a Miss Ellen Church, one of the "Original Eight" former nurses who donned them. It's on display near the entrance, adjacent to a Delta check-in counter of more recent vintage that now serves as the museum welcome station.

With all that glitz and glam, it's easy to overlook another artifact of great interest: the framed, certified gold 45" record for Susan Raye's 1971 country western hit, *L.A. International Airport*. It turns out that LAX lays claim to being the only airport with its own popular song, and one must admit that it does hold up. For the 2003 celebration, which also marked the museum's grand opening, Raye was invited to come and perform the song, decades after her recording rose through the charts (hitting number one in New Zealand and two in Australia), and to receive the proclamation that this was now the official song of LAX. Airport administration also simultaneously released a new version of the song with changed lyrics that favor an awkwardly sunny boosterism over the heartbreak story of the original classic, though that didn't deter Raye from donating her gold record to the museum for posterity.

Heading out an old departure door from the gallery onto the tarmac, past the security gate and with a docent escort, one can get close to their only full-size

airplane, a Douglas DC-3 emblazoned with the name "SPIRIT OF SEVENTY SIX." It was last in service to shuttle the top brass of Union Oil, which created the 76 gas station brand and was for many years based in El Segundo, directly adjacent to where the plane has been parked since 2006. While its retro interior is a true time capsule of '70s executive luxury, it has unfortunately been deemed unsafe for entry until its aging floorboards can be reinforced.

For one of the busiest airports in the world (and the most filmed), it's no small feat that any history has managed to be saved. That is of course thanks to the volunteers and museum board who not only keep the place running, but have also donated much of what they have to show, seeing as many are themselves former pilots and flight attendants. Through their efforts, the Flight Path preserves memories of a seemingly distant time, when commercial flight was a privilege for those who experienced it, and was synonymous not with stress or tedium, but with glamour and adventure.

Museum board members and volunteers model uniforms from the collection on the original 1950s DC-7 passenger boarding stairs. From top left: James Lobue, Katie Rampen, Bruce Scottow, Felicia Borsari, museum president Jean-Christophe Dick, and Lynne Adelman. On the tarmac: Tom Ohliger, Janice Solis, and Judy May.

Part 5
Hearth and Home

Horace Heidt Big Band Museum
Sherman Oaks

Unless you're a dedicated fan of big band music, seek out luau-themed parties, or happen to live at Horace Heidt's Magnolia Estates apartment complex in Sherman Oaks, it's quite possible that Heidt's name doesn't ring a bell like it did, say when he received not one but two Hollywood Walk of Fame stars (one for radio and the other for television) in 1960. But those who do fit one of the above descriptions can likely spend a while, preferably poolside, talking about this figure who played a significant role in American entertainment in his day. Even better, inquiring minds can plan for a tour of this highly unique compound, with special attention to the museum that brings the fascinating story of its namesake to life.

After a back injury while a student at UC Berkeley in the early 1920s dashed his dreams of becoming a football star, Horace Heidt pivoted to music, launching a decades-long career as a bandleader and starmaker. He hit the ballroom circuit with his Musical Knights and was an immediate sensation. By the late 1930s, at the height of the Great Depression, he became best known for hosting the *Pot O' Gold* radio program, credited as the first broadcast show to give away money. Heidt would spin a giant wheel three times, with the results determining which phone book from around the country to consult, then which page in the book, and finally the number of entries from the top to select the phone number of the random lucky listener, who would receive $1,000 just by picking up. The show was so wildly popular that movie theater owners brought a gambling suit against it; they were suffering because too many people were staying home by the phone in case they got the winning phone call. The whole episode loosely inspired the 1941 film *Pot O' Gold* starring Jimmy Stewart and Paulette Goddard (and Horace Heidt as himself), the filming of which was enough to lure Heidt and his band out to Hollywood.

Horace promptly bought this ten-acre San Fernando Valley estate, which had been a horse ranch, some of which was planted with orange and grapefruit groves for the California Fruit Growers Exchange (a.k.a. Sunkist). He had bunkhouses built for his several dozen band members and installed a hedge in the shape of a pot of gold, as seen from an early aerial view. He then just kept building; the property became a kind of boarding school for aspiring musicians, but with the flair of Heidt's favorite resorts in Palm Springs and Hawaii (think volcanic waterfalls, exotic birds, multiple pools, a golf course, and tropical plants galore). The original ranch house, once featured in the *Ripley's Believe It or Not!* column due to the number of walls made from glass blocks ("Orchestra Leader never throws stones; he lives in a glass house!"), now serves as the administrative offices as well as the museum. When Heidt purchased the home, it already had a small trophy room filled with horse racing memorabilia, and he expanded it to display his own treasures, adding

A bathroom in the historic ranch house, now home to offices and the museum.

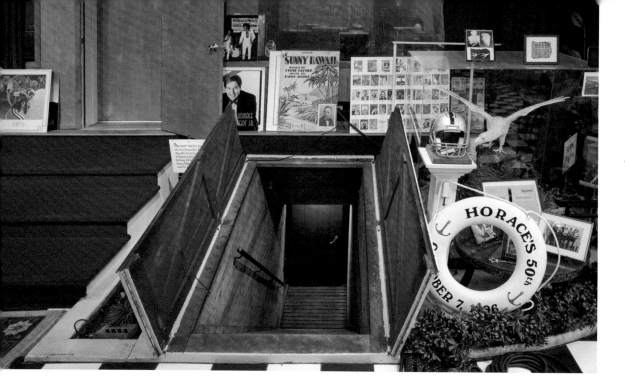

Inside the museum, stairs go up into the recording booth and down into the concrete bomb shelter (now archival film storage).

a recording studio and, one day after the attack on Pearl Harbor, a bomb shelter that is now used to store archival tape recordings.

The large A-frame museum room is bisected by a tall partition on which hang themed photo exhibits depicting various aspects of Heidt's career. With checkerboard floors and tall cases lining the walls, it remains a kind of trophy room, since some majority of the objects are gifts he received and honors bestowed on him by mayors, generals, and chambers of commerce. There are as many towns represented by their oversized wood and metal "Keys to the City" as he could have possibly visited on any one of his cross-country tours. Civic organizations contributed their own sometimes unusual offerings, such as the Oil City [Pennsylvania] Rotary Club's bottle of black crude, or a glass orb in a bell jar that contains Trinitite formed by the first atomic bomb, courtesy the Kiwanis Club of Los Alamos, New Mexico. Not to be outdone, Springfield, Illinois presented him with a slice of an oak rail purportedly made by Abraham Lincoln. Gifts aside, one standout historic artifact is the large, hand-painted, Tums-sponsored wheel from the *Pot O' Gold* radio production; a second one was acquired by the Smithsonian in 1980. The "Door of Opportunity" from his landmark traveling televised youth talent program is also on display, inscribed with his oft-repeated creed that even appears on his family's memorial at Forest Lawn Hollywood Hills: 'Tis Better to Build Boys than to Mend Men.

As a result of his band's many USO shows, there are also quite a few war-related pieces in the museum. Perhaps most interesting among these is a sign that reads "Welcome – Gate to Freedom"; it is from the DMZ in Korea and graced a doorway through which political prisoners were released when the 1953 armistice was signed, ending the Korean War. More gruesome, a set of Japanese *hara-kiri* daggers for ritual suicide were given to Heidt by the mayor of Kyoto;

they're accompanied by a note saying they were "actually used by two members of the Japanese Army Officer's League, when news of the Atomic Bomb reached them." In the same case sits a seemingly pedestrian set of golf clubs which, according to one of the many handwritten calligraphic labels throughout the museum, is said to have belonged to Nazi officer Hermann Göring and captured by American soldiers at Erding in Bavaria.

Heidt died in 1986, but his son, Horace Heidt Jr., has long since picked up the baton. A developer and businessman as well as a big band leader and trumpet player, Horace Jr. was musical director of NFL's Raiders team during their tenure in Los Angeles from 1982–94, and launched his own syndicated big band radio show in the early 2000s called "America Swings." Together, the two Horaces' ninety-plus years represent what is possibly the longest-running big band dynasty in US history.

Horace Heidt's radio and early TV programs served as a prototype for the game shows and talent showcases that are still mainstream entertainment today, but his brand of earnest enthusiasm and unwavering patriotism—not to mention his preferred style of music—didn't stand a chance against the shifting cultural tide during the Civil Rights Movement, Vietnam War, and the rise of rock and roll, even despite his fame and million-dollar smile. Yet one can't discount the joy his music still brings to those with the right flavor of nostalgia. And what stands in the Valley is more than a housing complex that continues to count artists and actors among its tenants, and host New Years and Superbowl watch-parties in the time capsule Aloha Ballroom. It is also a monument that a son maintains in tribute to his larger-than-life father, a destination for connoisseurs of big band history, and a fascinating landmark of American media and entertainment, lovingly preserved and made accessible to admirers and the curious, old and new.

Horace Heidt Jr. passes by the Aloha Ballroom.

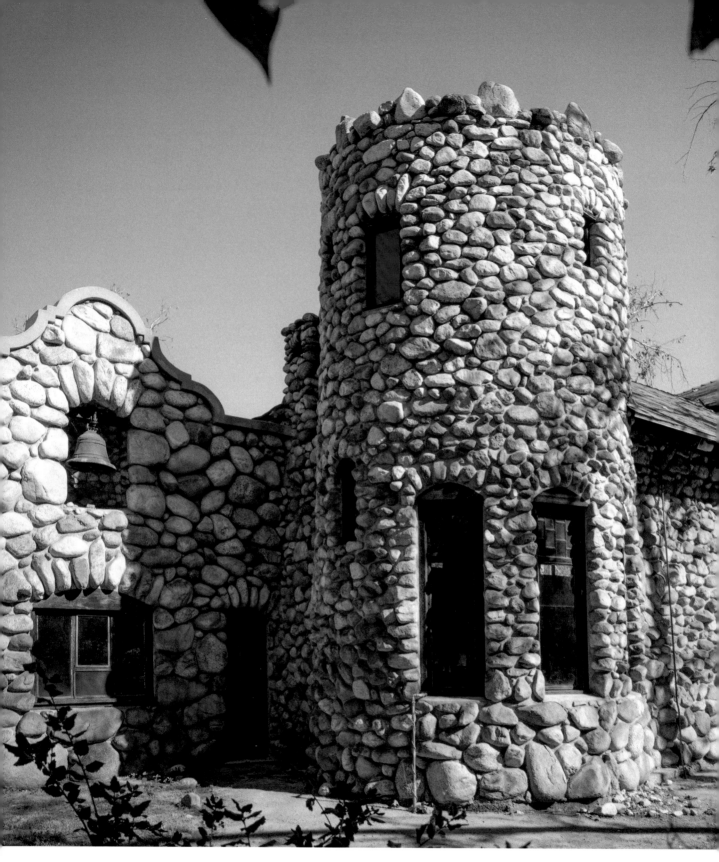

*Arroyo cobblestones and cobbled architectural styles; Lummis spent
more than twelve years building* El Alisal *by hand (with help).*

Lummis House – El Alisal
Highland Park

In trying to get a sense of Charles Fletcher Lummis as a person, one quickly encounters widely divergent perspectives. While many who knew him would have described an eccentric raconteur, pioneering preservationist, and capable genius with a magnetic flair, others saw an overly romantic and occasionally misguided huckster and philanderer. Local historians today readily acknowledge his faults and flaws, but few would dispute his importance to the modern development of Los Angeles, or his contributions to the appreciation and protection of culture across the Southwestern US.

Lummis was born and raised in Massachusetts, had dropped out of Harvard, and was working for a newspaper before setting out on his much-discussed "Tramp Across the Continent"—as he referred to his 143-day, 3,500 mile walk in 1884–85 from Cincinnati to Los Angeles. This was the first act in a lifelong transformation in which he became as much a frontier cowboy poet as any New Englander of his time possibly could. The day after he concluded his epic and widely publicized walk, he took a job as city editor of the recently established *Los Angeles Times*, working at a feverish pace and with little sleep for two years until a malady, possibly a stroke, left him partially paralyzed and forced him to step back. He returned to New Mexico to recuperate, living with Isleta Puebloans, and while there met his second wife, Eve.

By 1897 he was back in Los Angeles, editing a boosterish publication called *The Land of Sunshine* and later *Out West* (again working at an unsustainably manic pace). He began to labor on a castle-like home for his family on the three acres he purchased along the idyllic Arroyo Seco, using the plentiful stones from the property as the primary building material. He would name the residence "El Alisal" in recognition of the site's majestic sycamores, and even built the house around the largest among them, though that specimen has since died.

Lummis took great pride in building the house himself, though he did recruit assistance from his own small children as well as a few young Isleta Pueblo Indians whose families he had befriended and whom he had helped extricate from an oppressive federal boarding school. For the design of his house, he collected ideas in his travels around the Southwest, ultimately cobbling together elements from the Pueblo, Mission, and Craftsman styles. Though work on the home went on for more than a dozen years, it was left unfinished, as he did not get around to making the planned roof tiles, decorative iron grillwork, or the ninety-foot-long cloister that was likely meant to double as a balcony, if the doors to nowhere on the second floor are any indication.

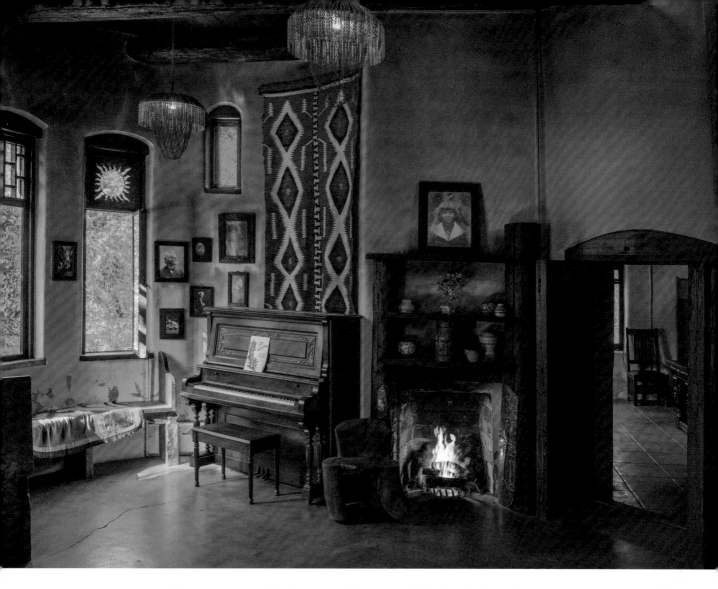

The main room of the house, which Lummis filled with his collections of artifacts and photos, was referred to as *el museo*, meant both as literally a museum and also as a space in which to entertain the muses, a reflection of his classical training. The museo's ceiling *vigas* (exposed rafters) are made from telephone poles that were charred to give the appearance of age, and the windows include small panes made from glass plate photographs captured on his travels in South America and around the American Southwest from 1888–96. A rounded niche at the base of the main turret was often reserved for musicians. This room was completed first and the family didn't hesitate to move in, slowly spreading out as additional rooms were completed in the years to come.

The dining room *(comedor)* includes wall niches typical of a pueblo-style home, hand-hewn wood built-ins, and diamond-shaped floor tiles taken from the Mission San Juan Capistrano when his Landmarks Club was working on its restoration. The *comedor* was also where Lummis recorded some six hundred Mexican and Native American folk songs on wax cylinders to prevent them

The room Lummis referred to as el museo, *with the rounded musician's nook at the base of the turret.*

from disappearing—"catching archaeology alive" as he put it, though some of them were not as traditional nor as endangered as he thought. Still, these recordings, which have now been digitized, are among the earliest and most unique of their kind.

In the kitchen, the walls swoop and curve upwards into a grand central chimney vent (also modeled after that in Capistrano's Mission), and the adjacent stairs lead down into a basement that served as cool storage for wine and produce as well as a darkroom for his photography. The second floor of the home held Lummis's office ("The Lion's Den") where he wrote several of his sixteen books, countless editorial columns, and thousands of letters with his many friends and correspondents.

The floor of the house is concrete, designed with a minor grade that would make it easy to hose down after the "Noises"—the name he gave for his famous parties at which he received many notable artists, writers, politicians, and tribal representatives of the day. There was constant activity at El Alisal during Lummis's lifetime, and a stream of friends and freeloaders living on site, often against his wife Eve's wishes. She taught a Spanish class out of the home that was attended by some of their bohemian artist neighbors; that is, until she left Lummis on account of his infidelity and egotism and decamped for the Bay Area with two of their three children.

Lummis deeded the home, property, and his collection of Native American artifacts to the Southwest Museum (at least in part to ensure that Eve would not be able to go after them in the divorce settlement), which in 2003 merged with the Autry Museum of the American West; the inventory has since been moved to a new state-of-the-art facility in Burbank. Soon after Lummis's death in 1928, the maintenance of the house was deemed beyond the Southwest Museum's capabilities, and after a threat that it might be sold to a motor court developer, the State of California took over before ceding it to the City of Los Angeles. It was the longtime headquarters for the Historical Society of Southern California, though their lease was not renewed after 2014, and while a few new partnerships for independent stewards have been explored, it has since been operated directly by the City Department of Rec & Parks under the care of docent/ranger, Christian Rodriguez.

The great irony of Charles Lummis's life is that the tireless boosterism that he engaged in, luring the masses to come out West, was also the direct cause of the rapid urbanization and erasure of the older, slower culture that he so romanticized and relished. Still, sitting today in the restored native gardens that dampen the noise from the adjacent Pasadena Freeway (which was routed around this landmark), we can appreciate this oasis that preserves the memory of a quieter time, one which favored Lummis's own brand of Noises.

Sam and Alfreda Maloof Foundation for Arts and Crafts (Maloof House)
Alta Loma

Any mention of the name Sam Maloof may elicit either a display of ecstatic admiration, or a hushed reverence, at least amongst those versed in the fields of woodworking, furniture design, or twentieth-century American craftsmanship more broadly. Here was an artist (though he preferred the term "woodworker," which he considered an "honest word") who fought back against depictions of craft as a lesser form than fine art. He slowly won out, being the first craftsperson awarded a MacArthur Foundation "genius" grant, as well as being featured in numerous landmark exhibitions including a 2001 retrospective at the Smithsonian; he was even referred to as the "Hemingway of hardwood" by *People* magazine in 1986. But if drooling over the spindles and joints of a rocking chair sounds fetishistic, a visit to his home in Rancho Cucamonga—now a museum holding the largest collection of his work anywhere—should help one appreciate the brilliance and skill with which he built each piece, not to mention his signature tenacity that has inspired many people, regardless of their own talent or area of obsession.

The son of Lebanese immigrants, Maloof grew up in Chino as the seventh of nine children, and spoke Arabic and Spanish before learning English. He picked up woodcarving at an early age, and after serving during World War II in the Aleutian Islands (where an expected Japanese attack never materialized), he returned to Southern California and began working as studio assistant to renowned designer and artist Millard Sheets in Claremont. In 1948, newly married to his life partner and business manager Alfreda Ward, Sam set to work building furniture to decorate their home, without any formal training and using wood salvaged from alongside the railroad tracks. After he was featured in a design magazine he started getting calls, which allowed him to quit his day job (at Alfreda's urging) and never look back.

Maloof did much of the design work for each new piece freehand on his trusty band saw, before refining it with hand tools and sanders, and finishing it off with three applications of linseed and tung oils, plus beeswax. His designs are highly ergonomic and relatively unadorned, making each flourish and curve that much more pronounced. The bassinets and music stands come off as slightly ostentatious given their niche function, but it was the rocking chairs that catapulted him to fame and which were collected by several US Presidents: Reagan, Clinton, and especially Carter, who visited Sam at home and referred to him as his "woodworking hero."

Throughout his career, Maloof turned down multi-million dollar offers to mass produce some of his chair designs, opting instead to continue handcrafting everything at the highest quality and turning out just a few dozen orders per

The iconic spiral staircase in Alfreda's former office.

The kitchen, with Maloof's unique system for suspending houseplants.

year. And while the waitlist was legendary, Maloof made an exception for any order of one of those bassinets, which risked obsolescence if it wasn't delivered in a timely fashion. Handcrafting each piece also meant that his work quickly became expensive to commission (forget trying to buy any originals now). Maloof remained modest despite his fame, and reported feeling almost embarrassed when he would receive letters from admirers sharing that the beauty of a chair had brought them to tears. He had set out to make a living, not to be enshrined amongst the greats of Modern design, though he certainly appreciated the freedom (and the fast cars) it afforded him.

A plaque designates the house itself as Maloof's most ambitious woodworking project, though the blue corrugated metal roof lines, loose brick floors that clink gently underfoot, and masterful use of natural light and flow between spaces (despite the piecemeal construction) demonstrate his innate sense for design well beyond a single medium. Granted, many more fixtures and features were hand-carved than in any typical home—toilet seats and countless whimsical door handles and latches included—and the wooden wall paneling inside and out make the theme clear.

For decades, Maloof worked weekends on the home, situated in the middle of a lemon grove, eventually adding more than twenty rooms and filling them

with furniture. Alfreda had spent eight years teaching art and organizing craft cooperatives on Indian reservations in New Mexico and Montana, and the house contains traditional Native American paintings, weavings, and pottery alongside contemporary works. In the kitchen, houseplants hang on ropes connected to a simple system of pulleys and tied to wooden cleats that lend a nautical feel. But perhaps the *pièce de résistance* is a spiral staircase in Alfreda's former office, with a swooping handrail, and each step stacked up and cantilevered off a central pole.

The house was nominated for protection as a historic landmark in defense against the looming 210 freeway that would overtake the property by eminent domain, compelling Caltrans to help relocate the home (in seven pieces) to the present location in 1999. Alfreda passed away shortly before the move, and Sam built another house that he lived in with his second wife, Beverly, until his death in 2009, remaining active in his shop until the end.

Today, the grounds feature an art gallery, educational space, and acres of citrus orchards and gardens of California native plants. A few of Maloof's apprentices carry on the tradition: Larry White, Maloof's first employee and an accomplished artist in his own right, leads workshops and acts as artist in residence, while Mike Johnson, who worked under Sam for some thirty years, has exclusive license to continue producing Maloof designs, working on site in the original shop. Sam and Alfreda are buried together on the property, and her casket was reportedly one of the most challenging jobs he ever undertook, even with the help of his son and assistants. Its lid was designed to resemble the gabled roofline of their home, now the museum, in which visitors will find not only an archive of his masterful work, but also both of their spirits very much alive.

There was always a long waitlist for a chair, but a rush order could be placed on a bassinet.

The unique Spanish-Mediterranean style
concrete home, built in 1933 by Jesse Hathaway.

Hathaway Ranch & Oil Museum
Santa Fe Springs

There were still more than 5,000 active oil wells within Los Angeles city limits when a resolution was passed in 2022 ordering their eventual closure and remediation. And while the pump jacks that flank La Cienega Boulevard through Baldwin Hills and throughout the small city of Signal Hill in southern LA County bob along quite conspicuously as of this writing, it's already merely a trace of the 1920s oil boom that saw vast tracts of the hills and beaches across the LA basin bleeding black and sometimes belching fire. There are a few historic sites that interpret the development of this controversial industry locally, but none more delightfully peculiar than the Hathaway Ranch & Oil Museum in Santa Fe Springs.

Many visitors to this semi-working ranch are asked upon arrival how much time they have, but be warned that anything shorter than a couple hours will come as a disappointment to the docent on duty. Encompassing five acres of "rusty, dusty history" and five generations of Hathaway family stories and keepsakes, this multifaceted preservation project is not meant for a casual drop-in. The whiplash one gets pulling away from the whizzing traffic on Florence Avenue into this idyllic and indeed rather dusty property gives the place the feeling of an anachronistic portal to lost ways of life, so it's best to slow down and try to take it all in.

Jesse and Lola Hathaway purchased forty acres here in 1902, and would drill eight wells after a major gusher nearby turned the area into a petroleum boomtown in 1921. Today, much of the old drilling and pumping equipment lies dormant in the back section of the site, and scale models of the derricks built by their three sons (Julian, Elwood, and Richard) remain on view, including an operational nine-foot-tall steam-powered diorama from 1928 that could reportedly drill one-hundred-feet deep. The family started the Hathaway Oil Company in 1932, which remained active until Julian's passing in the year 2000, and for decades it was quite possibly the largest independent oil company operating in California.

Anchoring the property is an imposing Spanish-Mediterranean-style concrete home built in 1933 and incorporating materials salvaged from the devastating Long Beach earthquake of that year. The home was already partially built when the quake hit, and as the story goes, Jesse made a bee-line for ground zero in search of free fallen bricks with which to finish construction. The family fireplace as well as their water heater and stove reportedly ran for many years on free gas from the on-site drilling operation.

Each of the three sons built homes for their families very nearby, with one being converted into the original museum proper by Nadine Hathaway, Richard's wife. She established the Rancho Santa Gertrudes Historical Society (named for the former Mexican land grant that encompassed this area) in 1983, and the museum was incorporated three years later. Inside the ranch house, an

The modern world (and its commercial loading docks) sits just beyond the fenceline.

introductory panel proclaims, "There are no artistic treasures in this museum. What you see is what was used." While each room of the house (and every corner of the property) is brimming with yesteryear's functional machines and practical products, as promised, there are also artistic and architectural features that shouldn't be overlooked. Compelling portraits hang over the fireplace in both main houses: one of Jesse and Lola Hathaway and the other of Richard and Nadine, painted in the 1960s by celebrated Cambodian artist and illustrator, Nhek Dim. A one-time classmate of Richard and Nadine's son, Dim returned to Cambodia and found great success creating official travel posters and album covers for famous musicians; in 1978, he was tragically murdered by the Khmer Rouge, which targeted artists and intellectuals.

Nadine would run the museum until her passing in 2002, when her daughter Francine Hathaway Rippy took over. Rippy, who is 85 as of this writing, has had a long professional career, and admits to being "something of a celebrity" at the LA County Fair for her canned preserves, which have been winning her ribbons for more than sixty years, and a museum visit often includes the possibility of acquiring some of them.

A highlight of the tour is the machine shop, where all the equipment is connected by flat belts to a single overhead shaft and originally run by steam engine, later converted to gas and finally electric power. When they fire it up, the whole room rumbles to life—a rare privilege to behold. A stone's throw from the shop, a large oil tank now houses artifacts including a rare International "woodie" truck that had its engine replaced multiple times, and which purportedly has between one and 1.5 million miles on it from decades of commuting up to the six-thousand-acre Temescal Ranch the family owned and operated near Castaic.

This was the largest undeveloped private property in all of LA County until the family sold it for $6 million in 2022 to be preserved as public open space.

Back in the city, air quality concerns as early as the 1940s prompted the phasing out of the farming operations, and the cattle rearing was brought to an end shortly after the incorporation of the City of Santa Fe Springs in 1957, amidst escalating complaints about the dust and odor by denizens of the encroaching developments. And while the low ground, formerly a fruit and nut orchard, is now parceled out and converted to corporate warehouses, caretakers still raise chickens and goats on a section of the triangular lot that remains. One animal pen backs up directly to Amazon loading docks.

The sign by the front gate continues to encourage neighbors to come over to buy a chicken or pick up some free firewood, a simple gesture that is of course vanishingly rare in the modern world that surrounds them. Truly, it's nothing short of a miracle that they have resisted the mounting pressure from developers to sell what's left. With any luck, another family member with an equally strong belief in the importance of history and the power of nostalgia will step in, keeping the shop belts turning, the goats fed, and the hours of stories shared with all who will listen.

Francine Hathaway Rippy, steward of the family legacy.

Arden: Helena Modjeska Historic House and Gardens
Modjeska Canyon

During the late nineteenth century, Helena Modjeska (born Modrzejewska) was among the most prominent celebrities gracing American stages, lending her name to perfume, flatware, shoe designs, an elastic corset, and a caramel-covered marshmallow candy from Kentucky that is still in production. One could learn more about the actress by browsing a "who's who" of turn-of-the-century Polish Americans, reading up on Orange County history, or sitting down with a Shakespearean scholar, but even better is a visit to her bucolic former home and estate, now restored and made accessible as a testament to her legacy.

Born in Kraków in 1840, Modjeska garnered unrivaled acclaim as a young actress, but her sphere of influence was limited in occupied Poland, where censorship was commonplace and calls for independence were in the air. Decamping to America was a popular fantasy circulating amongst the freedom-seekers in her circle, and in 1876 she made the leap with her husband, "Count" Karol Bożenta Chłapowski, her teenage son from her first marriage, Ralph, and a handful of their idealistic, bohemian friends. They headed for Anaheim to be near the established German colony there (they spoke German but not English), with the goal of starting a utopian farming community. They quickly faced the harsh reality that their romanticized plan didn't account for the specialized skills and ceaseless manual labor that agricultural pursuits would require. The colony failed in a matter of months, and Modjeska went back to acting the following year.

Her last name having been simplified for the benefit of her American audiences and promoters, Modjeska had long aspired to perform her beloved Shakespeare in his native language, and took to memorizing her lines while still studying English. Even with a strong accent and an imperfect command of the language, she quickly became one of this country's premiere Shakespearean interpreters, and would remain so over the next quarter century. After some years touring the country in her own private railroad car, she returned to Southern California to establish a home base away from the crowds, purchasing a friend's 1300-acre property in a remote canyon within an area that would soon secede from LA to form Orange County in 1889.

The ranch was given the name "Arden" after the forest in Shakespeare's *As You Like It*, and they set to work making it their own. Bożenta built what is purportedly the first swimming pool in Orange County, though Modjeska herself wouldn't touch the murky water, and it's long since been left unfilled. The renowned English botanist Theodore Payne lived and worked at Arden for a few years in the 1890s and was tasked with tending the plants Modjeska brought home from her travels. It was here that he developed an appreciation

Looking down the hall into the bedroom.

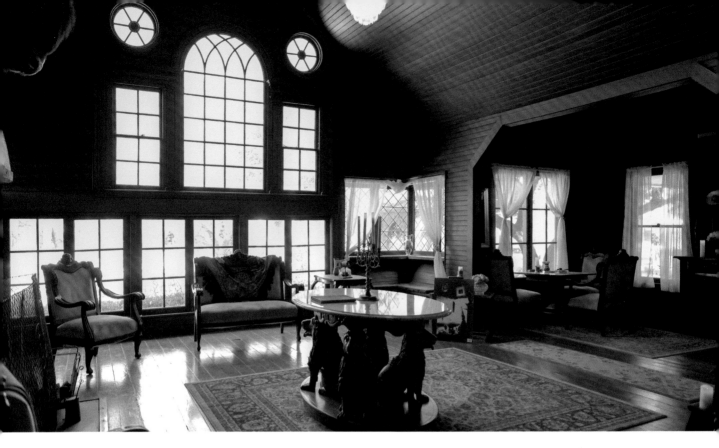

The library, with its grand Palladian windows.

for the native flora of the kinds propagated by his foundation and nursery, which still thrives in the San Fernando Valley.

Modjeska commissioned Stanford White, famed New York architect of Gilded Age landmarks, to design (by mail—he never visited) a home that is his sole remaining structure west of Kansas. The house features White's signature Palladian windows that flood the central library and music room with natural light, and lend a sense of elegance to complement the rustic elements, such as the bison head mounted above the large stone fireplace. Primarily using Arden as a place of retreat, she would also entertain friends for days at a time, including Ignacy Jan Paderewski, the famed pianist and composer who later had a stint as prime minister of Poland.

Modjeska sold the property in 1906 and spent her remaining few years in a Newport Beach cottage. When she died in 1909, her remains were sent back to her native Kraków, but not before they were paraded through the streets of New York, Chicago, and downtown Los Angeles, where throngs of admirers crowded into St. Vibiana Cathedral to bid farewell. Arden became a private resort, a restaurant, a short-lived and reportedly disreputable museum, and then a residence again, owned by the Walker family for sixty years until it was finally sold to Orange County in 1986 and opened as an historic site under the OC parks department. Four years later it was declared a National Historic Landmark, one of only two in all of Orange County (the other being Richard Nixon's birthplace in Yorba Linda).

There are a few disparate artifacts that are traceable back to the star herself, and these are supplemented by plenty of photographs and antique furnishings, some of which were sourced and even reproduced to match the historic photos.

Modjeska designed and tailored most of her own elaborate Victorian costumes, and there is one room dedicated to that aspect of her craft. In the bedroom—which was painted with dark colors and fitted with blackout curtains—a high shelf along the perimeter once displayed a collection of dolls that she made and dressed in miniature costumes matching those from her stage roles.

Another room features the fantastical fairytale book she wrote (in Polish and English) and lavishly illustrated as a Christmas gift for her grandson Felix in 1896. Titled *Titi, Nunu i Klembolo: the Adventures of Two Lilac Boys and a Six-Legged Dog*, it tells of a "strange country" (Mars) where "the apples are shaped like human heads with mouth, eyes, nose and chins…," not to mention the men covered in spots who are "great criminals or childeaters," apt to devour kids who are disobedient or "inclined to torture animals." Now digitized and available online through the UC Irvine Library, it demonstrates that her creative brilliance took many forms.

Driving in via Santiago Canyon on a crisp winter day, one might catch a glimpse of the snow-capped San Bernardinos in the distance, opposite the creek rushing alongside the road. Considering it's a bit of a trek even today, one can begin to imagine the arduous journey by horse and buggy in Modjeska's time. Once at Arden amidst the live oaks, one need not squint to view this part of the world as a stage. The curtains are drawn and the house lights are up, with docents and rangers acting to reveal how a remarkable life played out, winning new fans for a celebrated figure who has long since taken her final bow.

Modjeska's house at Arden was built as an extension onto an existing hunting cabin.

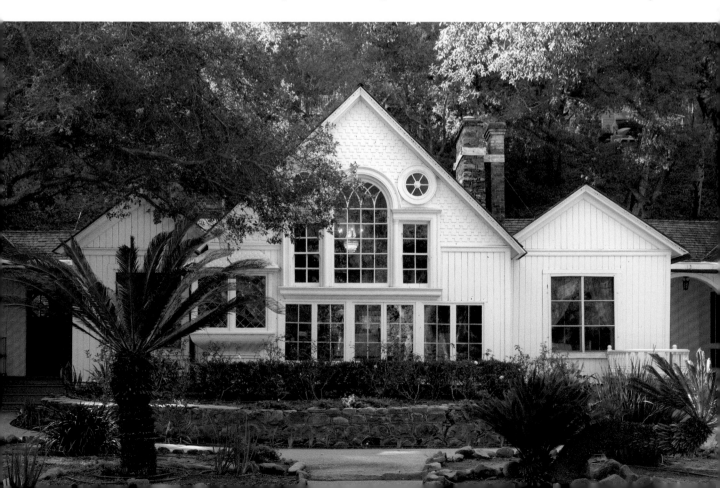

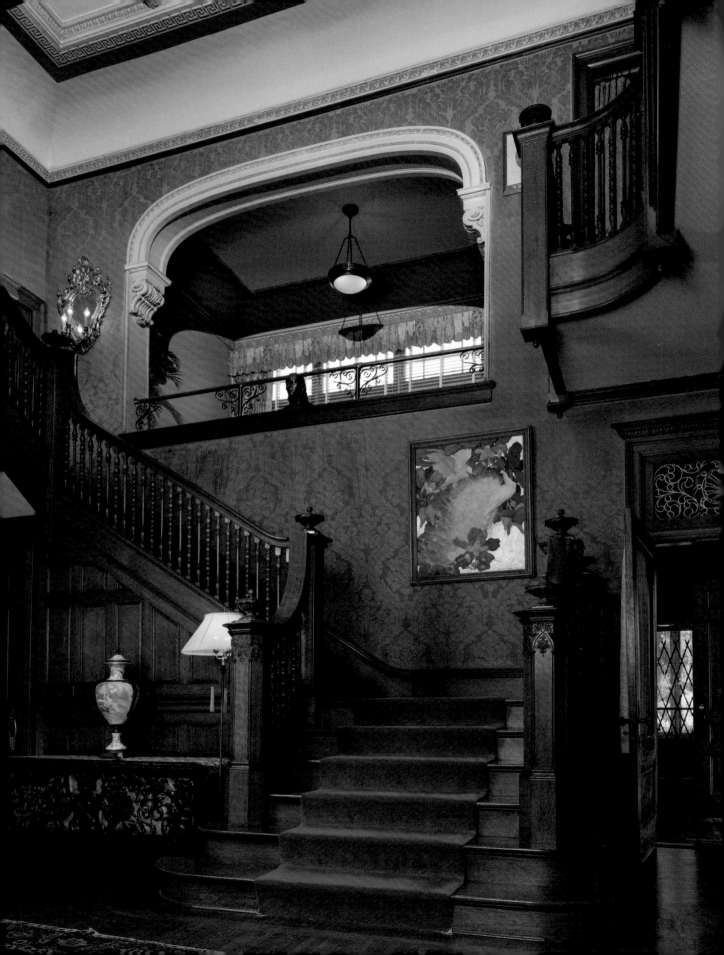

Kimberly Crest
Redlands

Much of the Inland Empire was radically transformed by the arrival of wealthy snowbirds and the rise of King Citrus starting in the late nineteenth century; the town of Redlands has managed to preserve much of its inherited grandeur (see also the Lincoln Shrine on page 251). One of the more idyllic strolls in town is through the eleven-acre Prospect Park, where just beyond the manicured paths and an inviting outdoor amphitheater, one might stumble upon an immaculate mansion seemingly straight out of a fairytale. This opulent home was constructed in 1897 by Cornelia Hill, a New Yorker who had been recently widowed by tuberculosis, which also took four of her six daughters. It was designed in the châteauesque style, in line with Revivalist trends and inspired by a French Renaissance castle of the sixteenth century that Hill had visited on European vacation. It was the only structure of its kind in Southern California when built.

In 1905, the home was sold to Helen Cheney Kimberly and John Alfred Kimberly, co-founder of the multinational Kimberly-Clark empire (think Kleenex, Kotex, Huggies, Cottonelle, etc.). Among the wealthiest of snowbirds, the Kimberlys made some alterations to the building and converted much of the obligatory orange grove surrounding the home into a terraced Italianate fountain and gardens. It was during this period that the estate took the name Kimberly Crest.

Rollin Lane, an acquaintance of the Kimberlys and a fellow Wisconsin native, so admired the home that he took the blueprints from architects Oliver Perry Dennis and Lyman Farwell to build his own "Holly Chateau" in Hollywood in 1909, with the only noticeable difference being the move of the main turret from one corner to the other. Lane's mansion has met a markedly different fate and is now better known as the Magic Castle (see page 263), though if a visitor to the castle squints hard enough looking up the grand staircase to the Owl Bar on the mezzanine, they might be able to imagine the sunlit conservatory in its place, much like the one that is well preserved at Kimberly Crest.

The Kimberly family was always civic-minded; Helen was a strong supporter of the Women's Club Movement of the early twentieth century, and their daughter Mary Kimberly Shirk later advocated for women's education and scouting, and served as acting president of Scripps College during World War II. After the death of John and Helen in 1928 and 1931, respectively, Mary lived in the home until she passed in 1979, leaving the building and

Though not quite "The House that Tissues Built", its history is preserved thanks in no small part to this and other personal care products.

The grand staircase and conservatory balcony, where musicians could entertain guests on both levels.

grounds to "the people of Redlands" (albeit through a private nonprofit). This gift had been promised after the city met her earlier challenge of raising funds to purchase the acreage surrounding the estate to form Prospect Park, the proceeds from which Shirk used to help found the Kimberly-Shirk Association that still oversees the property today.

Remarkably, everything in the house is original and was used by the family—aside from the fake cheese and grapes on the elegantly set dining table. Having so many original pieces is virtually unheard of amongst the dozens of historic house museums across Southern California, which most often are stocked with period antiques ("just like they might have had") and are lucky if there is a lone desk or chair or piano that belonged to the former residents. One particularly curious relic is a foot-operated call button, used to summon the butler to Shirk's seat at the head of the dining room table, though most visitors might be more drawn to the art, antiques, and architectural features such as the parquet floors in the library and the mosaic flower fireplace, the latter in a parlor which has not been redecorated since 1906.

The insertion of fake fruit notwithstanding, few alterations have been made to accommodate the public, though in truth it's thanks to a very active restoration program that this time capsule can be preserved. But the world around the museum has changed, as has the community it serves, as a majority of people in San Bernardino County and neighboring Riverside County now identify as Hispanic or Latino, compared to the largely white migrant population of a century ago. Today, more than 450 photo shoots take place on the grounds

The hanging portrait is of Mary Kimberly Shirk, who left the house to "the people of Redlands." The photo on the table is of Mary and her mother, Helen Cheney Kimberly.

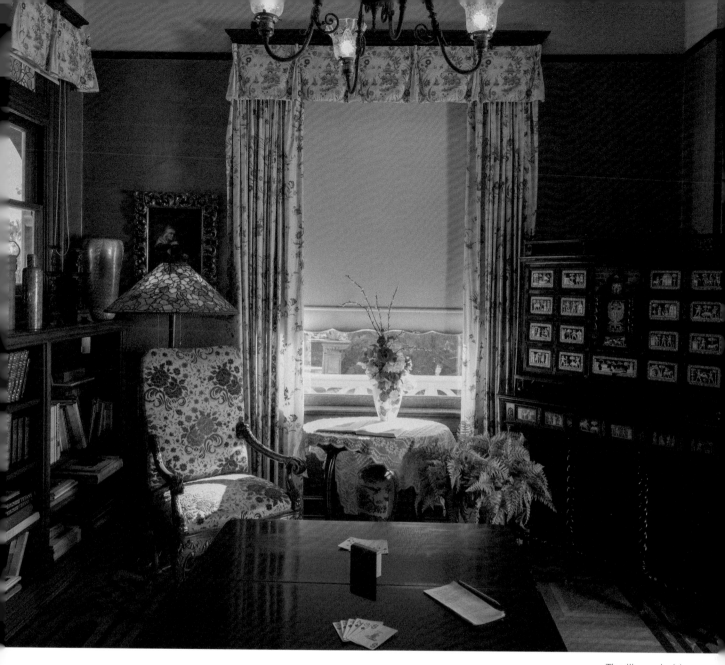

The library holds treasured artifacts including a Tiffany lamp, an antique Spanish chest, and Mrs. Shirk's bridge table.

annually, and the lion's share of these portrait sessions are for quinceañeras. It's perhaps an appropriate choice given the landmark's nickname after its succession of owners: the House of Three Women. These young women come from great distances, even out of state, to be part of the fantasy suggested by the architecture and environment, and reclaim it as an expression of their own culture. Posing in their epic gowns, one can imagine them thinking: who needs Hollywood, when Kimberly Crest is steeped in a magic of its own.

Overleaf: Kimberly Aguilera (right) & Liseth Gonzalez in their quinceañera dresses.

Antelope Valley Indian Museum State Historic Park
Lake Los Angeles

On a remote granite outcropping, where the southwestern edge of the Mojave Desert crosses into the northeast corner of Los Angeles County, sits a curious Tudor-Craftsman-style chalet built right into the boulders. The storybook elements of the structure are confused by the Native American motifs that cover much of its façade, and by the cut-out rattlesnakes that form decorative gables along the A-frame rooflines. In contrast to this rustic pastiche is the government-approved sign out front declaring that this place, the Antelope Valley Indian Museum, is also now a California State Historic Park. Even before experiencing any of the incredible interior environments and intriguing displays, it is clear that the story of how this place came about warrants further exploration.

Self-taught artist, poet, architect, amateur archaeologist, and Native American enthusiast Howard Arden Edwards acquired the 147-acre property in the late 1920s, when the federal government was still essentially giving away desert plots under the Homestead Act of 1862. Edwards planted some ill-fated barley crops in response to the requirement to "improve" the land, and left his wife Rose and their son Arden there full time while he taught art and stage design at Lincoln High School in Los Angeles during the week, commuting back to the homestead on weekends to continue building. He was also in the business of creating backdrops for urban theaters (the Belasco, Burbank Theatre, and the Grand Opera House, to name a few), and he utilized these skills as well as the leftover plywood stage sets in the construction of his desert folly. Giant (and inauthentic) Kachina dolls painted on the ceiling of his living room—or Kachina Hall—were also done on theater flats by some of his adult education students in the city, and he began filling the place up with his growing collections.

Edwards was actively involved in the pot-hunting, grave-robbing hobby that was sadly common throughout the American West at the time. Native American artifacts were seen as fair game to be taken and added to private and institutional holdings, with no regard for the ancient and often sacred sites from which they were extracted, let alone the beliefs and wishes of the inhabitants' living descendants. It would still be decades before any relevant legislation to protect such sites was meaningfully enforced, and by 1933 the top level of Edwards's house, which is accessed by scrambling up a narrow boulder staircase, was opened to the public as the Antelope Valley Indian Research Museum. It is fitting that the "Research" part of the title was since dropped, because although his interest in Indigenous cultures was legitimate and well-intentioned, much of his interpretation veered into questionable and sometimes harmful fantasy. His obsessive cataloging and arranging of arrowheads held little educational value, whereas some interpretations of objects were more overtly offensive, such as the

Edwards's living room, now known as Kachina Hall. The narrow stairway at left through the slot in the boulders leads to California Hall.

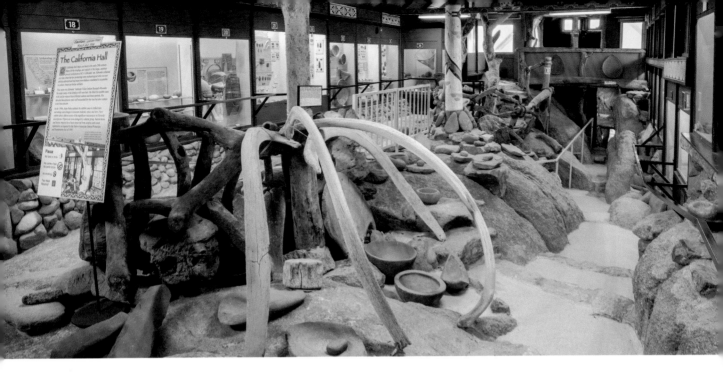

California Hall, originally the museum room. Many of these exhibits have recently been taken off display.

characterization of ceremonial pieces as beauty products, which he imagined to have been used by "the Dawn Maid," a character he had dreamed up for a novel. In the early years, Edwards would also produce large-scale pageants on the property, which were ahead of their time in some limited ways, such as the casting of Indigenous actors, but were hopelessly biased and inaccurate overall.

In 1939, the museum was purchased by fellow enthusiast and collector Grace Wilcox Oliver, who had stumbled into the property on a hike while visiting a friend nearby and immediately placed a call to make an offer. She only met Edwards some years later, when she hired him to come back and work on the exhibits as well as paint the building exterior. By that time, she had installed a number of infrastructural improvements and had built charming standalone guest cottages. Under Oliver's management the museum expanded to encompass every room in the main house, with the original public space on the upper level now renamed California Hall and only showing artifacts from tribes native to what would become the Golden State. During her tenure, Oliver also brought in a number of television and movie shoots thanks to her connections in Hollywood (one of the more egregious examples being the 1973 Charles Bronson thriller, *The Stone Killer*), until finally selling the entire property and its contents to the State of California in 1979, following a lengthy campaign by community advocates to support the acquisition.

After coming under the auspices of the California State Parks system, they were obliged to conduct accessibility and safety improvements, and they updated the entry rooms with displays exploring cultures of the local Antelope Valley area, the wider Great Basin (from the Sierra Nevada to the Rocky Mountains), and the Southwest. Critically, there was a new sense of accountability to the descendants and members of the tribes depicted. They also reined in the museum's scope, deaccessioning African and Latin American items deemed outside their mission. But what to do with Edwards's folksy, culturally insensitive handmade displays

would pose a more vexing challenge, and for decades these historic dioramas and storylines were left intact but with added signage noting that such fantasies were no longer an acceptable interpretation of Indigenous cultures. Until very recently, the primary function of the museum seemed to be a reflection on how Native representation in museums has evolved over the last century.

In 2023, a substantial overhaul of California Hall commenced with the deinstallation of many of the historic exhibits. Signs were taped up on the cases saying that the items that had been removed "should never have been taken and put in this museum to begin with." The AVIM began the process of repatriating all collections from the San Nicolas, San Miguel, and San Clemente Islands, and are continuing this work as tribal consultation proceeds in compliance with the federal Native American Graves Protection and Repatriation Act (NAGPRA) and the more stringent state law, CalNAGPRA, which provides guidelines for repatriation to California tribes that are not federally recognized. They plan to consult with local tribal governments to reimagine California Hall, creating new exhibits that tell their stories from their own perspectives.

Such a sensitive and complex process is sure to take a while, but in the meantime the museum has produced virtual tours led by representatives from the Fernandeño Tataviam and Gabrieleno/Tongva San Gabriel Bands of Mission Indians, as well as Pueblo artist Rowan Harrison. These focus more on the usage and significance of the artifacts than on Edwards's or Oliver's antics, and were made possible thanks to a grant funded by the special interest state license plate that features Snoopy and is adorned with the tagline, "Museums are for everyone."

When trying to think of which might be the most unique and underrated museum in Southern California, the AVIM is often one that comes to mind for its unlikely setting, its captivating artistry, and the complex layers of history that it continues to navigate. Balancing its role as a folk art and architectural landmark with that of an inclusive space for sharing Indigenous culture will be an ongoing challenge for the state parks' interpretive department and the dedicated staff assigned to this site. But no matter where they are in their ongoing efforts to amplify Native voices, it will always be worth a drive out to this parched corner of the county to be reminded of the nuance and collaboration required to get this right, and why it is so important to keep working at it.

The museum's spectacularly strange façade feels all the more disorienting after driving across the open desert.

Beatrice Wood Center for the Arts
Ojai

Winding up the long driveway on the still-rural (for now) outskirts of Ojai, one can expect that a visit to the former home and studio of artist Beatrice Wood will be a peaceful and delightful experience, if only for the view of the surrounding valley and mountains. Those unfamiliar with the incredible life of "Beato," as she was known, will be surprised by the many threads of intrigue and the major episodes of American and European art history that Wood had a hand in shaping over her long life that spanned almost the entire twentieth century.

Beatrice Wood's name is rarely introduced without the mention of her one-time romance and long-term friendship with Marcel Duchamp, or her nickname as the "Mama of Dada." Born into privilege in San Francisco in 1893 and raised in New York high society, she opted for the bohemian life of an artist, actor, and writer, much to the consternation of her overbearing mother. After time in Paris and then back in New York, a series of failed loves and departed friends led her to follow her spiritual teacher J. Krishnamurti, and art collector and patron friends Walter and Louise Arensberg, out to Los Angeles in the 1920s, remaining in Southern California for more than seventy years.

Though Wood practiced various art forms, she is most closely associated with ceramics. This interest began in 1933 with a class in the Hollywood High School adult education department, where she hoped to create a luster teapot to match the plates she had recently picked up in an antique store in Holland. Over the ensuing decades, she had exhibitions and travels too numerous to list, and for a time rented space at the Crossroads of the World development in Hollywood to sell her wares, but didn't find meaningful success or broad recognition until she was eighty-six. Fortunately, she still had another two decades left in her career, working right up until her death in 1998, just a few days after her 105th birthday. When asked her secret to longevity, she famously suggested it was a result of her appetite for "art books, young men, and chocolate."

Beato's final home, the present-day museum and art center, sits on a much larger property with its own fascinating trajectory. In 1927, this five-hundred-acre-plus parcel was acquired by the Happy Valley Foundation, which had been set up by Annie Besant, the influential leader of the Theosophical Society spiritual movement. The vision for the campus was stalled after Krishnamurti (Besant's

Glaze jars in the working ceramic studio.

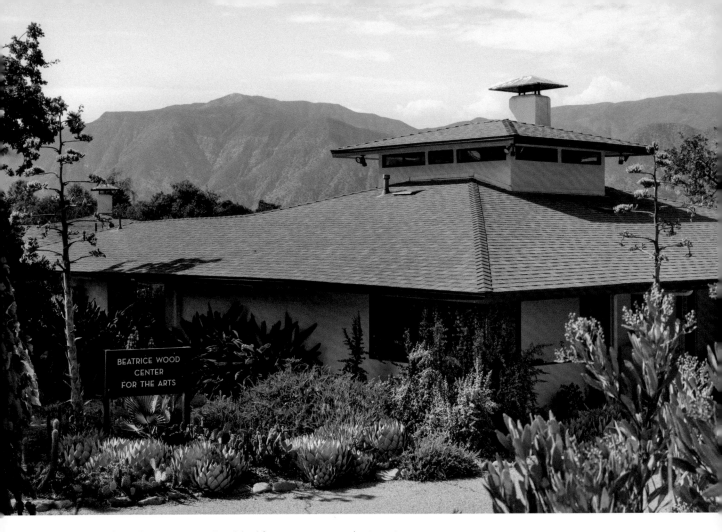

Beato's home in a picturesque setting, ideal for a museum and art center.

adopted son) rejected the idea that he would become a great World Teacher and messiah, though the Theosophists did manage to establish a boarding school with support from Aldous Huxley and many others that is still going strong. In the 1970s, Wood was invited to make her home there, next to that of her best friend and the school's director, Rosalind Rajagopal. The sale of a Duchamp drawing helped pay for its construction, which was done with the understanding that it would be donated to the Happy Valley Foundation upon her passing.

Kevin Wallace, who was a fan and friend of Beato, had curated a few shows of her work starting with a retrospective at the Craft & Folk Art Museum (now the Craft Contemporary) and was invited by the Happy Valley Foundation to create the art center out of her former home and studio. The Beatrice Wood Center for the Arts opened in 2005, and Wallace has been at the helm ever since, sharing Beato's work and environment, interpreting her story and those of her endlessly fascinating friends and associates, and highlighting other local artists. Throughout the house, shelves, tables, and mantels are artfully arranged with Wood's whimsical ceramic sculptures and drawings, interspersed with pieces

from her folk art collection that helped inspire her aesthetic, including many spectacular examples from her extensive travels throughout India as well as Japan. The art book library holds her numerous awards as well as artifacts relating to Krishnamurti, Besant, and Theosophy.

Though the old sign Wood posted offering the sale of pottery ("Reasonable and Unreasonable") is now relegated to museum display, the ceramics studio attached to the home still contains Wood's original plaster molds, her final unfinished projects, and kilns and tools as she left them. Her many jars of experimental glaze ingredients give the feeling of an apothecary. Not just a preservation project, the studio has been brought back to life through classes and use by other artisans. Shelves of newer glaze ingredients have been added, including ash from the deadly 2017 Thomas Fire that wiped out hundreds of thousands of the surrounding acres, even claiming the lower campus of the adjacent school. But perhaps no glaze is as poignant as the one applied to and fired on the iridescent rocks that dot the front garden; that one was made with the ashes of Beato herself.

The former living room is now a gallery showing a combination of the artist's own work with art and objects she'd collected.

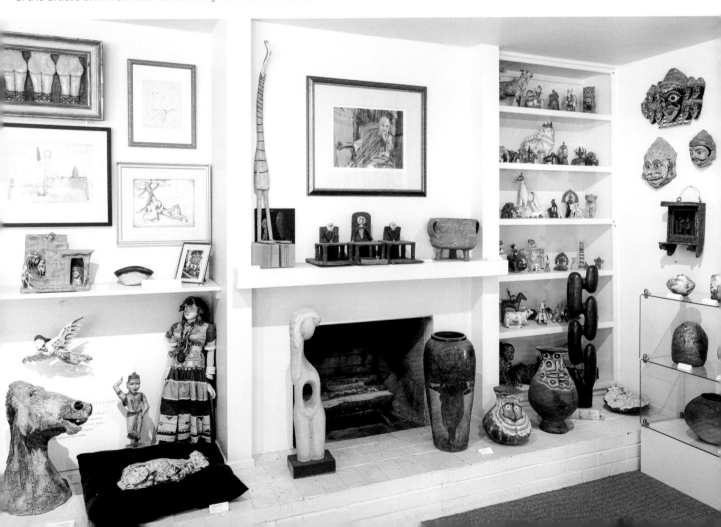

Part 6
Specific Histories

Patton and Metropolitan State Hospital Museums
Highland and Norwalk

California has five massive, state-run mental hospitals in operation, with two in Southern California: Patton, in an unincorporated section of San Bernardino County near the city of Highland, and Metropolitan, in the city of Norwalk in southeastern LA County. Given the cloistered nature of psychiatric care facilities, and the widespread and persistent stigmatization of mental illness, their presence elicits a natural curiosity, at least for those who aren't more directly impacted personally or professionally. To satisfy the external interest, and in response to internal preservation efforts, these two sister institutions have each established a historical museum on their grounds, providing a unique opportunity to explore a larger story from distinct yet interrelated vantage points. Taken together, they provide a look behind the curtain, interpreting historic and modern approaches to addressing one of the most profound challenges facing so many in our society, and the vast infrastructure that's been built to serve that purpose.

It's hard to grasp the scale of these operations, even while on the properties. The older of the two, Patton, opened in 1893 and originally encompassed 668 acres (it still occupies 247 acres today and houses around 1500 patients). By 1916, overcrowding and a burgeoning population in the region led to the founding of Metropolitan (or Metro), which initially occupied a 305-acre campus (and was similarly overcrowded as early as 1923, though it's now down to roughly eight hundred patients). For decades, these campuses were self-sustaining micro-cities, where patients helped erect new buildings, farmed and raised livestock, made their own clothing and furniture, and worked in blacksmith and barber shops, among other occupational programs designed to keep them active. The era of self-sufficiency ended by the 1970s, when the population of each site began

A stash of historic mail, discovered in an attic at Patton.

Both state hospital museums are in former administrators' homes that look plucked from a leafy suburb.

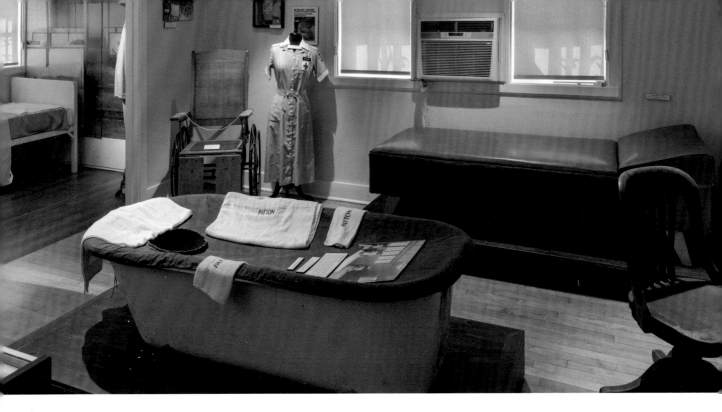

to decline precipitously amidst a push towards deinstitutionalization. Since the 1980s, the hospitals no longer take patients who aren't referred by court order; most have been convicted of crimes, deemed incompetent to stand trial, or ruled not guilty by reason of insanity.

Patton and Metro each have their own unique history, but take a complementary approach to preserving and interpreting stories of how the perception and treatment of mental illness has evolved over more than a century. The idea for a historical museum originated at Patton, where a committee was formed in the 1980s to start archiving and collecting its history. Chief social worker Anthony Ortega was hired in 1999, and he soon began collecting as well, eventually becoming hospital historian and setting up a makeshift museum in the archives room in response to increased interest from his colleagues. When students from nearby California State University San Bernardino's museum studies program approached the big, old hospital in 2015, unaware of Ortega and his collections, a partnership was formed, and students spent the rest of the year helping to set up the museum, which is open for tours today. Inspired, Metro staff set to work creating something similar on their campus, with music therapist and now administrator Rebecca McClary acting as curator, and opening just in time for their 2016 centennial.

The museums are both situated in quaint 1920s cottages that were originally built as housing for high-level staff (neither hospital still houses any staff on campus). They showcase art, craft, and practical creations made by patients as part of their occupational and recreational therapy, such as wicker furniture and shoes, as well as industrial cooking equipment designed to feed thousands of residents a day. Both also display a bathtub draped with a heavy canvas that was used for hydrotherapy, a treatment in which patients were

A hydrotherapy tub is one of several displays on treatments that have long since been phased out.

subjected to sometimes extreme temperatures, discontinued by the 1960s in favor of then-new antipsychotic medications.

At Patton, an unexpected exhibit features a mysterious stash of vintage mail to and from patients in multiple languages that was found in an attic, stuffed into old sugar bags and sewn shut. A more sobering artifact is a headstone inscribed only with an ID number from the on-site graveyard, where more than two thousand individuals were interred from 1893 to 1933. Unique pieces at Metro include a pen-activated alarm system from the mid-'80s, in use until newer technology was implemented in 2013, and a former bedpan cleaning vault from the 1950s that has been repurposed as a time capsule and installed within a defunct fireplace.

Though patient identities are strictly confidential, there is one notable exception on view: the great actor of *Dracula* fame, Bela Lugosi. After being prescribed morphine and later methadone and Demerol for sciatica resulting from an injury in World War I, Lugosi voluntarily committed himself at Metro in 1955 (when self-referral was still an option), and was one of the first public figures to openly undergo rehabilitation for an opioid addiction. A display includes press photos from his stint at the hospital, as well as one of the letters he received there from an anonymous admirer signed, "With a Dash of Hope." He would track down the sender, Hope Lininger, and marry her within weeks of taking a leave of absence from the hospital, though he passed away just a year later.

The histories of these hospitals are as fascinating as sometimes troubling, and to their credit, museum staff don't shy away from portraying the shocking conditions and cruel practices once employed in the name of therapy, including involuntary sterilization and transorbital lobotomies that involved pushing an icepick-like instrument deep into a patient's eye socket (the one at Patton was used on more than 200 patients). But they also seek to show how far today's trauma-informed treatments have come. These twin museums offer a chance to more deeply reflect on the role these institutions play, and to show appreciation for those who have found their calling in this difficult yet critical work.

Industrial-scale baking equipment to feed thousands. The apron hanging from the rack was made by a patient from mattress fabric as part of a work therapy program.

Westminster Historical Museum
Westminster

The historical museum of the city of Westminster in northern Orange County is situated in the two-acre Blakey Historical Park—named for Leaora Blakey, donor of the property to the city and early resident, who arrived via covered wagon in 1894 at age three. The town had been established by a Presbyterian minister as a temperance colony in 1870, in response to the wine-fueled German "Mother Colony" of Anaheim. For decades, the area was primarily rural and agriculture-oriented, producing sugar beets and lima beans like so much of present day Orange County, until the postwar population boom filled in all that open space with houses, churches, and malls.

Most of the structures in the park were moved here in the late 1980s under the direction of chief volunteer and former mayor Joy Neugebauer. These include a windmill and blacksmith shop, and the Warne family farmhouse from 1915 furnished with period antiques, as well as the Warne barn, now occupied by classic old fire trucks and equipment. There is the city's first drug store within the 1874 McCoy-Hare house, filled with rows of old-time elixirs, along with a massive scrapbook of historic pharmacy receipts, likely on display since before HIPAA medical privacy laws came into play in the 1990s. Most recently, the dedicated and historically minded volunteers arranged for the relocation of a massive yellow plow to the front lawn. Built in 1937 and billed as the world's largest, the plow required multiple tractors to pull it, and was used locally to restore farmland in the event of flooding.

The main museum building on the campus is a large hall with a bow truss ceiling, hardwood floors, and an inviting stage. Built in 1929 as the Midway City Women's Club, it held USO shows to entertain troops during World War II, and was eventually donated and moved to its current site. The main exhibits are typical of small historical society timeline displays, starting with a wanting interpretation of pre-contact Native American society, moving into missions and ranchos, the arrival of the Americanos and the formation of Westminster colony, and on to early- to mid-twentieth century daily life. There are a few outlying collections, including charming cloth dolls from a teacher for whom the local elementary school was named, a glass case featuring dozens of miniature metal pencil sharpeners, and a long, multi-level platform with a variety of household devices in various states of obsolescence. An unassuming round table on view is the one from the kitchen of resident Lillian Bersuch, where the City of Westminster's incorporation papers were signed in 1957.

The 1976 Shutter Shak in all its programmatic glory.

Though only open three hours per month, the museum's most conspicuous delight is actually visible day or night from the public sidewalk and busy boulevard: the 1976 Shutter Shak, a drive-thru photo booth in the shape of a classic camera. The Shak is an example of a unique form of architecture, sometimes called "mimetic," since the form mimics the commercial product or purpose, though the term "programmatic" seems to have won out. Gargantuan oil cans and ice cream cones were once plentiful along Southern California roadsides, with this trend reaching its peak with the rise of car culture in the 1920s and '30s. Examples of programmatic architecture are now few and far between, but they have undergone a popular resurgence in the Instagram era; high profile survivors include the meticulously restored hot dog-shaped Tail O' the Pup in West Hollywood and the Donut Hole in La Puente, where drivers cruise right through the hole itself.

Getting up close, one can better appreciate the Shutter Shak's details, such as the row of small clerestory windows lined with photos and made to look like negatives on a roll, and a metal mailbox on the door fashioned to resemble a plastic film roll being unspooled. Inside is a dusty assortment of vintage cameras, along with an arrangement of indiscernible trophies. The original proprietor of the Shak, Michael Bel Monte, told the *Los Angeles Times* in 1987 that the city resisted the cartoonish design for the structure that was drawn up by his wife Susan, and when no builders would take the project on, he personally spent four months constructing it. Though the shutter has long since closed on this eccentric small business, its relocation to this historical park meant that the architectural curiosity itself would not face demolition, as so many booths of its kind did with the inception of digital photography.

This section of Orange County has in recent decades become a major enclave of the Vietnamese diaspora, and there is a modest exhibit of relevant cultural traditions in the museum, with a few of the official signs designating part of the city (and neighboring Garden Grove) as Little Saigon. For a complementary exploration, there is the nearby Vietnamese Heritage Museum, which opened in 2023 with the acquisition of an exceedingly rare *sampan* river boat used by refugee Boat People, as well as the Museum of the Republic of Vietnam (see page 189). The Westminster Museum is all but frozen on the cusp of modern developments which have brought much change to the region, and it's exactly this time capsule effect, taken together with the surrounding diversity that one experiences even by simply driving here, that makes it so uniquely captivating and worthwhile.

Pharmaceutical and mending supplies displayed inside the McCoy-Hare house, the city's first drugstore.

Overleaf: Historical society members on stage in the main museum building, formerly the 1929 Midway City Women's Club. From left: Diane Tollefson, Don Anderson, President Harry Paul, Leo Lefebvre, Stephen Iverson, Nick Popadiuk.

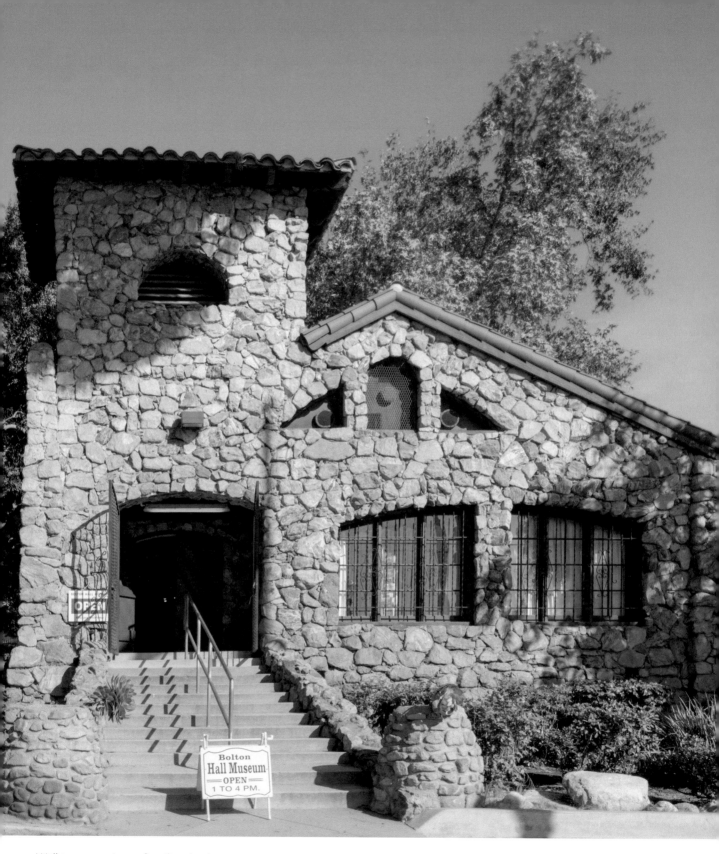

Well over a century after the utopian experiment, the hall continues to serve as a community gathering place.

Bolton Hall Museum, Little Landers Historical Society
Tujunga

The historic Bolton Hall, a stone structure in the idyllic foothill community of Tujunga, is a hall named after a man whose name was Bolton Hall. The real life Bolton Hall was an Irish immigrant who became an influential back-to-the-land reformer and founder of the still-active Free Acres colony in New Jersey. He was also the friend and hero of idealistic publicist William E. Smythe, who helped organize a few similarly cooperative colonies throughout California (San Ysidro, near Tijuana, was the first). When agriculturalist land developer Marshall Hartranft (who would later publish a book entitled *Grapes of Gladness,* in response to the Steinbeck classic) went about subdividing this section of the Crescenta Valley, he tapped Smythe to help sell it as the site of a new self-sufficient community, *Los Terrenitos.* This translates to "the little lands," and residents would be known as the Little Landers.

In 1913, Smythe launched his campaign for this new agrarian, utopian community by promising an easy paradise via promotional literature: "all will be sure of a comfortable living in the midst of ideal surroundings and the best of society." Prospective Little Landers would purchase plots one acre or smaller on which to live and farm, with a quote from Bolton Hall as their mantra: "A little land and a living, SURELY, is better than desperate struggle and wealth, POSSIBLY." Two critical details were acutely oversold with a marketing pitch that would likely intrigue a sizable group even today: the area's available soil ("sweet and kindly") and its water ("unlimited").

In short order, construction began on Bolton Hall, the cooperative's all-purpose public building, by fashioning the abundant stones into a Spanish-style structure with Craftsman-inspired details. It was designed and built (with the help of some young Eastern European stoneworkers) by George Harris, who had given up a successful career in advertising to become a self-taught "Nature Builder," cobbling home and garden furniture and eventually fireplaces, fountains, and actual homes out of found tree branches and fieldstones. In the construction of Bolton Hall, Harris purportedly rolled each stone downhill, so it could be set in the building in the exact position in which it naturally came to rest.

The clubhouse quickly became the heart of the nascent community, hosting town meetings, church gatherings, and Saturday evening dances, at which the musicians would sometimes play under moonlight. Sadly, the original vision of an independent lifestyle didn't last, as the rocky ground proved too difficult to plow, and the promised water was not forthcoming. Bolton Hall would be converted into an American Legion, and when the City of Tujunga incorporated in 1925, it was the natural site for the city hall, jail, and health department, among other civic services.

The main exhibit and event space, with resident Mabel Hatch's trunk and the colony's hand-crafted manifesto.

Within a few more years, the new city needed to secure more reliable water and power, and was divided as to whether giving up its independence and being annexed by the City of Los Angeles would provide it. The first three votes on the proposed annexation failed, and it wasn't until 1932, when allegedly every vacant house and lot was mysteriously filled up with new arrivals, that annexation finally passed. It's said that all those newcomers quickly abandoned their properties in the area after the deal was done, and while it's still a source of intrigue and debate, it fortunately no longer pits neighbors ruthlessly against one another as it did at the time.

As part of the City of Los Angeles, the hall spent a few decades as an outpost for the building and safety and health departments, but was boarded up when a new municipal building was put up nearby in 1957. As early as 1959, Little Landers Historical Society members had begun collecting artifacts and records in their homes in anticipation of bringing this space back to life. Despite being honored as Los Angeles Historic-Cultural Monument Number 2 (the first being the Leonis Adobe in Calabasas, which was declared at the same inaugural Cultural Heritage meeting in 1962), Bolton Hall sat empty and facing

the threat of demolition until 1980, when the long-standing vision of saving the hall and converting it to a museum finally came to pass. The historical society's vision has been markedly more successful than the original utopian project, as its dedicated members have been disseminating local history quite a few years longer than the building served in any of its previous capacities.

Alongside changing exhibits featuring nearby landmarks, historic businesses, and the work of local artists, are long-term displays such as a weathered trunk from Mabel Hatch, an original *Terrenita* who would operate her own insurance business and single-handedly look after the area's cemetery for some thirty years. Then there is a remarkable hammered-copper manifesto written by Smythe, along with rustic furniture and fixtures, all constructed by self-appointed Nature Builder, George Harris. Another sign hanging prominently above the fireplace proclaims a more recent yet no less evocative tagline for the Sunland-Tujunga area: *Showplace of the Chaparral*. And though a bit more subtle in appearance, the original Little Landers colony did leave a permanent imprint carved into the underside of the fireplace mantel: *To the Spiritual Life of the Soil*. This can be read in retrospect as both a dedication and as a deferred dream, but thankfully one that's still being cultivated by the Little Landers of today.

The original inscription on the fireplace mantel

A sculptural Seabee greets visitors outside the museum.
The mascot's official appearance has never been codified.

U.S. Navy Seabee Museum
Port Hueneme

Port Hueneme is a small coastal town in Ventura County, with an active deepwater port that is known for its role in importing more than three billion bananas each year. (The vast majority of its business is in importing vehicles, but bananas were apparently deemed a more lively theme around which to organize an annual family festival). The area is also known for its strong military presence, as the Navy controls a majority of the land within city limits, and is the largest employer throughout the entire county. Officially, the base here is called the Naval Construction Battalion Center, but it's better known as the home of the Seabees, a nickname derived from their designation as Construction Battalions (CBs). It's a relatively niche force under the Navy umbrella, but one that has carried out a diverse range of building and support projects around the world over the last eighty-plus years. They've also been preserving and exhibiting their own history for almost as long, having established an on-base museum promptly upon return from their maiden missions. That makes the U.S. Navy Seabee Museum the second oldest of ten official museums operated across the country by the Naval History and Heritage Command, though you wouldn't know it from visiting the sleek facility it occupies today.

The need for the Navy to develop its own construction and engineering department arose during World War II. After the attack on Pearl Harbor, it became clear that having civilian contractors building things like bridges and roads and runways in battle zones was problematic, as they were forbidden from defending themselves lest they be taken for guerrillas. The new militarized construction force known as the Seabees were often on the front lines of the war, island hopping and building to make way for more combative military units. About 325,000 Seabees were conscripted during World War II, with the vast majority of them shipping out to the Pacific theater via Port Hueneme. At the end of the war, they brought back a plethora of souvenirs and spoils, with many opting to abandon them at the base rather than complete the government paperwork that would clear them to take everything home. This incidental archive was soon put on display, with the Seabee Museum opening on October 27 (Navy Day), 1947.

After a decade in its original building, now the Beehive Gymnasium, the museum moved into a pair of Quonset huts (a signature Seabee edifice) that were roomier and closer to the main entrance gate. By 2000, the space was badly in need of renovations, and a major rehab plan was ready to begin when 9/11 triggered new security measures that meant it would no longer be practical to authorize visitors to come on base. They pivoted, moved back the fence line, and broke ground on a purpose-built museum which opened in 2011, still on federal property but just outside the new gate and accessible to all.

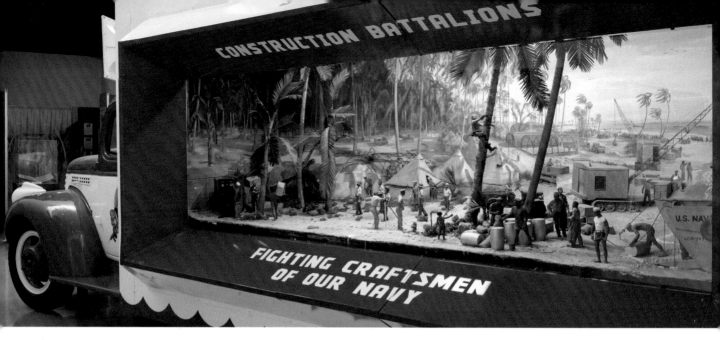

The 1943 diorama apparently served as a compelling recruitment tool.

Past the check-in desk in the soaring central foyer, parked under a giant glowing movie theater marquee, is a reproduction of a 1943 Seabee recruitment truck, built around an original diorama of a tropical island scene with miniature men performing jobs the future Seabees might be tasked with after enlisting. This mobile unit made for a compelling advertisement, and was promptly donated to the museum after the war. The diorama makes an appearance in the 1977 in-house promotional film, *Home for the Seabees,* hosted by John Wayne in what was likely his final (if not his finest) acting role—he also starred in *The Fighting Seabees* war film more than thirty years prior. Backed by groovy upbeat music, *Home for the Seabees* features a glimpse of the museum in its Quonset hut digs, cut with clips of new recruits trading in their bell bottoms and looking rather sullen while their long hair is buzzed off.

There is no official design of the Seabee, unlike more formalized military heraldry, so it remains open to artistic interpretation. The most common depiction of the Seabee mascot is of a mid-flight bumblebee with sailor cap, bellicose facial expression, and three pairs of anthropomorphized and uniformed arms holding hammers, wrenches, and a Tommy gun. Disney artists were responsible for some of the early insignia, part of the studio's broader campaign that resulted in some 1,200 World War II-era designs for military units. The Seabee mascot also lends itself well to folk art realizations, whether in battalion plaques or sundry tchotchkes, all of which are heavily represented in the museum collections. A stroll through the galleries is loosely chronological, beginning with their origins in World War II, including a battered chunk of the U.S.S. *Arizona* that was attacked at Pearl Harbor—Seabees help maintain the memorial there today. If there is one thing the museum hopes to convey about the Seabees it is their "Can Do" spirit, and this motto features prominently throughout the space.

Items that may interest even a conflict-averse outsider include trench art made from artillery shell casings, giant earth-moving equipment, paintings (including a triptych from a chapel on a Hawaiian base by famed Art Deco

muralist and designer, Hildreth Meière), and the tiara and throne from the last "Seabee Queen" in 1992. There are large-scale recreations of projects such as the SEAhuts (Southeast Asian huts) erected hastily as barracks in Vietnam, complete with pin-up girl posters, or a timber observation tower like those built in Iraq and Afghanistan. A Polar section explores work in the Antarctic in support of the National Science Foundation; the control panel console from the PM-3 nuclear power plant Seabees built at McMurdo Station in 1962 sits alongside a few stuffed penguins; there is also the top section of a geodesic dome from a facility at Amundsen-Scott South Pole Station. The Underwater Construction Teams are represented by NEMO, a deep-diving vehicle with an acrylic bubble-shaped observation pod. Towards the exit is a play area offering STEM and building activities for kids. Future plans include expanded outreach and education programs, and building out exhibitions according to a master plan that is presently only partially realized.

Seabees' numbers have historically been quickly bolstered during wartime. There are roughly 14,000 active Seabees across the country today; their other major base, at Gulfport, Mississippi, houses a museum annex. Historian and longtime museum professional Dr. Lara Godbille studied the social impact of civil engineering projects in the American West before becoming Director of the Seabee Museum in 2003. She has since overseen the design and construction of the new museum building and exhibitions, as well as the cataloging of their 13,000 artifacts and declassification of archival research materials, which take up two miles of shelving. Godbille says that much of what Seabees do today is not public information, but we can be sure they're not solely putting up prefabricated buildings wherever their superiors point and say build, or being called to provide disaster relief and humanitarian aid on account of their ability to get anywhere in the world within forty-eight hours. Of course, the mandate of this official military museum is to support an uncomplicated sense of patriotism and celebrate these hard-working servicepersons' contributions to the national defense. Any Seabee would be sure to agree that their mission has been accomplished.

The new building opened in 2011— outside the base's front gate, to avoid strict security measures.

Noah Songer
her to separa
widow's silk.

Above, Nan prepares to wind the precious silk to the wire frame spools.

Left, three "ladies" spinning their silk are held on a piece of Yucca stalk. The yucca plant was used to hold the spiders as Nan worked the silk.

Mousley Museum of Yucaipa History
Yucaipa

There are more than one hundred community historical societies spread across the greater LA area, with this being a uniquely rich and highly underappreciated aspect of the museum-scape, broadly speaking. To the most intrepid and curious of museumgoers, the promise of unexpected delights handily outweighs any perceived risk of wasting time by driving as much as two hours to destinations for which the contents (and sometimes, the open hours) are completely unknown. On occasion, the things one may encounter are so profoundly fascinating that visitors can come away feeling their life is somehow richer for having learned about them. One case in point is the story of local hero Nan Songer, the so-called "Spider Lady of Yucaipa," whose legacy is preserved for all who make a point to visit the Mousley Museum of Yucaipa History.

During World War II, Nan Songer developed in her Inland Empire home what may have been the world's only "spidery," a one-woman arachnid factory that could provide spider silk on demand in specified width, strength, and elasticity—putting as many as ten thousand black widows and banded garden spiders to work at a time. This product was of particular interest to the US military, as it proved to be an ideal material with which to make the crosshairs in bomb sights and other high powered optical devices, far surpassing the performance of hair, for example, since spider silk is orders of magnitude finer and is not prone to sagging or breaking under extreme temperature or humidity conditions. (It has since been superseded by synthetic materials). Songer's method of "silking" the spiders involved gently pinning them against a section of Yucca plant stalk and "tickling" them with a camel hair brush until she was able to draw a strand of silk from their spinnerets, winding it around a custom U-shaped frame which could be easily packed for transport.

In an article entitled "Spiders for Profit," published in 1955 in *Natural History,* the magazine of the American Museum of Natural History, Songer explained that only "healthy and contented" spiders could be relied upon to produce webbing of the required quality and consistency. Later in the article, she notes that male spiders are of no use, stating pointedly that "spiderdom is apparently one province in the animal kingdom where the ladies excel in almost everything." As of this writing, Nan's story is the subject of a forthcoming children's book, and it's no wonder that this fascinating figure would be an inspiration to contemporary feminists as well as budding arachnologists. But to get a personal feel for the context of Songer's work and see some of her original implements, including an unusual set of eyeglasses with the lenses replaced by hollow tubes of Yucca stalk—to aid her vision while doing the precise work of separating silk threads—a visit to the museum is a must.

Nan Songer, Yucaipa's Spider Lady, at work harvesting silk wearing her custom yucca stalk specs.

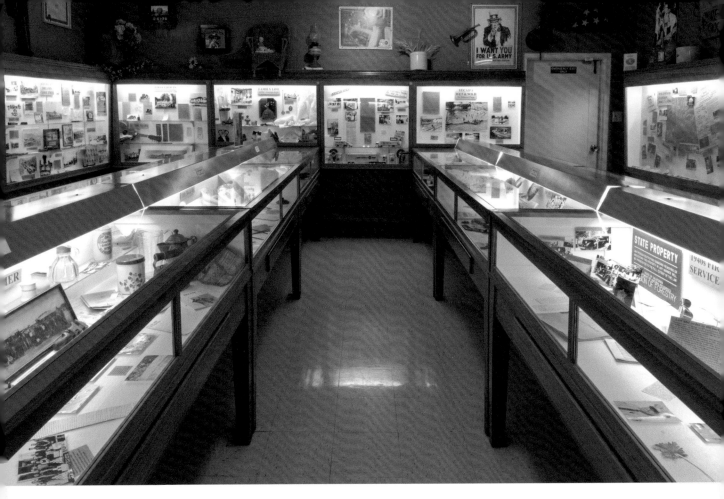

*Once filled with seashells, gems, and minerals, the rows of display cases
are now stocked with countless artifacts relating to the local history.*

This is but one of many stories on view in this capacious space, where long
rows of illuminated cases document various local industries and aspects of daily
life and community development. Large gold cut-out letters spell out thematic
sections like "FAMILY LIFE" (with domestic goods and implements), "HERITAGE
ROOM" (with genealogical resources), and "GOLD" (mining). Some of the more
colorful displays relate to things like the proliferation of mobile home parks,
square dance clubs, and the area's Prohibition-era moonshine industry, which
casually mentions that homemade applejack liquor can still be acquired in the
nearby orchard town of Oak Glen. Another exhibit features some teapot lids
found at the site of a short-lived Communist children's camp from the late 1920s.

Guided tours of the museum begin with a section on the Serrano Indian
village site of Yu'kaipa't (possibly translated as "the place in the wetlands"), which
gives modern Yucaipa its name. They cover traditional games and customs,
contemporary efforts by the Morongo and San Manuel Bands of Mission Indians
towards language preservation, and artifacts including shells from the coast as
well as pottery from present-day Arizona that help interpret this as a site of trade
amongst diverse tribes. For a deeper dive, visitors can head to the nearby Malki
Museum on the Morongo Reservation in Banning—possibly the first museum in

California established and run by Native Americans—preferably during their Fall Gathering when one can hear Cahuilla bird singers and learn how to leach and grind acorns, a critical traditional food source.

As for the Mousley Museum's name and the building itself, that's an interesting story as well. Real estate broker, amateur archaeologist, obsessive conchologist, and world explorer Louis B. Mousley originally built it next door to his house, calling it the Mousley Museum of Natural History. For decades it housed tens of thousands of objects collected on his travels, including his gems and minerals as well as one of the nation's largest collections of seashells. The museum became an outpost of the San Bernardino County Museum upon completion in 1970 (bequeathed as a result of his mounting debt from the construction) and remained in its original form well past Mousley's death in 1981. Today, very little of his original vision remains, with the bulk of the collection reclaimed by the County and loaned out to universities for research purposes. The historical society officially got the keys in 2005, and although it would be fascinating to see a five-thousand-square foot room full of shells, one can appreciate that it was ready for a more locally relevant focus. Thus far, they've done an admirable job collecting and showcasing gems again, this time sourced from the immediate vicinity.

Historical society members, standing from left: Steven Maurer, Joanie James, Robert Will.

Seated: Kandie Cansler and Lenore Will.

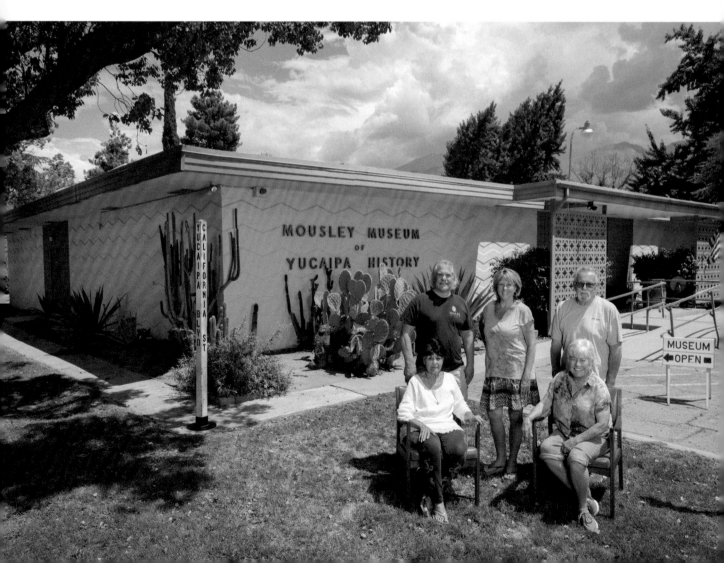

The first and last tires ever produced at Firestone's South Gate plant, with
the Evolution of Writing *mosaic by WPA artist Stanton MacDonald-Wright.*

South Gate Civic Center Museum
South Gate

Housed in a sprawling Colonial-style municipal complex, the South Gate Civic Center Museum is a repository of history and art that forms a dynamic portrait of the city, thanks to the range of stories collected over the years, combined with a recent changing of the guard. Built in the 1930s as a library by the Federal Works Progress Administration (WPA), this structure served in that role until a larger facility was constructed in 1973, and it became the museum in 1980. Several original features remain: at the museum entrance, visitors are greeted by a colorful 1938 mosaic titled "Evolution of Writing" by renowned WPA artist Stanton MacDonald-Wright, made using his invented "petrachrome" process, which set crushed rock or glass in tinted concrete. Inside, more WPA art adorns the space in the form of tempera murals by Suzanne Miller, which depict scenes from the history of papermaking and printing, including Chinese block printing, Egyptian papyrus, and a twentieth-century print shop. But the shelves that once held the library's books are now loaded with different kinds of stories, and all of them are specific to South Gate.

Local industry is represented by the biggest and most significant game in town, Firestone Tire and Rubber Company, which just down the road built its first production plant outside of Akron. Visitors will see the first tire ever which rolled off the line in 1928, labeled with gold paint as a "Gum-Dipped Balloon"; it's the same one featured in a publicity photo with founder Harvey Firestone himself overseeing production. Alongside that is the plant's last-ever passenger tire from February 13, 1980, like a pair of rubber bookends representing the countless jobs and lives that played out in between. Once a campus of nearly a million square feet, only Firestone's grand Art Deco administration building still stands, and even that is in a state of limbo as of this writing while the LA Community College District considers its fate.

A more optimistic local business tale is that of the nearly century-old clothiers, Greenspan's, internationally known purveyors of "original" styles favored by retro-minded pachucos and West Coast hip hop stars alike. With exclusive arrangements with Pendleton (they sell more than the factory store itself) and an unrivaled collection of deadstock Zoot Suits, they managed to survive the rolling changes in taste that would eventually bring these pieces back into fashion and cement their museum-worthy legacy.

Like so many American towns, South Gate's signature annual festival provides a sense of identity and a themed celebration they can claim as their own; the Azalea Festival is prominently featured in the museum through photos, banners, trophies, and timelines. Established in 1965 by area boosters, it may sound like any other hometown pride event, but is in fact somewhat unique. For one, azaleas have no significant agricultural, natural, or historical relevance locally, and the plant

seems to have been chosen somewhat on a whim. But much more importantly, whereas the roles of festival queens and their courts are most often bestowed on the community's youth, the crown of the Azalea Queen is awarded each year to a community member over sixty who has put in decades of voluntary service towards bettering the city. Take the 2019 Azalea Queen, Susan Felsenthal Janer, who is active in the South Gate Women's Club, is a past president of the Art Association, and a volunteer poll worker. Janer recognizes that South Gate is special for honoring its elders and says that this is important for the prosperity of any community.

Despite the museum's galleries overflowing with artifacts, new historic items were acquired in January 2023, when a time capsule buried at the city's fiftieth anniversary in 1973 was opened as part of a centennial event at the adjacent city hall. There is a quaint letter to future residents from then Mayor Frank Gafkowski Jr. stating his belief that by 2023, after our nation's "test of its resolve" (a possible reference to the Vietnam War), we will have emerged a more "mature" nation, bringing peace to the world and enjoying new technological solutions to problems like pollution, land use, and transportation. Also recovered were promotional materials from the 1973 celebration, along with a tie featuring knights with shields and spears from a long-gone men's clothing store, a 7-inch record from the high school's spirit squad, and a photo of one-year-old J.J. Henville sitting on the capsule, along with a letter from his dad sharing his desire that J.J. would make it back for the unveiling exactly half a century later. (He did.)

Susan Felsenthal Janer, 2019 Azalea Queen.

While too often the history displayed at small historical society museums overlooks recent decades and skews heavily (if not exclusively) white, the most exciting changes at this institution are the ways it's adapting for the future to make itself more relevant to the community it serves today, which is more than ninety percent Hispanic. Since the appointment of artist and designer Jennifer Mejia as the city's cultural arts coordinator (a post that includes museum oversight), they've injected life into their online presence, expanded programmatic activities, and launched new promotional efforts. Organizing and diversifying the museum exhibits has been slow and steady, but they've leaned into the need for representation by mounting group shows incorporating dozens of local artists in the attached gallery space. Though the old tires and tiaras will hopefully always have a place here, we can be glad that more recent chapters and diverse voices will also get the pedestal treatment and be preserved, for the benefit of South Gate in 2073 and beyond.

Museum volunteer Linda Parsonson (seated) with staff, from left: Blanca Carla Arriaga, Jennifer Mejia, Elizabeth Uribe.

Museum of the Republic of Vietnam (RVN)
Westminster

The city of Westminster is the unofficial Vietnamese Capital of America; according to the 2010 census, forty percent of residents are of Vietnamese heritage. The largest enclave outside of Vietnam resides in this section of Orange County, better known as Little Saigon, which also includes part of neighboring Garden Grove. In Vietnamese diasporic communities such as this, it is not unusual to see the solid yellow flag with three red stripes that was originally created in 1948 to represent the Republic of Vietnam (RVN, or South Vietnam more popularly), and which has since been reclaimed as the Vietnamese Heritage and Freedom Flag. It's also not uncommon to have a museum reflecting an area's predominant cultural heritage and identity, in this case on the upper level of a strip mall on a major thoroughfare, next to a karaoke bar and above a nail salon supply store. What's more unique is a museum dedicated to the armed forces of a nation other than that in which it resides, let alone for one that has long since ceased to exist. Yet here, for good reason, is the Museum of the Republic of Vietnam, which fought under that yellow banner half a century ago.

The Museum of the RVN opened in 2016 on a significant date. April 30th is a public holiday in Vietnam—"Reunification Day"—but is commemorated within the diaspora as Black April, as this is the date of the Fall of Saigon in 1975, which marked the official end of South Vietnam as a recognized, sovereign entity. Out of fifteen military museums in greater Los Angeles, the Museum of the RVN has the added distinction of being the only one focusing primarily on the Vietnam War, likely due to the fact that America did not prevail in that conflict. As such, this museum offers a singular perspective that diverges from what most people in this country have been exposed to, not just in American museums, but in our educational system and popular media at large.

Near the museum entrance, flanked by uniforms of the various RVN military branches, is a ring of imposing (even if inert) army tank ammunition canisters encircling a small table, on which sits a miniature model of a South Vietnamese "junk" boat. This was the actual architectural model used in the 1960s at the Saigon Naval Shipyard in the construction of the hundreds of ships that would become known as the Junk Force Fleet, specially designed to navigate the network of rivers in the interior landscape. On either side of the ship's bow are a pair of stylized, painted-on eyes; this common river boat feature was meant to ward off evil spirits.

The majority of the displays feature military documents, flags, insignia, battle scene dioramas, and more ship models, though they also feature objects from the "re-education" prison camps in Vietnam that were the fate of RVN veterans and sympathizers who were not able to be evacuated after the war. One particularly poignant artifact is a banjo that was made by musician and

View from the museum entrance of the model ship used in construction of the RVN's Junk Force fleet.

Museum volunteers, from left: Hong Linh Vo, Quan Nguyen, Loc Nguyen Le, Jenny Nguyen, Chris Nguyen, and June Nguyen

veteran Xuân Điềm from cast off materials, including aluminum bomb scraps for the instrument's body and wire from US aircraft for its strings. The instrument was constructed over the course of six years while Điềm was held captive, and the names of the prison camps are inscribed amidst intricate designs on the underside of the metal body. The head of the banjo features a silhouette of a mourning soldier, representing the statue called *THƯƠNG TIẾC* that stood at the South Vietnamese military cemetery until being torn down. This rendering was carefully hammered out by the same artist responsible for the original cemetery statue, Nguyễn Thanh Thu.

In this country, the Vietnam War is commonly depicted, both in mainstream documentaries and in a mountain of scholarship, as a war between the United States and Communism, but this glosses over the subtext of a civil war between ideologically opposed Vietnamese. When one does attempt to research the RVN (at least amongst sources printed in English), one quickly finds that it is often disparaged as a corrupt agent or even "puppet" of the US government. But for those who were part of it, it was

a fledgling independent state that wasn't given the needed support to hold back global Communist powers long enough to achieve stability.

Outsiders who are curious about other cultures often hold up food as the best way to expand their understanding. A visit to this museum, and a conversation with those running it, is of course deeper and more mind-expanding than any nearby bowl of phở. The Western tendency to regard South Vietnam abstractly as a geopolitical footnote is powerfully challenged by a single meeting with one of the now elderly RVN veterans, civilian survivors, or their children. For anyone interested, this space boldly serves the purpose of facilitating this important conversation, and for those it represents directly, it exists to honor the sacrifices of their family and community members who fought for their homeland and their beliefs.

It's become a Southern California adage that interesting and incredible things can often be found in strip malls.

Part 7
Nature and Cultivation

California Citrus State Historic Park
Riverside

Approaching a small building in the shape of an orange—a replica roadside fruit stand that serves as the welcome sign to the California Citrus State Historic Park—one is put in a sunny mood. No doubt that was the goal of the booster machine that set to work idealizing Southern California as an Earthly paradise more than a century ago. During the boom period of the late nineteenth and early twentieth centuries (the "Second Gold Rush"), endless acres throughout the Inland Empire and greater Los Angeles region were covered with orange groves. The rows of stately palm trees that line the road entering the park today are a practical feature from that era; they were a necessary landmark to guide the growers back home, or to the edge of their property, when they might otherwise have been disoriented by the sea of green leaves dotted with fruit.

The postwar population boom of the 1950s dethroned King Citrus, and the ensuing decades saw the groves torn out as frenetically as they had been planted to make way for housing. By the time California Citrus State Historic Park was established in 1993, this once-dominant industry had shrunk precipitously in cultural and economic influence. But the history of citrus and its impact on the development of Southern California was deemed by the state too important not to preserve and share through an experiential and surprisingly educational working farm and museum.

The most memorable aspect of a park visit is a guided tour of the varietal grove that may include a citrus tasting, pending both seasonal availability (go in winter for best results) and the current status of the Huanglongbing "citrus greening" disease, which presents an existential threat to the industry today in California (which still grows a large majority of the country's fresh citrus) as well as in Florida (which has cornered the juice market). On a good day, one can sample uncommon varieties such as the Australian finger lime, also known as the "caviar" lime for the sour little pearls that spill out when one is cut open, or the variegated Eureka lemons, noted for their striped rind and sweet pink flesh. One can also marvel at the Buddha's hand, a curious citron with crooked fingers that's all rind and no flesh. The park cultivates about 180 acres in total, and much of the fruit is sold to benefit their operations.

Beyond the more sensory experience of the groves, the visitor center provides a polished, whirlwind stroll through a global history of citrus and citriculture. Themed props and environmental displays begin with the likely origin of citrus in the Himalayas more than seven thousand years ago. They then trace the subsequent travels of citrus along Silk Road trading routes, to the earliest

Buddha's hand citrons contain no pulp or juice, but can be candied or used for zest.

greenhouses or "orangeries" of Rome (until the fall of the Roman Empire). This was followed by an expansion amongst Arab communities in the Mediterranean and the Middle East, reintroduction in Europe as a result of the Crusades, travel from Spain and Portugal to Central and South America by way of colonization, and finally the arrival of oranges in Alta California in 1769 with Junipero Serra and other Franciscan missionaries. There is a feature on Eliza Tibbets, widely recognized for cultivating the first ("parent") Washington navel (or "Bahia") orange trees in the country in the 1870s, thereby setting the region's citrus fever into motion. Some final installations, just before visitors arrive at the gift shop, document the development of irrigation canals, the completion of the transcontinental railroad that would allow for distribution to markets back East, and the harvesting of ice blocks from mountain lakes to keep the produce refrigerated on its cross-country journey.

Finding that this timeline lacked representation of communities who were affected by the industry locally, the park began a partnership in 2016 with UC Riverside's Public History program, launching the Relevancy and History Project, which produces community festivals and conducts oral

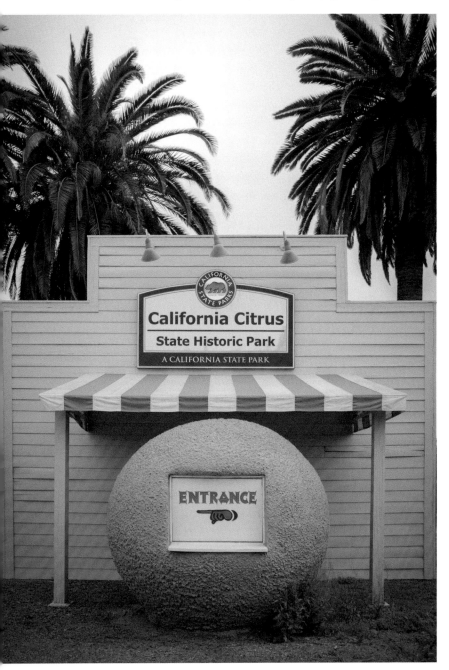

A welcome sign, made to resemble an old roadside fruit stand.

histories and original research. A fresh exhibit was installed nearest the entrance, highlighting histories of labor, such as African American growers and the role of women in packing plants; immigration, like the Bracero program that brought a massive workforce from Mexico to work the groves from 1942 to 1964; and cultural connections to citrus from around the world, including stories of orange blossom festivals recalled by Afghan refugees. In addition to their commitment to the cultural and historical relevance of citrus, UC Riverside also promotes scientific advancements through their Citrus Research Center and Agricultural Experiment Station (CRC-AES); as a matter of fact, UC Riverside itself was originally founded in 1907 as simply the Citrus Experiment Station, then an outpost of UC Berkeley.

The tasting of sweet and sour fruit requires no nuanced interpretation, but the park does have a large-scale expansion plan that will result in the construction of a packing house demonstrating the sorting and packing process, an event space made to resemble a grower's residence, and a bunkhouse highlighting the communities of workers who would have made such a massive operation possible. Together, these developments will help tell a more inclusive and dynamic story of citrus in Southern California and show—as the Relevancy and History Project puts it—just how juicy the past can be.

An exhibit on the harvesting of ice to keep the product cool in transit.

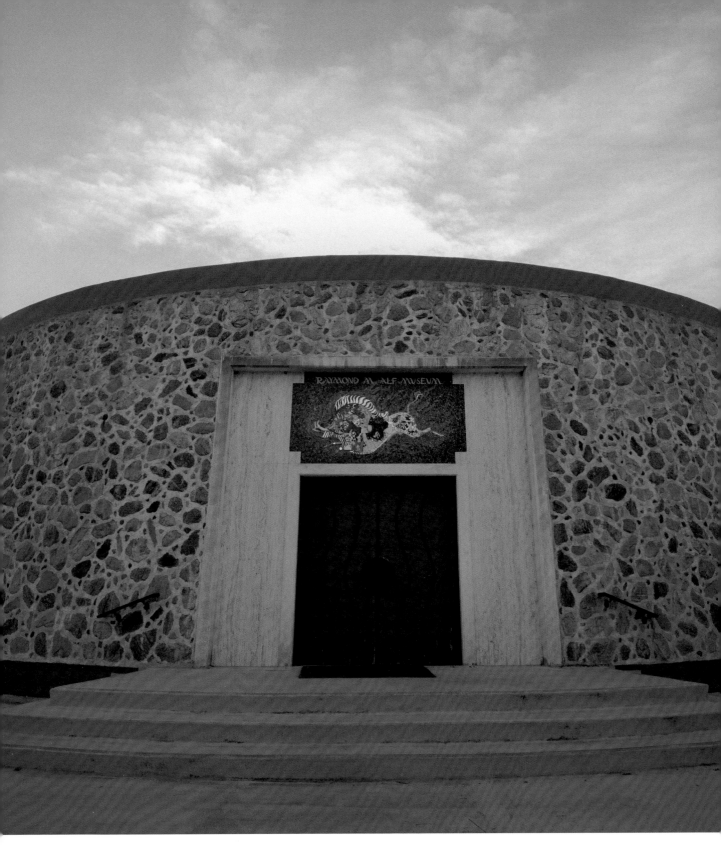

Millard Sheets designed the museum as a circular structure with a fieldstone façade. His signature mosaic is of the peccary that also serves as a logo for the Webb Schools.

Raymond M. Alf Museum of Paleontology
Claremont

Many people might not think of a high school as a likely place for a museum of significance and intrigue that reaches well beyond its alumni network, but those people are simply not aware of the Webb Schools, a century-old private boarding school occupying 150 acres in the Claremont foothills. Their Raymond M. Alf Museum of Paleontology is the nation's only accredited museum on a high school campus, a fact which only hints at what makes it so unique. Ray Alf was a respectable paleontologist, but he was by all accounts a world-class educator, who could pose a simple question to students and leave them thinking about it decades later. An example often recalled by Webb alumni is the challenge to consider the impact they might have in their brief lifetime against the backdrop of the geologic record and the evolution of life on Earth across millions of years: "What are you going to do with your moment of time?"

Alf was born in China in 1905; his parents were Swedish American missionaries, but the 1911 Chinese Revolution forced them to return to the US and settle in North Dakota. He was a star track athlete and had won some regional races (barefoot no less) before going on to greater success in college and then at the Denver Athletic Club. In 1929, he was invited to move west to join the Los Angeles Athletic Club's team that was training for, and preparing to help host, the 1932 Olympics. Desperate for work upon arrival, he accepted a tutoring gig at the then relatively new Webb boarding school in Claremont, where he would soon meet his wife, and end up living and working on campus for his remaining seventy years. He was initially charged with teaching biology, but his casual interest in paleontology became progressively more feverish. In 1936, he declared his desire to establish a natural history museum on campus with his budding collections, mere months before a life-altering discovery.

In November 1936, Alf took a few of the boys (yes, it was an all-boys school until 1981) out on what was quickly becoming a tradition: a desert fossil hunt, this time near Barstow. Bill Webb, a student and son of the school's founder, went exploring and slid down a rockface, tearing his jeans on what they discovered was a tooth-filled jawbone. They were able to excavate the whole skull and bring it back, only to learn upon consultation with respected Caltech paleontologist Chester Stock that it was from a species of peccary (a pig-like animal) that was unknown to Western science. In their euphoria over the revelation, these fossil-hunting excursions were rechristened "Peccary Trips," and would become a permanent core curriculum for the school. Participating students established the Peccary Society (a young Art Clokey, future creator of Gumby, was a founding member) and by 1939 they had even begun to develop a satirical theme song set to the tune of "A Bird in a Gilded

The student-discovered peccary skull that started it all.

Cage": *We're peccary men out looking for bones / In the wilds of this wild country / We'll find them and then we'll return again / To the little museum on the hill...*

For some thirty years, the "museum" was housed in Alf's classroom on the bottom level of the library building, overflowing every available storage area. After decades of dreaming and scheming, noted Claremont artist Millard Sheets (father of two Webb alumni and a school board member) donated his services to design a new museum building, which opened in 1968. Sheets's circular building was inspired by Alf's spiral model of geological time, still on display near the entrance (with merely the dust on its tip representing all of documented human history). The exterior façade is appropriately composed of local foothill stones, sometimes referred to as "Claremont potatoes." A signature Sheets mosaic above the main entrance depicts an artistically rendered peccary (which has since become the de facto mascot for the school), seemingly engulfed in fire, which Alf claimed represented "the flames of enthusiasm."

Exhibits have been updated a few times over the years, and have recently been overhauled to hearken back to Alf's original vision: the upper floor is the Hall of Life, showing the 4.6 billion year history of Earth, the Peccary Society's recent discoveries, and life forms from the Precambrian, Paleozoic, Mesozoic, and Cenozoic eras. The lower level is the Hall of Footprints, dedicated to a remarkable collection of fossilized tracks and trackways, one of the largest and most significant of its kind at any institution. On one Peccary Trip in 1960, a set of fossilized impressions was discovered that was determined to be the first and only tracks of the extinct "bear-dog" ever found in North America. Another prized piece is a giant slab of Coconino Sandstone collected from Seligman, Arizona over Easter in 1961 and covered with 275 million-year-old tracks of reptile-like animals. Alf named it "Footprints on the Sands of Time," and it was so massive that it had to be set in place by crane before the museum's roof was completed.

The fossil preparation lab is viewable through a window in the lower galleries, and it's not unusual for visitors to find students hard at work. All

students still go on a Peccary Trip as part of their ninth grade paleontology unit in evolutionary biology, and in upper grades there are numerous opportunities to get more deeply involved in trips, research, and volunteering, with nearly a quarter of the approximately four-hundred-member student body participating. The staff who have followed in Alf's own footprints offer a comprehensive paleontology course that culminates with students conducting professional research projects, co-authoring academic papers in collaboration with instructors, and even presenting at conferences nationwide, all before they can legally vote.

Over his long tenure, Alf led around 250 weekend and summer Peccary Trips throughout the Western US in search of fossils, or "documents of life." He died in 1999, after cementing his legacy not only with the establishment of the museum, but also in the form of numerous former students who have gone on to distinguished paleontology careers. A picture of Alf wearing a tie and hanging from a pipe in the classroom like a chimpanzee (demonstrating the utility of the opposable thumb adaptation, naturally) sums up his character. And a small black rock from South Africa that contains some of the world's oldest known fossils, which Alf kept under his pillow, suggests the limitless sense of wonder that he passed on to so many. Today, the museum that bears his name stands as a globally significant contribution to the field, as well as a testament to the pride of accomplishment that our society's greatest teachers can help facilitate and inspire.

Museum director Andrew Farke, PhD (center) with student Peccary Society participants Aidan Helgeson and Yvonne Kan.

Jurupa Mountains Discovery Center
Jurupa Valley

Those who have driven Highway 60 east from Los Angeles will have noticed the twenty-foot-tall Columbian mammoth perched atop a hill, surveying traffic and the wider valley just west of Riverside. Built in 2003 and more recently named Eddie, this mammoth—don't call him a woolly mammoth, and definitely not an elephant—has become a landmark in its own right, and even made it into the official city seal of Jurupa Valley when it became California's newest municipality in 2011. Eddie's primary purpose, however, is to signal to drivers that they should exit the freeway and check out the eighty-two-acre Jurupa Mountains Discovery Center (JMDC).

Originally called the Jurupa Mountains Cultural Center, the JMDC was founded in 1964 by enthusiastic collectors and rockhounds Ruth and Sam Kirkby. Ruth was a paleobotanist who had an ancient arthropod named in her honor, and whose interest in geology and Earth science was reportedly sparked during her honeymoon, when a ranger at Great Smoky Mountains National Park told her the stone she had just picked up was a garnet, her birthstone. Back home in SoCal, she soon started visiting classrooms and lecturing about the nature in kids' own backyards. She and her husband eventually set to work building out the campus that's still going strong sixty years later. Along with the geologic and scientific displays, they also built and installed throughout the property a series of folk art dinosaur sculptures that have come to largely define the visitor experience, even if this part of the world was underwater during the Mesozoic Era. In 1992, Sam told the *Los Angeles Times:* "When you're making a dinosaur, it comes right from the heart because they were real," a sentiment that one can try to appreciate, even not knowing exactly what's meant by it.

Ever the educator, in 1989 Ruth engaged in a high-profile, albeit unsuccessful, battle against the US Postal Service, calling on them to stop the presses on a new stamp labeling an *Apatosaurus* with the more commonly recognizable, if technically incorrect, term *Brontosaurus.* In an earlier and more effective campaign, she was heavily involved in organizing protests against the dump adjacent to the center that has since become known as the Stringfellow Acid Pits. This toxic Superfund site is now in the midst of a five-hundred-year cleanup, after a mismanagement scandal that drew national attention and resulted in the 1983 resignation of Reagan's EPA Administrator Anne Gorsuch Burford (the mother of Trump-appointed Supreme Court Justice Neil Gorsuch).

The Kirkbys retired in 1995 and relocated to Scottsdale, Arizona for their remaining years. One of Ruth's primary successors, Mary Burns, served as JMDC director for more than a decade, and was herself an avid environmental activist, leading the local school district to become possibly the first in the nation to transition their school buses away from diesel fuel to natural gas.

Eddie, the Columbian mammoth, overlooking Jurupa Valley and highway 60 traffic.

Wes Andrée, director since 2014, had prior experience in construction and mining and as a volunteer with Boy Scouts of America and Los Angeles County Parks and Recreation's scuba diving programs. About the JMDC he noted, "When I started here we were really, *really* rustic and now we're really rustic. My goal is to get to 'quaint.'"

The old Earth sciences museum on the grounds has begun to better represent life sciences, and has been rebranded the Museum of Discoveries. Gone is the time capsule interior, with wonderfully retro graphic design and carpeted corridors lined with large vitrines set into faux wooden wall paneling. These and the drop ceilings have all been stripped to reveal a single brightly lit hall large enough to contain full-scale replica dinosaur skeletons. Most of the gems and minerals, as well as the scrimshaw collection, antique mining equipment, and even their Native American artifacts, have been swapped out for fossils of plants and fish, a curiously robust selection of dinosaur eggs from across China, and even petrified feces known as coprolite, all arranged on plinths of varying heights and protected by a stanchion-lined path.

Extreme seasonal heat notwithstanding, a highlight of any visit is the trail that weaves through a landscaped cactus and succulent garden past several of the colorful dinosaur sculptures, some rendered more imaginatively (and skillfully) than others, and culminating with a group of figures on top of

One of the earlier sculptures from the 1970s, made with telephone pole legs, chicken wire, and gunny sacks and later covered in fiberglass.

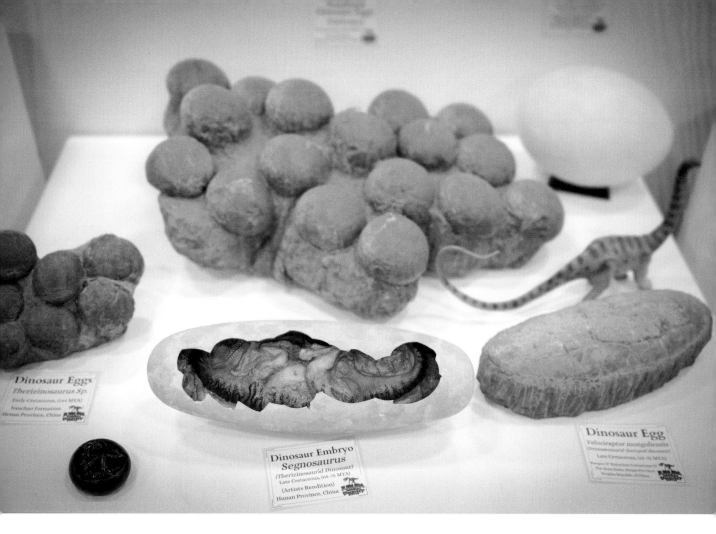

Dinosaur Eggs
Therizinosaurus Sp.
Early Cretaceous, (144 MYA)
Nanchao Formation
Henan Province, China

Dinosaur Embryo
Segnosaurus
(Therizinosaurid Dinosaur)
Late Cretaceous, (65-75 MYA)
(Artists Rendition)
Hunan Province, China

Dinosaur Egg
Velociraptor mongoliensis
(Ornamosaurid theropod dinosaur)
Late Cretaceous, (65-75 MYA)

Dinosaur Mesa, where archaeological and other educational activities take place during field trips. The "learning expeditions" offered for school groups include a simulation of an *Allosaurus* excavation, lessons in adobe brick making, and presentations on botany and the geology of California.

The gift shop doubles as a live animal display in the Critter Corner, with terrariums housing spiders and reptiles, like the gopher snake named Beef Stroganoff. The former Biblical Garden is also being reworked as the Critter Garden; JMDC was never explicitly a Christian institution, and Andrée says this was meant as a cultural and educational encounter rather than anything theological. The change makes sense given the high volume of public school field trips the center accommodates, especially if they want to distance themselves from the more famous Cabazon Dinosaurs attraction on Interstate 10, which featured controversial creationist propaganda from 2005 until 2017.

The JMDC has plans for even more interactive programs going forward, and have recently developed an app with an augmented reality find-the-dinos activity. Despite the introduction of contemporary technology, the open natural setting, tactile programs and objects, and whimsical sculptures will help ensure that this remains an embodied experience, with much to discover for anyone inclined to stop rather than speeding by.

The museum contains an abundance of fossilized dinosaur eggs from across present-day China.

Western Foundation of Vertebrate Zoology
Camarillo

When you spend time exploring unique destinations throughout Southern California, it quickly becomes apparent that spectacular things are commonly situated in modest strip malls, and especially in nondescript office-park warehouses. Of the latter category, the Western Foundation of Vertebrate Zoology (WFVZ) has to rank among the most magnificent and unexpected. Tucked between freeway-adjacent outlet stores, acres of strawberry fields, and the small Ventura County–owned Camarillo Airport, this independent nonprofit research facility and museum is home to a globally significant bird egg and nest archive.

Egg collecting, thankfully, is not what it used to be. This activity was one among many Victorian-era obsessions that found countless wealthy, white "gentlemen naturalists" seeking clout through acquisition, and it remained a popular hobby until it was curtailed by twentieth-century regulations. In 1956, LA businessman and egg enthusiast Ed Harrison founded the WFVZ as a collection of collections, since many of the original amateur oologists were dying off, and even major institutions felt at the time that eggs' scientific value was outweighed by the need to clear some space in storage. WFVZ would eventually acquire as many as five hundred discrete collections, including those of the Natural History Museums of Los Angeles, San Diego, and Santa Barbara (it likely didn't hurt that Harrison served on the board of all three).

The WFVZ spent its first few decades housed in a private museum behind Ed Harrison's Brentwood home. In 1992, in desperate need of an expansion, Harrison purchased the present location, which was built in the late 1970s as a BMX bicycle assembly factory, and carefully moved six hundred cabinets full of specimens (without breaking a single egg, as the staff proudly notes). The main room holds long rows of custom built cabinets, each with racks of pull-out drawers that hold the eggs, sorted by species and arranged in individual plastic boxes based on clutch size (those laid by the mother at one time). The initial sense of awe one might feel upon stepping into the cavernous facility is soon eclipsed by the beauty and intrigue of individual specimens.

The WFVZ now holds more than 275,000 egg sets (clutches), adding up to well over a million individual eggs, plus 20,000 nests, 57,000 bird study skins, 1,800 taxidermied specimens, and a massive research library and archive. It represents what is likely the second largest collection of eggs anywhere (after only the British Natural History Museum) and easily the largest as far as nests are concerned. And while acquisition has slowed considerably, the WFVZ is still permitted to collect new specimens as part of ongoing research, and continues to receive historic collections as well as the occasional donation of contraband seized by US Customs and Border Protection during routine inspections.

The glossy eggs of the Tinamou are always a highlight of the tour.

The variety of egg sizes, colors, textures, and other features is staggering, and distinctly pleasing to behold. Some are pointed at one edge (pyriform) and roll in tight circles, a helpful adaptation for those species such as common murres which lay on the side of cliffs and would prefer their offspring not to roll to their death. Some are inscribed with pigment markings resembling calligraphy or abstract art, like the red-winged blackbird. Some are perfectly glossy and candy-colored (the fabulous tinamou). The smallest are Broad-tailed hummingbird eggs the size of a Tic Tac, and as for the world's largest laying species, forget about ostriches: only twenty-eight eggs from the extinct elephant bird from Madagascar are known to exist across all museums, and the WFVZ has seven of them.

Some of the eggs that have proven to be the most scientifically consequential are also some of the ugliest. The once-common pesticide DDT caused the thinning of egg shells to the point that they were often crushed under the mother's weight. Study of these specimens helped lead to the banning of the chemical in 1972, with deformed and broken brown pelican and double-crested cormorant eggs from the WFVZ collections serving as evidence in one critical case that shut down the last DDT producer in the US in 2001.

The nest collection also displays a wider range of forms than one might imagine. A few of the more amazing examples include those which are made from accumulated piles of guano (an oilbird from Ecuador), those excavated from pieces of saguaro cactus (the gila woodpecker of the Sonoran desert), and those crafted entirely from solidified saliva that is overharvested by humans to make bird nest soup (an edible-nest swiftlet from Malaysia). Numerous others are built inside cast-off items such as cans and headlight casings, or incorporate found materials such as plastic "grass" from Easter baskets, newspaper, fishing line, shreds of a blue tarp, and countless other scrounged materials that display a high degree of ingenuity and adaptability, while serving as stark reminders of habitat loss and human waste.

Integral to the story of WFVZ, beyond the actual eggs, is that of the Collection Manager René Corado. His incredible life journey has taken him from abject poverty, shining shoes from a young age to support his family, to immigrating from Guatemala to Los Angeles with little formal education and speaking no English, to picking up work for WFVZ Founder Ed Harrison as a gardener. Corado went back to school to get his degree in biology, after which he was hired to work on the WFVZ collections and ultimately became somewhat synonymous with the organization for the last several decades. Corado is now a true public figure in his native Guatemala and his story has been recounted in a bilingual children's book, *El Lustrador (The Shoeshine Boy)*. In 2019, he was declared a Guatemalan Ambassador of Peace, and was given knighthood by the Order of the Quetzal, the government's highest honor. It is fitting then that among his ongoing conservation projects is one to protect the resplendent quetzal, a showy, threatened species that is both the national bird of Guatemala and the name of their currency.

Collection manager René Corado in his resplendent quetzal jacket, with a small sampling of diverse nests.

Harrison passed away in 2002, and avian biologist Dr. Linnea Hall took the reins as Executive Director, greatly expanding their research and educational outreach ever since. Conservation remains the top priority, and staff conduct regular seasonal fieldwork to monitor bird populations and long-term responses to habitat restoration at sites including the Santa Monica Mountains, Channel Islands, and Santa Clara River. Other research projects look at how climate change is affecting breeding biology. When not in the field, they regularly open for public and school tours, helping to inspire and amaze the next generation of biologists, ecologists, and yes, vertebrate zoologists.

Antelope Valley Rural Museum
Lancaster

The farthest northeast corner of Los Angeles County, which includes the cities of Lancaster and Palmdale, has seen a rapid population boom in the last few decades as more and more folks—disproportionately people of color—are priced out of central Los Angeles. Nevertheless, the character of this area, broadly speaking, remains in contrast to that of the denser urban sprawl, as if in reaction to the geographic and climate differences between this high desert basin and the coastal one on the opposite side of the Angeles National Forest. It is in this more wide-open context that some committed members of the community are working to recognize and preserve memories of the area's rural character, as it continues to develop into a bedroom community, and as solar and marijuana farms have become more lucrative and prevalent than the alfalfa and onions that previous generations were apt to sow.

The Antelope Valley Rural Museum can be found at the Antelope Valley Fairgrounds, where it opened in 2005 in the Farm and Garden Building as the Rural Olympics Hall of Fame, honoring a disappearing way of life and celebrating the legends of the fair's longtime signature games, such as competitive hay bale loading and wheelbarrow races. By 2009, their scope had expanded into a larger and broader museum of local history, bursting at the seams until they were able to build a brand new, ten-thousand-square-foot building that opened in September 2022 with great fanfare.

Easily the most unique Rural Olympics event documented here is the Antique Auto Potato Race, which was introduced in 1963 and remained a crowd favorite for sixty years. In this whimsical race, old cars (traditionally pre-1956) were driven along the racetrack while a passenger hung out the window wielding a nail-tipped pole, attempting to stab and collect a series of evenly spaced potatoes in record time and without missing or dropping any. The potatoes were originally painted red but were later wrapped in tin foil. They were raw, except for one infamous race in which local town mayors were pitted against city managers, and the managers' potatoes were baked so that they would be squashed on impact or fail to stick on the nail.

John Knapp, on the driver's side of his 1930 Model A Ford, competed in the Antique Auto Potato Races every year from 1973 to 2023, winning many together with his son. In this reenactment, museum chairman Giovanni "G" Simi wields the potato pole and his wife Janine Simi assists.

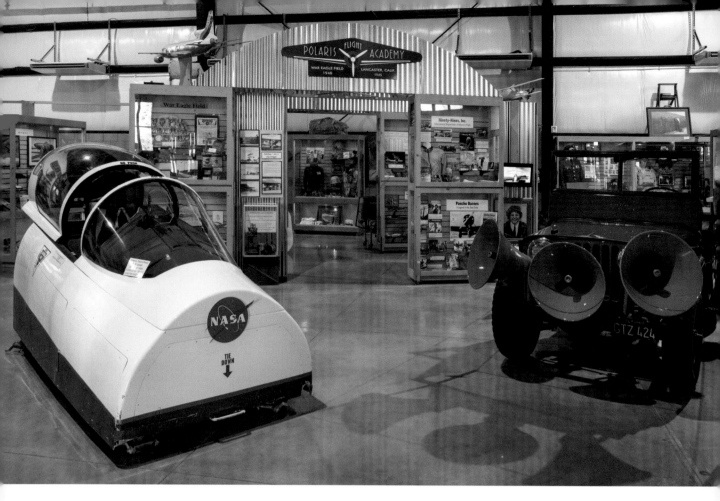

The KAVL radio jeep and the demo F-15 cockpit.

Unfortunately, owing to the dissolution of farms throughout the region, declining participation and attendance led to the announcement that the 2023 Rural Olympics games would be their final event after more than eighty years of these distinctive country contests. Despite its discontinuation, this unusual event that brought people together for generations will have a dedicated shrine for years to come, and plenty of fairgoers who come and learn all about it. They will see the Golden Hay Hooks that Hall of Fame inductees would receive, and artifacts such as the chaps worn by local legend Lloyd Mason in 1962, the year he became the first person to beat the Losey brothers in the Hay Loading Contest since their reign began in 1949.

Beyond the Rural Olympics, displays include a Jeep with massive bullhorn speakers mounted to the front bumper, given by the family that ran KAVL radio; they used to park it in front of the bleachers at the Antelope Valley High School to call sports games before a permanent PA system was installed in the stadium. A few steps away sits a large landing-gear tire from the space shuttle Discovery that was recovered after it landed at nearby Edwards Air Force Base in October 2000, a demonstration F-15 cockpit loaned by NASA that visitors can climb into and marvel at the mess of control panels, and other items that relate to the aerospace industry, which remains the largest employer in the region. Former board member Sheila Sola has created miniature local history dioramas,

such as a scene of a twenty-mule-team delivering a cartload of freshly mined borax out of her native community of Boron just across the desert valley; a nearby display highlights Sola's sashes from 1965, when she was named both Miss Boron as well as Miss Antelope Valley. Near the entrance, there is a modest exhibit featuring the area's Indigenous tribes, with information courtesy of the Antelope Valley Indian Museum State Historic Park (see page 155), as well as an exhibit exploring signs of prehistoric life in the area.

While the museum does highlight widely varied aspects of the local history, culture, and industry, there is sadly not much to show of the native pronghorns that gave the valley its name; these once-abundant creatures were depleted by a combination of overhunting and habitat degradation, and were totally gone from the area by the 1940s. The developments the exhibits do capture are of course part of a longer trajectory of change, but the museum has some room to grow. Its volunteers applied their inherited hardscrabble attitude to creating what can be seen today, and by all appearances will continue to do so, as new memories come to light, or are made.

Objects relating to the Rural Olympics and the Alfalfa Festival.

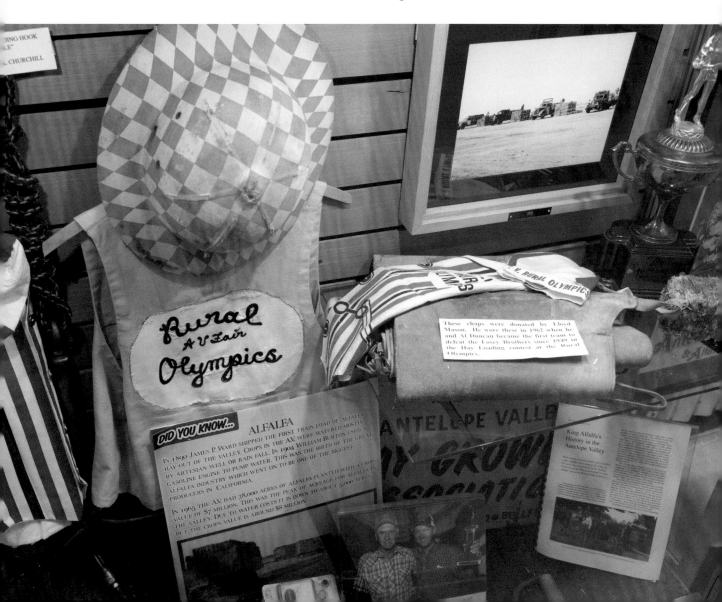

World Museum of Natural History
La Sierra University
Riverside

On the outskirts of the city of Riverside sits a small private school formed in 1922 by Seventh-day Adventists, originally known as La Sierra Academy. Growing steadily to become a four year liberal arts college, it merged in 1967 with the similarly Adventist health sciences behemoth, Loma Linda University, and eventually regained its independence in 1990 as La Sierra University. The school is notable not only for its global student body, but also for a seemingly incongruous museum that brings curious visitors from far and wide.

The story of the World Museum of Natural History (WMNH) can be traced to its founder, Dr. E. A. "Billy" Hankins III, a dermatologist by training who has had a lifelong fascination with taxidermy. While still in grade school, he mounted his first specimen—a coot he found near the Santa Ana River—but it was while serving as a military doctor in Thailand during the Vietnam War that his specimen intake escalated. He would pick up the mortalities from markets selling wild and exotic animals, returning home after his two-year tour with dozens of crates packed with creatures foreign to North America. He approached his alma mater (Loma Linda University at that time) with his dream of setting up a museum and, finding them amenable, opened on campus not long after in 1971.

The museum began with just a few displays in an existing building on campus before moving into its own dedicated space in 1989 in the newly constructed E.E. Cossentine Hall, where it's been ever since. Most notably, Hankins developed a freeze-drying method for preserving specimens in life-like positions using equipment acquired from NASA and other government agencies. It is possibly the only museum that employs this technique, certainly at such a large scale, having prepared hundreds if not thousands of reptiles and mammals in this manner.

Though he began with just his core Southeast Asian collection, Hankins soon found himself on the shortlist of people to call when an animal died at a zoo or nature preserve, allowing him to amass a surprising range of diversity. One noted acquisition is Minnie the Komodo dragon, which holds the record for the world's heaviest lizard (365 pounds while living) and serves as something of a mascot for the museum, as it is the first thing one sees upon entering the building. In 1933, Minnie was brought from Indonesia to the St. Louis Zoo by way of Alaska, and tragically died just two weeks later of pneumonia from exposure to the cold. She was prepared by a prominent taxidermist but was then passed around to undignified venues, including a bar and a school where she was treated as a piece of playground equipment, before being claimed by the WMNH and given a permanent and more respectful home.

Plenty of snakes are on view in this herpetologist's paradise.

The museum's home since 1989.

Inside the museum, a clockwise path winds through a series of tall cases holding dense and systematic displays. Reptiles of the world, birds of the world, mammals of the world, and more are all shown against stark white backdrops, with labels noting that dioramas placing them in their native habitats are planned for the future when more space can be obtained. The goal has always been to include one example of every animal in the world (hence the name), which is also why there is the occasional painting of extinct animals and even small figurines of others the museum has yet to acquire.

Herpetologists in particular will have a field day here, where they can view specimens representing ninety percent of the known species of crocodilians, as well as myriad lizards, turtles, tortoises, and plenty of snakes coiled and mounted directly onto vertical walls like so much cooked spaghetti. The Southeast Asian bird collection is billed as the largest of its kind in the US; a prized example is the monkey-eating Philippine Eagle named "Last Chance," donated by the Los Angeles Zoo upon its death in 1984. Past the animals and Native American artifacts (a nod to Hankins's partial Indigenous ancestry) is an equally astonishing gem and mineral section. This includes what is likely the largest gathering of petrified Joshua Tree wood, as well as a captivating selection of their more than 1,300 polished mineral spheres, a niche fixation in the lapidary world.

Across campus is an altogether different type of archive, but one which may soon join forces with the WMNH. The school's Center for Near Eastern

Archaeology (CNEA) has been leading archaeological digs since 1968, primarily in Jordan (the country from which it's easiest to obtain removal permits). They've amassed 20,000 pieces, including large ceramic storage jars, jewelry, oil lamps, and coins, ranging from the Chalcolithic period (a.k.a. Copper Age) up to almost the present day. The center focuses on biblical history, and degrees are conferred under the divinity school (it is an Adventist college after all). CNEA students and staff work to reassemble fragmented specimens and perform carbon dating, ancient DNA and residue analysis, and 3D modeling to further the study of the region's deep cultural heritage. A campaign has been launched to create a brand new university-wide museum that will bring together its disparate collections. Pending the completion of that grand vision, a visitor's best bet in the near term is to head to the heart of the peaceful campus to Cossentine Hall. Here, uniquely preserved, is an ambitious exhibition of natural history, with nearly enough specimens to fill an ark.

Two hundred hours were spent preparing this endangered Philippine Eagle specimen, named Last Chance, which was donated by the Los Angeles Zoo.

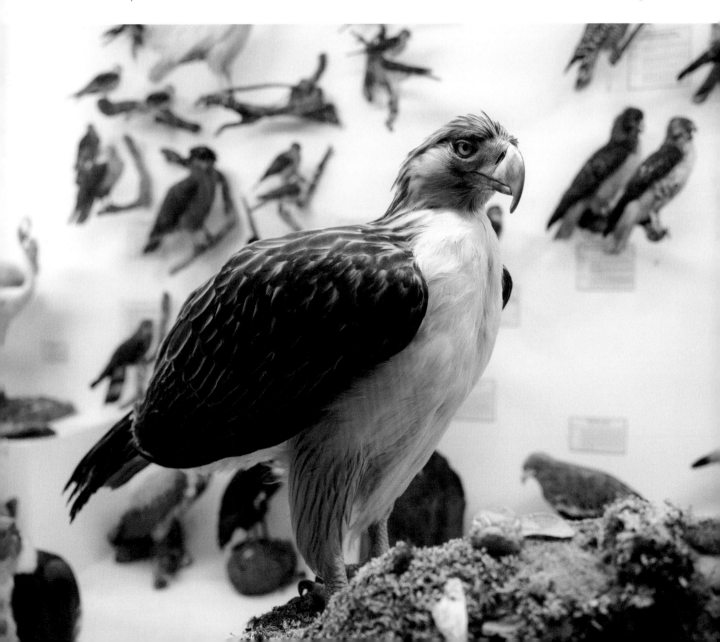

Graber Olive House & Museum
Ontario

Down a charming but otherwise unremarkable residential street in the city of Ontario lies a family-run business that has operated here since long before the area would have qualified as suburban. A 1907 Craftsman home anchors the grassy lawn and is surrounded by oak and redwood trees, plus a few aging Manzanillo olive trees, their preferred variety. A flatbed 1925 Ford pick-up emblazoned with the company name is parked near an antique mill with giant granite wheels used to crush olives and extract the oil. The main gift shop, Casa del Olivo, resembles an old ranch house that fits in perfectly alongside the low-slung, whitewashed sheds that house a working factory. The whole scene feels like stepping into a glossy lifestyle magazine spread, but here everything is authentic. Since the late nineteenth century, the Graber Olive company has distinguished itself not only for maintaining the same time-tested approach to picking and processing their namesake product, but also for cultivating a deep appreciation for history throughout their landmarked 2.5-acre property.

C.C. Graber was just nineteen when he came from Indiana to Southern California in 1892 seeking more healthful air, as many ailing Midwesterners (and Easterners) were wont to do. He acquired a small acreage along with his brother and first began to grow citrus trees, but quickly became enamored by another crop he learned about from some of the older ranchers in the area, who themselves would have originally seen them planted at the missions built throughout Alta California. Graber developed a signature method of curing olives that was an immediate hit, with neighbors lining up to buy them straight out of the vats. His production was in full swing by 1894, making this not only the oldest operating business of any kind within the city of Ontario, but also perhaps the longest-running olive company in the whole country. And while the industry has long since gone the way of mass production, four generations of Grabers have understood that, after modernizing once in 1934, their process couldn't be scaled any further without sacrificing quality, and they have declined to alter their operation in any meaningful way since.

In 1962, an unused room of the factory accessed through a sliding barn door was converted into a museum by Betty Graber, civically engaged matriarch of the second generation. Displays of artifacts and photos cover some of the history of the family and its business, as well as the surrounding community, such as a hanging wire basket that was once shuttled around the local P.E. Ostran Department Store like a miniature indoor ski lift. An exhibit on the evolution of the design of their olive packaging explains that in the early days the goods were sold directly out of a barrel and later in unmarked aluminum cans, at least until they were compelled by state law to start labeling them in 1925. Their signature font

The olive farm's 1925 Ford truck, parked by the Casa del Olivo gift shop.

was developed in the 1940s, with the design meant to convey "plumpness," and their classic gift box packaging artwork—recognized as outstanding in a framed, yellowing 1959 award from the Fibre Box Association—was designed by noted California watercolor artist Rex Brandt. But the real prized possession is an olive-grading machine built in 1910 by founder C.C. Graber and powered using a Model T Ford engine, one of the seven in use prior to their Depression-era upgrade.

Interesting as it may be, the museum itself is not as big of a draw as the factory tour. Those who visit during the fall harvest season are more likely to get the most exciting version, when the annual 50- to 150-ton crop is processed, most often by women from the community who have been with the company for decades. It's a true delight seeing all the 1930s machinery still in operation. First is the grading machine, which pulls the olives along via nylon ropes that slowly spread apart and drop them gently into crates, with the smallest falling first and going all the way up to size sixteen (with a 1" diameter). Then it's on to the adjacent vat room, a large warehouse filled with long, perfect rows of roughly 550 concrete vats, in which the olives soak in a salt brine for three weeks, their water drained and replaced daily. At some point, a guide will have likely pointed out that Graber olives are never pitted, as that can only be done if they are picked while still hard, whereas they famously wait to pick tree-ripened olives that would fall apart if pitting were attempted.

One of the original 1910 grading machines designed and built by founder C.C. Graber.

After curing is complete, a conveyor belt deposits the fruits (yes, it's a fruit) onto the filling wheel, where they are guided by hand into cans through the holes around the perimeter of the spinning table. The massive Panama paddle packer then affixes the lids and seals each can tight, an industrial boiler in the next building sterilizes them with steam in two giant pressurized retorts to kill any unwanted bacteria, and paper labels are slapped on by another dedicated dinosaur of a machine. Everything about the operation is rustic, including at least one wall that was fashioned out of wood from the crates that delivered their empty cans back in the 1920s.

In 2018, Graber sold the groves in the Central Valley where they have been cultivating their olives since the 1960s, but continue to harvest from the same trees. The factory was featured on a ghost-hunting television program, and has since drawn attention for the spirits that purportedly haunt the grounds. Perhaps a bigger boost came when they were glowingly featured by Jimmy Fallon while he was filming from home during the pandemic. But this renewed interest could do nothing to prevent the meager crop in 2023 that meant they would not operate that fall. As of this writing, the family says the future of the business is in jeopardy, even as they mark their 130th anniversary in 2024. If they don't re-open, it will be the pits, not only for the diehard fans whose families have been eating Graber olives almost as long as they've been producing them, but for anyone who recognizes that the product's history, and the family's longstanding dedication to preserving it, far outpaces that of the competition. One sincerely hopes they won't give it over to the ghosts.

Concrete vats where the olives are cured in a salty brine for three weeks.

Part 8
Faith and Spirit

Hsi Lai Temple Museum
Hacienda Heights

On a wayfinding map of the Hsi Lai Temple grounds, which one may need to navigate the sprawling complex, the aerial perspective reveals that the property takes the shape of a sacred Bodhi tree leaf. A perimeter road encircles an orderly cluster of Ming and Qing Dynasty-style pagoda structures, and is lined with concrete sculptures of baby Buddhas demonstrating stretches and positions associated with the types of meditation practiced here. The fifteen-acre compound sits on a slope above Hacienda Heights, a bedroom community at the southern end of the San Gabriel Valley, and provides an all-encompassing environment perfect for anyone interested in Buddhist teachings, Eastern art and architecture, and monastic communities where one might transcend modern anxieties.

Hsi Lai Temple may be the largest center in North America of the Chinese Buddhist organization, Fo Guang Shan, but it pales in comparison to their six-hundred-acre headquarters in Taiwan. Founded in 1967 by Venerable Master Hsing Yun, who passed away in 2023, the sect has expanded dramatically; they now have outposts in more than fifty countries, serving the global Chinese diaspora as well as mainland China. Hsi Lai Temple was the first branch outside of Taiwan (its name translates as "coming to the West"); it opened in 1988 after a decade-long campaign and several failed attempts to win over the neighbors in other proposed locations. There are around thirty resident monks and nuns at Hsi Lai at any given time, and most stay for three years and then transfer to one of their other global locations. They practice what they call Humanistic Buddhism, which emphasizes social harmony and compassion in this lifetime, as opposed to focusing on the afterlife.

The museum on their campus was created with the explicit purpose of forming a cross-cultural bridge, introducing Westerners to the tenets of Buddhism and exposing them to the beauty of Asian art. In the gallery's twisting hallways lined with display cases sit plenty of Buddha statues (naturally), rendered in bronze, jade, and wood, as well as a captivating collection of small snuff bottles, each two-to-three-hundred years old, with intricate scenes painted on the inside. The most spectacular presentation of sculptures is in a curtained-off gallery where an immersive combination of infinity mirrors and strings of fairy lights evoke the viral sensation of a Yayoi Kusama installation. Fo Guang Shan's headquarters in Taiwan has a similar infinity mirror installation (twenty-seven of their temples around the world have art galleries), and while Kusama may have pioneered the concept, you can be fairly confident there won't be a long line to get into this one, nor anyone limiting your time admiring it.

One of the most intriguing artifacts is also the most significant to adherents: a shrine featuring a reclining Buddha lying beneath an elaborately carved

The temple has a sweeping view of the San Gabriel Valley and Mountains.

2600-year-old relics of the Sakyamuni Buddha.

wooden archway, in front of which sits a bell jar enclosing a golden, stupa-shaped reliquary about the size of an Oscar statuette or little league trophy. It has a round window through which its contents are revealed: little unassuming balls said to be relics of the Buddha. These balls (pea-sized or smaller) are said to miraculously appear amidst the cremated remains of individuals who have attained a high level of spiritual enlightenment. When asked how this might be understood from the Western scientific perspective of an outsider, the guide was quick to point out that it is beyond explanation through that framework. These 2600-year-old relics are from the Sakyamuni Buddha, and were acquired by founder Hsing Yun in 1963 during a pilgrimage to India. If the relics alone don't provide enough context for visitors, nearby is an intricate and quite large *thangka* (Tibetan painting on cloth) depicting scenes and stories from the Sakyamuni Buddha's life, gifted to the temple by the Dalai Lama when he visited in 1989.

Outside the museum, a grand staircase leads from the expansive central courtyard up to the Main Shrine. This is the spiritual heart of the monastery, which is most striking for the more than 10,000 miniature Buddhas occupying as many dedicated niches covering the walls and two massive, lighted orange pillars. Typical features of Chinese Buddhist shrines, these figures act as guardians, and represent both the countless individuals who have achieved enlightenment in the past as well as the belief that all sentient beings are instilled with a Buddha-like nature.

All are welcome to join in chanting the sutras at one of the temple's regular Dharma services, with non-Mandarin speakers following along in English pinyin transliteration. In addition to their meditation and conversation groups and various festivals, the community even has its own summer camp, scout troops, youth symphony orchestra, and fully accredited Buddhist college, University of the West (which has moved out of the temple complex to its own campus in Rosemead). But one of the biggest draws for outsiders and curious visitors is the

cafeteria, which serves a highly economical and traditional vegetarian lunch daily, always without garlic or onions, since these are believed to cause an undesirable bodily excitement (same goes for the Hare Krishnas, see page 237).

A new historical museum in a different space is in the works, as is a long-planned major expansion that would nearly triple the size of the complex's footprint with seventeen new buildings, though that is facing pushback from environmentalists concerned with the impact on wildlife in the adjacent preserve. Regardless of the outcome of that campaign, the present campus is undoubtedly a positive force in the spiritual realm. And while it may all be unfamiliar to some, the oasis of calm they've created makes it easy to cross that bridge.

Arhats Garden, or the Assembly at Vulture Peak.

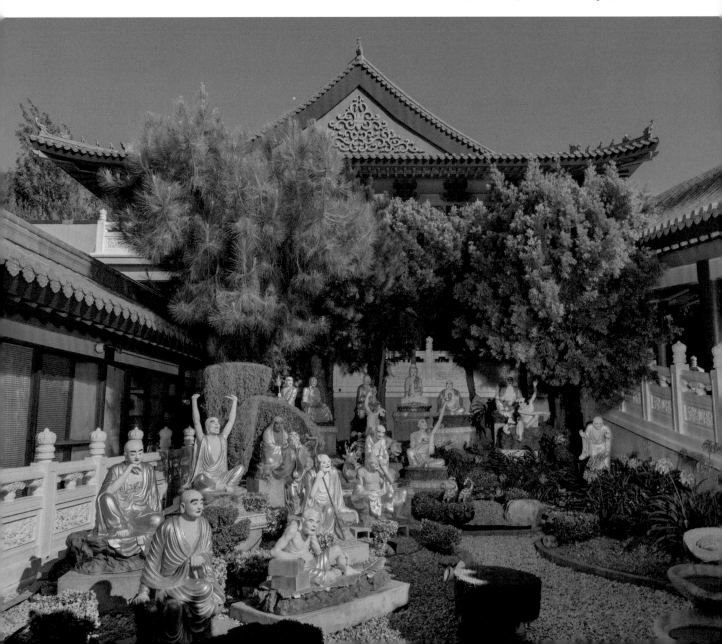

Parsonage of Aimee Semple McPherson
Echo Park

Eighty years after the death of the barnstorming, gender nonconforming, celebrity firebrand evangelist and megachurch founder, Aimee Semple McPherson, her legacy still elicits almost as much moralistic debate and breathless accusations as during the height of her fame. With popular media tending to highlight controversy and skewing decidedly negative, it's to be expected that the Parsonage museum, acting as a shrine to the creator of the Church of the Foursquare Gospel, serves essentially as the church's official rebuttal, celebrating their founder's vision and charity while offering a glimpse into her private life and the history of the church itself.

By the time Sister Aimee's "Gospel Car" rolled into Los Angeles in 1918 with her mother, Mildred, in tow, she had already found major success as a Pentecostal tent revivalist, touring the country with little more than her tambourine and signature uniform (both on view) of starched white servant dress with dark navy military-style cape, apparently representing her dual roles as spiritual caretaker and soldier for Christ. McPherson brought her old-time religion to the masses using tried and true spectacle in addition to new media technology; by the early 1920s she had pioneered the use of radio to broadcast her sermons far and wide. Opting to lay down roots and preach to the droves who were flooding into Southern California during that decade, she quickly raised $250,000 (over $4 million today) to build the 5300-seat Angelus Temple, adjacent to Echo Park Lake.

The Parsonage—built in 1922, just a year prior to the temple dedication and originally serving as a training institute for missionaries—is a two-story semicircular Beaux-Arts-style residence, with a striped awning over the entrance that faces a manicured lawn and the lake across the street. For all her marketing genius and flair for over-the-top showmanship, Sister Aimee's living quarters display a more traditional elegance (mirroring her conservative personal appearance during this period), with an Arts & Crafts-style fireplace with Batchelder tile, a grand curving staircase illuminated by tall leaded and stained glass windows, and a striking Art Deco bathroom covered with more tile depicting stylized koi fish and waves in black, gold, and teal.

A trove of artifacts are on view all throughout the house, from a chunk of the apple tree that stood on Sister Aimee's childhood family farm in Canada to an ornate urn that holds the ashes of the bank loans that allowed for construction of the temple, burned after they were paid in full. Framed on the wall at the top of the stairs, just off the bedroom, is a long, flowing dress completely covered with countless white sequins, one of her iconic looks from the later, flashier years. In another display, the press of a button activates a holographic dramatization of one of McPherson's famously overproduced Sunday evening "illustrated

One of Sister Aimee's attention-grabbing outfits.

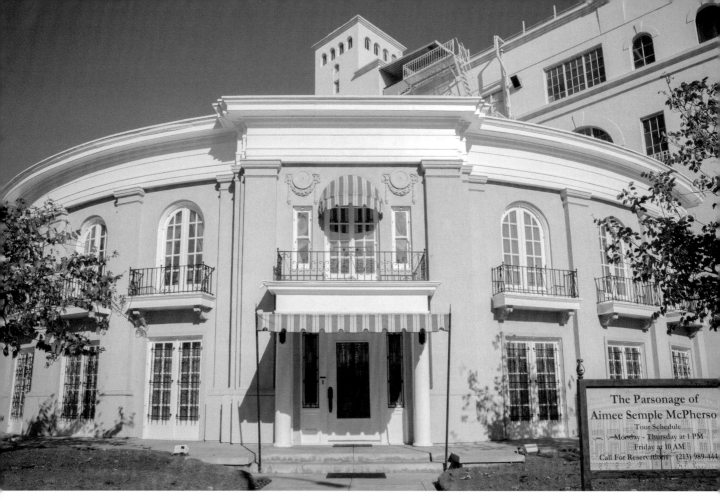

The sign reads:

The Parsonage of
Aimee Semple McPherso
Tour Schedule
Monday - Thursday at 1 PM
Friday at 10 AM
Call For Reservations (213) 989-444

The Beaux-Arts parsonage possesses an understated grandeur that's often overlooked by visitors to the adjacent Echo Park Lake.

sermons," which harnessed the full creative talent of Hollywood scenic, lighting and sound design to rival a Broadway production and attract even secular audiences and fans from "the industry," including Charlie Chaplin.

Many visitors will undoubtedly be on the lookout for the section addressing McPherson's controversial 1926 disappearance, a contested episode for which she is still best known. Alongside framed documents including a melodramatic ransom note signed by "THE AVENGERS," are a few museum labels taking McPherson at her word regarding the alleged kidnapping that saw her held captive in a shack in the Sonoran Desert until her daring escape. Concerning the accusations of a secret affair and tryst with her former radio engineer, still in wide circulation, the museum's official narrative points to a lack of evidence, corruption of the investigators, and the sensationalism of the popular press, then and now.

One prominently featured tenet of the Foursquare Gospel is the idea that biblical miracles are still possible today. A large case holds various body braces and crutches left in the temple's "miracle room" after Sister Aimee's faith healing rendered them obsolete, such as the torso support device abandoned by twenty-year-old Don Bond of Pasadena, who was relieved of "infantile paralysis" (polio) in 1937. Massive healing events she staged included a "Stretcher Day" in Denver drawing 12,000 attendees, and another series of revivals filling the Spreckels

Organ Pavilion in San Diego's Balboa Park, both in 1921. The church's website still highlights stories of historical as well as contemporary miracles realized under McPherson's proverbial tent.

Following Sister Aimee's death in 1944 by an accidental overdose of sleeping pills, her son Rolf took the reins of the church and oversaw its explosive growth over the next four decades. Today, the Foursquare Church claims millions of members in tens of thousands of outposts all around the world. The Parsonage itself, by contrast, sticks to its early history and its charismatic founder, presenting a uniquely intimate portrayal of a chapter of Los Angeles history that still resonates in the city's popular imagination.

A brace, among the displayed items reportedly abandoned after acts of divine healing.

Benjamin Creme Museum
Sawtelle

It's best to hit the Sawtelle neighborhood of West LA with an exploratory mindset, not just for the culinary delights that await, but also for a unique chance to transcend the physical plane entirely. Originally founded in 2015 in a third-floor office suite in the Pacific Palisades, the Benjamin Creme Museum relocated in 2020 to a more visible storefront location on Sawtelle Boulevard so that they might pique the interest of passersby on their way to udon and yakitori dates. Proprietors Scott and Olga Champion report that the most common question they get from visitors is, "Why haven't I heard of this artist?"—to which they might respond, "How much time do you have?"

Born in Scotland in 1922, Benjamin Creme began painting in the Modernist style as a teenager in the 1930s, and left school by age sixteen to pursue his passion for art. In 1959, Creme was contacted by an enlightened "Master" via an encounter with a stranger at a bridge in London, and from that point on he understood that he had been given a mission. Inspired and guided by what he referred to as his Master's Ageless Wisdom, which he received telepathically and through meditation, his writing and artwork took an esoteric turn, somewhat in the tradition of Theosophy. His primary message was to convey that the Maitreya—whose appearance is anticipated by the major religions and is variously referred to as the Christ, Messiah, Krishna, Buddha, or Madhi—is alive and in the world today, waiting on humanity to recognize and receive healing from this World Teacher and evolve to a higher state of consciousness.

According to Creme, Maitreya arrived in London in July 1977 in a self-created adult body, the form of which he can change at will. In 1998, Creme told Art Bell, the longtime purveyor of late-night paranormal and fringe radio, that he had personally met Maitreya in the form of a baby Jesus in the arms of a homeless woman on the London Tube, and again in Berkeley as an adult Jesus, this time a hippie beggar. Through writing, lecturing, art, and full page ads in mainstream newspapers, Creme promoted the idea that the Maitreya has predicted and been responsible for, among other things, the collapse of the Soviet Union and the Berlin Wall as well as the release of Nelson Mandela from prison.

Creme had no significant connection to Los Angeles, though he did come through town twice a year on average, usually lecturing in hotel ballrooms. Scott and Olga Champion met through Transmission Meditation sessions, a form of meditation that Creme designed and introduced. "Transmission" refers to the process of "stepping down" energy from higher Masters to a conveyable vibration. Over the years the Champions have been growing their spiritual practice together while collecting Creme's art, eventually organizing a small group of collectors to open a museum dedicated to their teacher and his message.

Museum proprietors Scott and Olga Champion. Behind Scott is their prized 1965 painting, Thangka for the coming Buddha Maitreya.

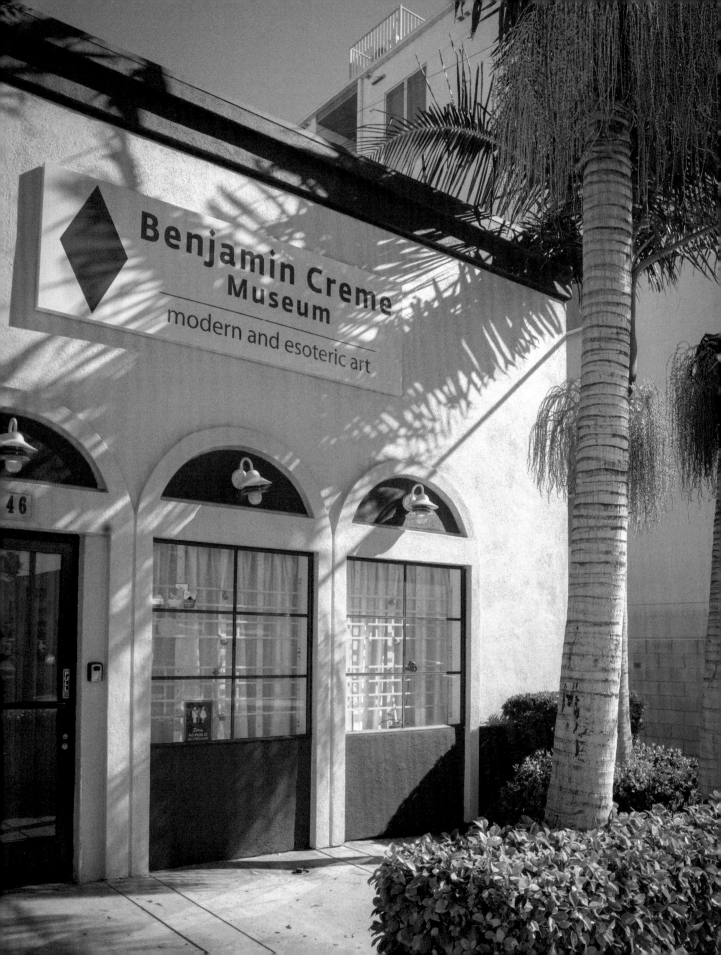

Originally in an
office building
suite, the
museum moved
to a Sawtelle
storefront to better
reach interested
passersby.

The museum consists of a single modest gallery that belies the depth of experience one might encounter, if so inclined. It showcases only artwork by Creme, including examples of his earlier works in addition to the main focus, his esoteric paintings. The latter are modern mandalas, rich with spiritual symbolism and meant to recreate his visions on canvas. The images were delivered to Creme in meditation and through his telepathic link with his Master, who guided the creation of the works, at one point compelling Creme to make the paintings larger. The artworks are to be seen as tools for meditation, conveyed in a language of symbols but ultimately a very personal experience.

The 1965 painting that serves as a kind of logo for the museum is called *Thangka for the coming Buddha Maitreya.* It's a modern take on the traditional Buddhist *thangka,* scenes painted on cotton or silk, often depicting a central deity surrounded by elaborately detailed smaller figures and used for meditation or as a teaching aid (see also the Hsi Lai Temple Museum on page 221). Creme's version features an abstracted figure with circles around the head meant to represent levels of consciousness, and rose-colored lines curving across the body symbolizing "the cosmic energy of Love and the interconnectedness of the universe," per a description in the *Share International* magazine published by Creme and his adherents.

Creme was not interested in arguing or trying to convince anyone, he said that he was simply putting information out there so people will understand what is happening when the true World Teacher, Maitreya, comes forward. Creme died in 2016, but his received wisdom is preserved via his art, and thanks to the efforts of his followers, remains on view for those who can see it.

The one-room
gallery is devoted
entirely to the
work of Benjamin
Creme, especially
his later esoteric
paintings.

Forest Lawn Museum and the Hall of Crucifixion-Resurrection
Glendale

Don't call it a cemetery: Forest Lawn was founded in Glendale in 1906 and reimagined in 1917 as the prototype for a "memorial park." Per the Builder's Creed, as inscribed at the entrance to the Great Mausoleum, "unsightly stoneyards…depressing customs…misshapen monuments" are evicted in favor of "sweeping lawns, splashing fountains, singing birds, beautiful statuary…" Hubert Eaton, the self-proclaimed "Builder" and Forest Lawn's larger-than-life, longtime director, goes on to single out lovers, artists, and school teachers as being among the target audience; in short, it is "a place for the living," as opposed to the alternative.

Across the six memorial park campuses now under the Forest Lawn banner, the art collection includes thousands of works in bronze, stone, stained glass, and mosaic, a number of which are integrated within imposing structures, architectural landmarks in their own right. The combined parks encompass a total of more than 1,300 acres, with twenty-three miles of private roads and no fewer than twenty dedicated flower vans. But the jewel in the crown remains the original Glendale location, where the Hall of American Sculpture within the Great Mausoleum was serving as a proto-museum before the official Forest Lawn Museum opened on the hilltop in 1952. For most of its existence, the museum has primarily focused on their permanent art collection of sculptures, bronzes, and paintings, all still featured in the front gallery. They also have the severed head and foot from a marble statue of David that collapsed in an earthquake— the outdoor replica of Michelangelo's masterpiece is in its third iteration and is now made of bronze, as the original David's thin ankles turned out not to be engineered to withstand California's seismic activity.

Even for those who don't seek out Western European art and architecture, and who might not be inclined to visit the graves of the many celebrities and public figures interred here, there is at least one artwork that should impress the most jaded teen or secularized hipster. Renowned Polish artist Jan Styka's 1897 painting of the Crucifixion is billed as the largest religious painting in the US, and possibly the largest framed painting in the world, concealed by what might be the largest curtain in the world, and housed in one of the most indisputably epic buildings ever constructed with the express purpose of showcasing a single work of art. The huge, white, cross-topped, warehouse-like structure visible from the 5 freeway and almost all of downtown Glendale and the surrounding neighborhoods is none other than Forest Lawn's Hall of Crucifixion-Resurrection.

Styka's gargantuan scene is 195 feet wide and 45 feet tall—two-thirds the length of a football field—and the central figures are approximately life-size. The

Jan Styka's Crucifixion in its purpose-built auditorium.

panoramic work toured Eastern Europe with exhibitions in Warsaw, Moscow, and Kiev before being shipped to America for the 1904 World's Fair in St. Louis. Sadly, not only was Styka unable to install the painting in St. Louis due to the lack of a sufficiently large venue, but he also couldn't afford the export duty to bring it back home to Poland and was forced to abandon it, never to see his masterwork again. After going missing for several decades, it was found wrapped around a telephone pole in the warehouse of the Chicago Civic Opera Company, and Hubert Eaton enthusiastically purchased it sight unseen.

After it was shipped to Los Angeles, the Crucifixion painting was first unveiled at the Shrine Auditorium, which was at that time the only venue in town large enough to contain it. Construction commenced on a dedicated building for the work, with the façade made to resemble the centuries-old Orvieto Cathedral in Italy. Visitors pass through a soaring Gothic corridor inspired by Notre Dame before entering into the six-hundred-seat auditorium that feels like a cross between a movie palace and a double-wide college lecture hall. The Hall of Crucifixion-Resurrection opened to great fanfare on Good Friday of 1951, just a year before the adjacent museum, the staff of which oversees both facilities.

With the Last Supper rendered spectacularly in stained glass in the Great Mausoleum and the Crucifixion painting in place, Hubert Eaton was two-thirds of the way to a "Sacred Trilogy" of art, which he only needed a representation of the Resurrection to complete. After more than a decade of contests and commissions, finally in 1965 Eaton hired the local artist Robert Clark, who had done scenic painting for Hollywood and in the Los Angeles County Museum of Natural History's beloved dioramas, to paint the massive companion piece. At seventy-five feet wide

The museum was completed in 1952. The adjacent cathedral façade marks the entrance to the Hall of Crucifixion-Resurrection.

The marble foot of David, *salvaged after the statue collapsed in an earthquake.*

by fifty-one feet tall, Clark's Resurrection had to be painted on site in a wing added onto the hall as both studio and storage for the work when not on view; it rolls (slowly) on a track in front of the Crucifixion for each presentation. With Eaton and others hovering over Clark and providing detailed notes throughout the process (including the insertion of some bright orange California poppies), in the end he did not even claim this work as his own, and a prominent copyright notice placed by Forest Lawn appears where an artist signature might otherwise be.

In recent years, the museum has begun to produce a refreshing exhibition program. This includes recent shows on the iconic Bob Baker Marionette Theater, one celebrating panoramic arts presented together with the Velaslavasay Panorama (see page 255), and a feature of Judson Studios, the oldest family-operated stained-glass business in America that is synonymous with the artform in Southern California. In 2023, they completed an overhaul of the audiovisual program that accompanies the Crucifixion and Resurrection paintings. It takes a more contemporary and history-focused approach compared to the earlier, more dramatized and religious presentation (with their apologies for cutting the thunder and lightning effects). It also incorporates archival video footage, including of Forest Lawn's Easter sunrise ceremony and pageants that date back to 1924.

The whole experience gives visitors much to consider as they wind their way back down the hill, past the families honoring their departed loved ones, then past the signature crane fountain, and finally out through the heraldic wrought iron front gates from 1932...which, naturally, are purported to be the world's largest. Call it ostentatious, but one must concede that the Builder was onto something, as not only are they the memorial park whose endowment happens to be the world's largest, but more importantly, it's one that has proven to be a dynamic cultural destination, and indeed a welcoming place for the living.

Bhagavad-Gītā Museum
Culver City

"*F*ATE has brought you here..."

...So declares an assertive pre-recorded voice just after the museum's front door closes behind you, as soft lights rise on a life-size model of the guru seated at his desk. This is A.C. Bhaktivedanta Swami Prabhupada, or Srila Prabhupada, the founder of the International Society for Krishna Consciousness (ISKCON), popularly known as the Hare Krishna religious movement. In this animatronic depiction he is writing, perhaps translating the Bhagavad Gita, that sacred Hindu text, into English, just as the immersive multimedia experience that follows was created under his direction to translate the book's transcendental teachings for the American public. And that's *fate* in the traditional sense, but also F.A.T.E.: this is the First American Transcendental Exhibition, the original name for what is now the Bhagavad-Gītā Museum.

In the mid-1960s, Srila Prabhupada took the Western world by storm, setting up dozens of centers throughout the US in a few short years. He visited Los Angeles some twenty times in less than a decade, staying in a dedicated apartment above the temple complex in Culver City. In 1973, he instructed his followers to create a theistic exhibition, an idea implanted in him by his own guru, and a small group of artist devotees set off for India to learn the traditional craft of *putul* (puppetry, or doll-making) from master artisans. They spent fifteen months in the village of Mayapur perfecting centuries-old techniques, using only natural materials from the banks of the Ganges River such as clay, bamboo, rice straw, natural pigments, and a kind of gesso made from arrowroot and chalk. The resulting sculptures were typically produced for temporary use during village festivals honoring a deity, but this small band of artists would bring what they learned back to Los Angeles and combine it with modern technology to create the museum that still stands today.

Though only a handful of disciples went on assignment to India, as many as one hundred community members contributed their time and talents to the museum effort, finally unveiling their creation in 1977. Marek Buchwald, also known as Baradraj, was one of the few who went to Mayapur, and is still a devotional artist half a century later, with hundreds of works published in Hare Krishna literature and on display in their temples around the world. Another adherent is said to have devised his own early computer just to operate the timed light and sound presentation that helps dramatize the experience and compels visitors through the dark, winding corridors.

A diorama featuring Krishna's various manifestations.

The museum's narrative unfolds across eleven stops depicting the philosophy presented by the Gita. One diorama features an out-of-control carriage meant to represent metaphorically "the precarious condition of the embodied soul," with the horses serving as the senses, the driver as intelligence, the reins as the mind, and

the passenger as the soul, which is subjected to "unpredictable and dangerous states of consciousness." Another station, and perhaps the most spectacular, is in a small mirrored room where visitors take a seat and are given *divine eyes* with which to see the true nature of the god Krishna. A diminutive prince Arjuna—the Gita's protagonist—sits in his chariot below a tall curtain, which is drawn to reveal a towering mass of gods, people, snakes and other entities, plus cosmic and psychedelic projections of the heavens, all contained within Krishna. Visitors next move to a Sankirtan Festival, at which the ecstatic chanting of the name of God— *"Hare Rama, Hare Rama, Rama Rama, Hare Hare..."*—prompts a release from the burdensome cycle of birth and death. The tour culminates with a blissful dance party in the spiritual realm, with Krishna on flute surrounded by *gopis:* something like a devoted groupie, albeit more enlightened.

Though their founder and guru passed away the same year the museum opened, and has since come under fire for remarks seemingly at odds with his message of unconditional love, anyone who thinks Hare Krishnas are a faded relic should know that the adjacent apartments still house around two hundred devotees, and many more come out for their annual Ratha

A full-scale model of Prabhupada in his time capsule apartment above the temple.

Yatra (Festival of the Chariots) parade in Venice Beach. They are also quick to point out the staying power of various cultural concepts the movement has helped introduce into Western society, such as yoga, vegetarianism, and the idea of reincarnation. In 2024, the global ISKCON headquarters in Mayapur completed construction of one of the world's largest temples of any denomination, the massive Temple of the Vedic Planetarium.

The museum was restored most recently in 2019 and has enjoyed a kind of resurgence, with print and podcast features and local art school professors bringing their classes. Govinda's Imports gift shop and natural food cafe provides further enticement to visit, and on special tours, one might even get to see Prabhupada's living quarters above the temple, preserved just the way he left it. There, at his original desk, sits another full-scale model of his likeness, wearing a knit beanie and glasses as he speaks into his trusty Dictaphone, like an eternal translator making ancient wisdom accessible to seekers everywhere.

Artist Marek Buchwald, aka Baradraj, was among the small group of disciples sent to India in 1973 to learn traditional techniques for creating the museum displays.

Mel Mermelstein Museum/Orange County Holocaust Education Center
Newport Beach

Anyone who believes in the value and importance of small, specialized museums and idiosyncratic or unconventional displays will be deeply validated by the assemblage artworks created by Holocaust survivor Mel Mermelstein. Occupying a single modestly sized room with a drop ceiling, bare concrete floors, and no special technology to speak of, it is easily one of the most profoundly moving experiences to be had in any museum in Southern California. Mermelstein's story is incredible, and demands to be preserved, retold, and seen firsthand through his art.

After Mermelstein's mother and two sisters were murdered in the gas chambers of the Auschwitz-Birkenau concentration camp, his father insisted to him and his brother that they separate so that they would not have to witness each other's suffering, and to increase the odds that one of them would live to tell of the horrors to which they were exposed. Mel was moved twice to different camps as the war front advanced, and when Buchenwald was finally liberated in April 1945, he was eighteen years old and weighed sixty-eight pounds. As the sole survivor in his family, he dedicated the rest of his life to the promise he made to his father, that he would not let others forget the unconscionable hatred and ignorance that led to the murder of those he loved along with millions of other innocent souls.

Beginning in 1967, Mermelstein returned to the scenes of the crimes on some forty occasions, primarily to Auschwitz, uncovering and collecting more pieces of debris on each visit. On a 1978 trip with his then-teenage daughter, Edie Mermelstein, he put a hulking concrete fencepost in a suitcase, and she recalls walking around Paris with him lugging it everywhere they went. Over a span of fifty years, Mel arranged, manipulated, and combined his poignant and even gruesome bits of evidence into works of art, though it's unclear whether he considered them as such, or simply as a cathartic way to process his grief and trauma. In 1972, Mel opened a small museum at his lumberyard and pallet manufacturing facility in Huntington Beach, and over the next four decades it grew to 1600 square feet in a maze of conjoined shipping containers. Inside, the wood-paneled walls were packed tight with artworks, newspaper clippings, and photographs. He opened it to school groups, and would even show it to customers who had only stopped by to purchase firewood, often asking his workers to go on break so the noise of the yard wouldn't disturb the tours.

Most of his works are assemblage compositions in shadow boxes or frames, with artifacts set in resin, often depicting Stars of David in barbed wire, human figures crafted from twisted cutlery, the names of the camps spelled out in buttons, autobiographical pieces with pictures of his murdered family members,

Edie Mermelstein's tours emphasize her father's belief in the importance of love and tolerance of others.

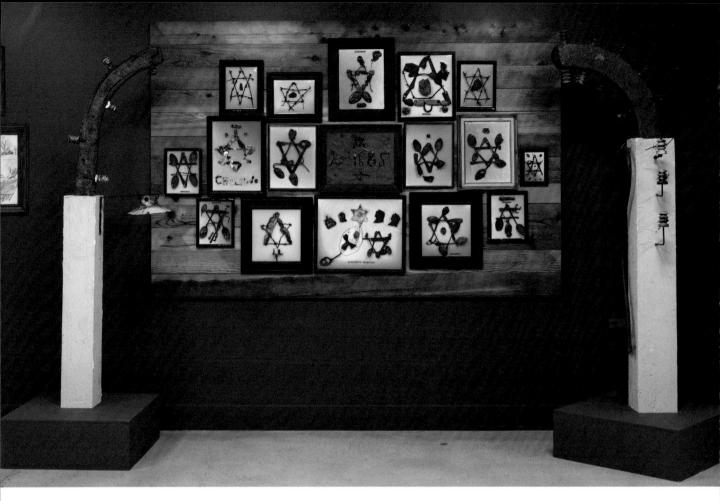

Stars of David made from barbed wire and rusted cutlery,
framed between concrete posts from electrified fences.

and more abstract compositions comprised of ashes, scrap metal, canisters of Zyklon B poison, and the posts from which electrified wires were strung along the camp's perimeter. They are haunting and oddly compelling, representing one man's lifelong search for meaning. Totally untrained in any artistic medium, Mel created works that possess a rawness of vision which can't be taught.

Mermelstein is perhaps best known for his legal victory against a Holocaust-denying hate group that had challenged him to prove that Jews were gassed by the Nazis, resulting in a 1981 ruling that took official judicial notice that the Holocaust was simply a fact and was not up for debate or consideration in an American court. A 1991 TNT movie, *Never Forget,* featured Leonard Nimoy as Mermelstein in a largely faithful retelling of the legal saga, filmed in part in the real-life museum and featuring cameos by Mel and Edie. Disturbingly, the Holocaust denial group, whose name does not warrant reproduction, still exists today and openly distributes repulsive lies rooted in fear and bigotry, the likes of which continue to find mainstream outlets.

Mermelstein's lumberyard closed in 2018 and everything went into storage while the family searched for a new home for the roughly seven hundred artworks. They approached a number of the major Holocaust museums locally

and internationally, but these institutions sought to cherry-pick the unaltered artifacts such as a framed camp prisoner's uniform, shying away from the pieces Mermelstein created from the wreckage. To a conservator or museum professional, Mel's works might be perceived as a desecration, or as too unusual to be presented with the objective and omniscient voice that's typical of large museums. But the fact that they are so personal to his experience—and that visitors are actually encouraged to touch them—results in a powerful sense of immediacy that more official, professionalized museums too often fall short of facilitating in the name of best practices.

Edie, an attorney who advocates for women and the underserved, has taken on the role as caretaker of her father's legacy. She was able to keep the works together and make them accessible again as the only Holocaust education center in Orange County, a priority since schools in the area don't have the resources to bus students up to museums in Los Angeles. Just a few months before Mel's death from COVID-19 at age ninety-five in January 2022, the collection was relocated to the Chabad Center for Jewish Life, set in a quiet subdivision adjoining a vast nature preserve in Newport Beach. Under the stewardship of Rabbi Reuven Mintz and Judy Richonne, director of the education center, they welcome school groups and individuals for tours that emphasize how visitors can become "upstanders" rather than bystanders when they witness injustices in the world. Edie continues to give tours to help guide the experience from one of pain and sorrow to highlight the need for tolerance, and love, in alignment with her father's core purpose.

The Auschwitz Study Foundation, a nonprofit which Mermelstein formed in 1978, still owns and oversees the works and continues to engage in educational activities, such as the production of a forthcoming feature documentary on Mermelstein's life. Only ten percent of the collection is currently on view, though the Chabad is working on expanding their capacity. Edie still dreams of an exact recreation of the original museum's interior, and has held onto all of the wooden wall paneling in case that someday becomes reality. In the meantime, this

A piece depicting the names of Mermelstein's immediate family members who were murdered at Auschwitz.

one room houses an exhibition of depth and purpose that cannot be fabricated with any amount of money or immersive technology. If a visit to just one museum were to be made compulsory for everyone in a one-hundred mile radius, the Mel Mermelstein Museum should be it.

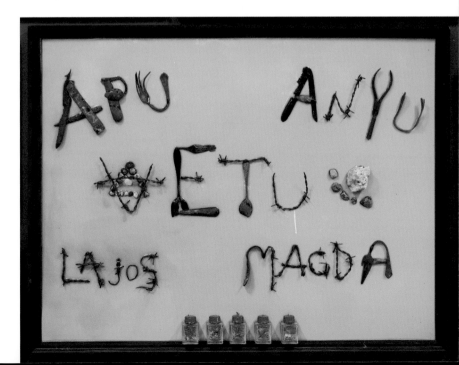

Part 9
Portals in Time and Space

Rubel Castle and Tin Palace Museum
Glendora

Pulling up to a residential block in the foothill town of Glendora and seeing a Medieval-esque gate, a large cut metal sign proclaiming this "Rubelia," and the towering stone turrets rising from behind the perimeter wall, it becomes clear that there is something seriously distinctive about this property. Rubel Castle is a monument to creative vision, camaraderie, and community in the form of a folk-art stone castle built into a former citrus orchard cistern, and its existence is thanks to a remarkable confluence of personalities and circumstances, all orchestrated by a most unlikely ringleader.

Michael Rubel was only six years old in 1946 when he lost his father, Heinz Rubel, a colorful character himself who was both an Episcopal preacher and a gag writer for radio comedian Joe Penner. After Heinz's passing, Michael's mother, Dorothy Deuel, became a real estate agent to make ends meet, while Michael and his friends quickly started building "castles" (glorified forts) out of salvaged materials from a nearby junkyard. Each time one was torn down by adults who disapproved of their precarious and obviously dangerous design, he would build another one even bigger than the last; by the time he turned ten, his creations were reaching four stories tall. After traveling the world as a teenager, he returned to Glendora to "settle down," and would spend his entire adult life building the legitimate castle that was his childhood dream.

Michael moved into the packing house of what was once a 1400-acre citrus ranch, occupying a parcel he acquired from Singer Sewing Machine magnate Alfred Bourne, who he had known since boyhood. First his mother and then his grandfather moved in, making this a rather unconventional three-generation household, complete with cork-insulated refrigeration compartments converted into bedrooms. The long main room of what was quickly dubbed the Tin Palace would prove ideal for Dorothy's infamous and frequent parties. Dorothy, ever the socialite, had been a vaudeville dancer in the Roaring Twenties, and counted the famous silent screen actress and risqué fan dancer Sally Rand as a close friend and regular attendee of her gatherings. Bob Hope, Alfred Hitchcock, and Dwight Eisenhower all reportedly made appearances at the soirées as well.

By 1968, the construction projects were on. First, Michael needed a quiet refuge from the unceasing raucousness, so he decided to make a small bottle house in the middle of the big old cistern on the property, using cast-off bottles from the Tin Palace shindigs. He was so broke that he would drive out to a nearby concrete factory just to shovel up anything that came spilling out of the trucks. Eventually, a friend and wealthy benefactor told Michael that he would pick up the tab for all the concrete needed, and continued footing this substantial bill for decades as the construction grew by leaps and bounds.

With the raising of the clock tower in 1986, Rubel Castle was complete.

The inner courtyard and former cistern interior, with the machine shop at right and the castle itself surrounding.

If there were any plans for the castle when work began, Michael was the only one who knew about them. With this, one of the most remarkable creative reuse projects in the country was born, putting to use anything that could be procured or donated, building into the walls not just bottles but also bicycles, appliances, toys, and at least one motorcycle. The citrus industry that had dominated the area was on the retreat in the face of rapid postwar housing development, so there was easy access to all manner of neglected machinery and discarded materials that could be combined with the underwritten concrete and the plentiful boulders from the nearby San Gabriel Mountains to construct a fortress complete with turrets, an automated portcullis gate, blacksmith and machine shops, and an escape tunnel.

Perhaps Michael's greatest skill was in convincing friends, neighbors, and kids from the community to help out, with crew members taking on the moniker of Pharm Hands and performing back-breaking work towards a common but arguably pointless goal. One of their mottos, as reported by a 1984 feature in *The Glendoran* magazine, was "work hard, enjoy life, and safety third." Michael worked odd jobs over the years, including as a school bus driver, and would commandeer the bus during off hours to transport telephone poles and stones needed for construction. He would also allow some of the early Pharm Hands to build their own living quarters, which are still rented out as apartment units to this day.

Many neighbors were opposed to the project, at least until the devastating floods of 1969, when Michael was able to temporarily house and provide assistance to the displaced. Still, Glendora repeatedly sent city inspectors to red tag the unpermitted and completely illegal structure, and took Michael to court in the early 1970s, where he confessed to the judge that he simply could not stop building. Since he had garnered some goodwill in the community, and because his mother was well-connected, to simply show up with bulldozers was a political non-starter. The legal hassles continued until 1984, when Michael finally signed a contract agreeing that the whole place was condemned, which

simply meant that he could never sell it.

Upon the 1986 installation of the clocktower, the castle was considered officially completed. Michael and his wife Kaia remained with their Pharm Hand tenant friends, eventually donating the castle and grounds to the Glendora Historical Society in 2005; Michael died in 2007 and Kaia in 2009. The historical society continues to operate the property, and residents are joined by members and volunteers in maintaining the facilities and the general magic of the place, while steering it into the future with a long-term plan for conservation and preservation underway.

Lucky visitors with at least a few hours on their hands might be led on a tour by Scott Rubel, Michael's nephew and one of the original Pharm Hands, who grew up visiting and working on the castle. Scott's own commitment to the project throughout his life, and his talent for recounting hilarious and unbelievable stories, should leave visitors more amazed and inspired than can reasonably be expected. Michael was possessed of a profound wisdom that has often been overshadowed by his quirky demeanor and unorthodox life path. Rubel Castle certainly constitutes an architectural and engineering feat, but through the craftsmanship and hard labor expended by so many for what can best be described as a folly, it also embodies a level of passion and dedication far too rare in this world.

Scott Rubel, nephew of Michael Rubel and storyteller extraordinaire, sits in Michael's former bedroom in one of the Tin Palace refrigeration units.

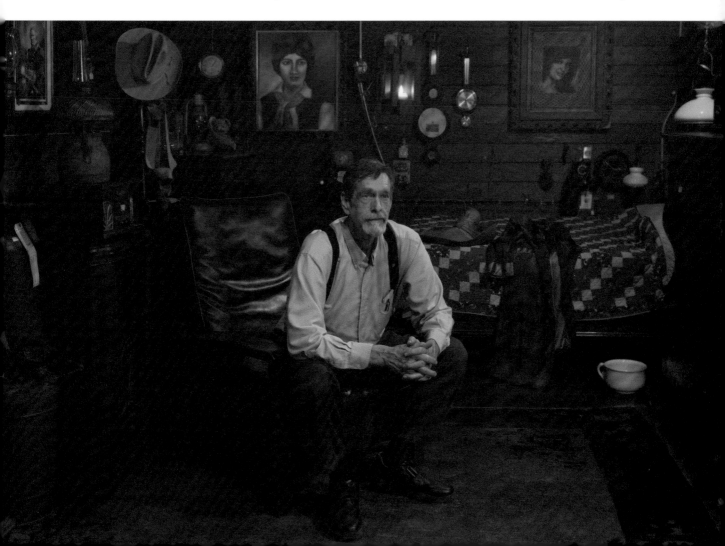

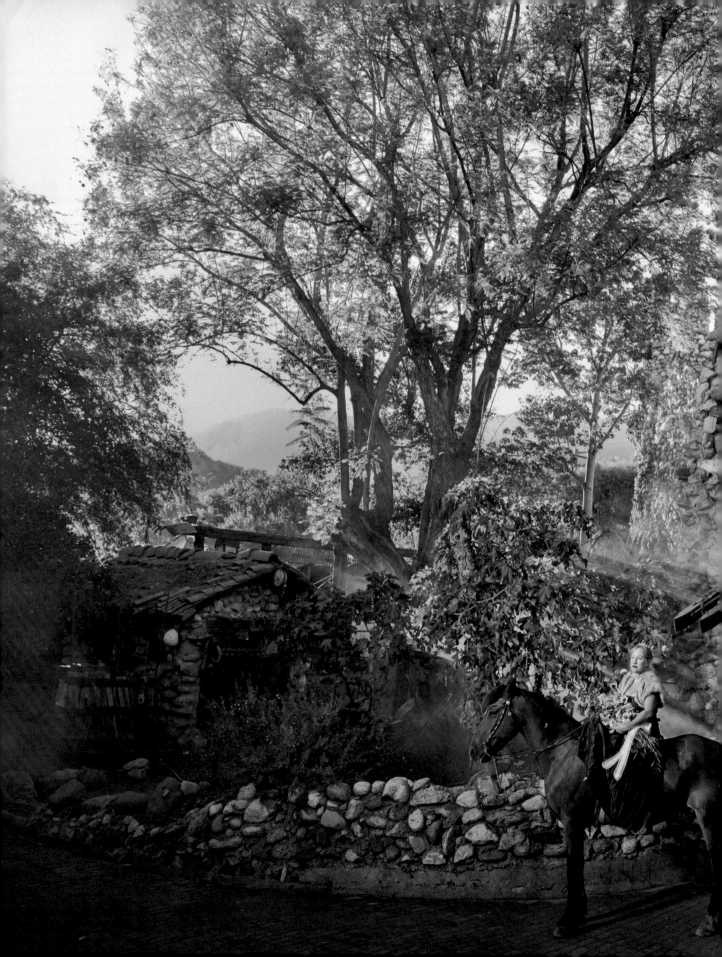

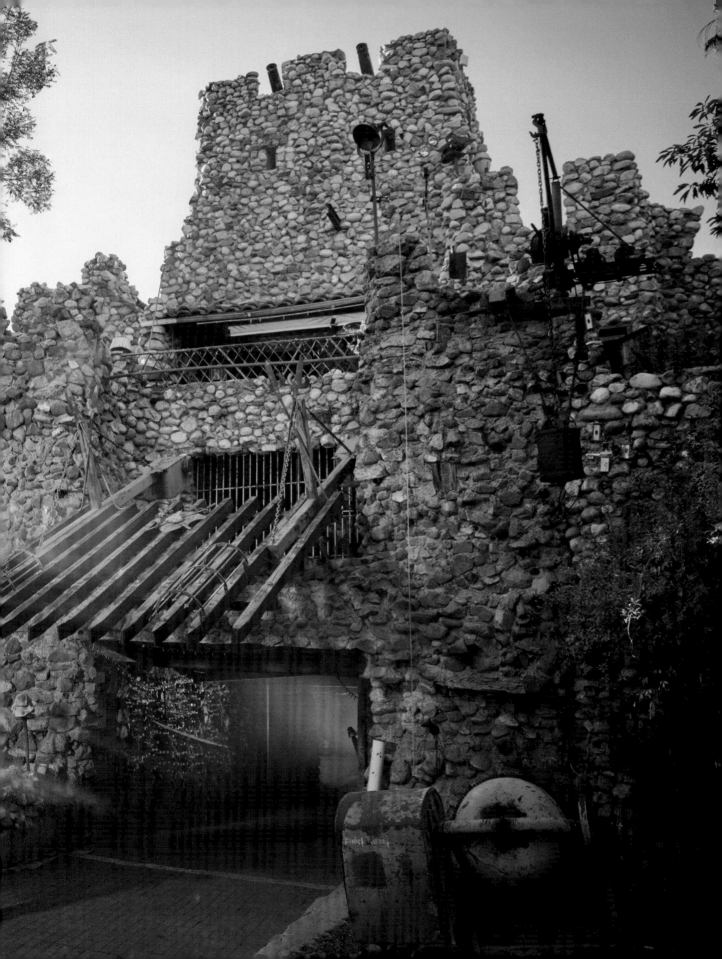

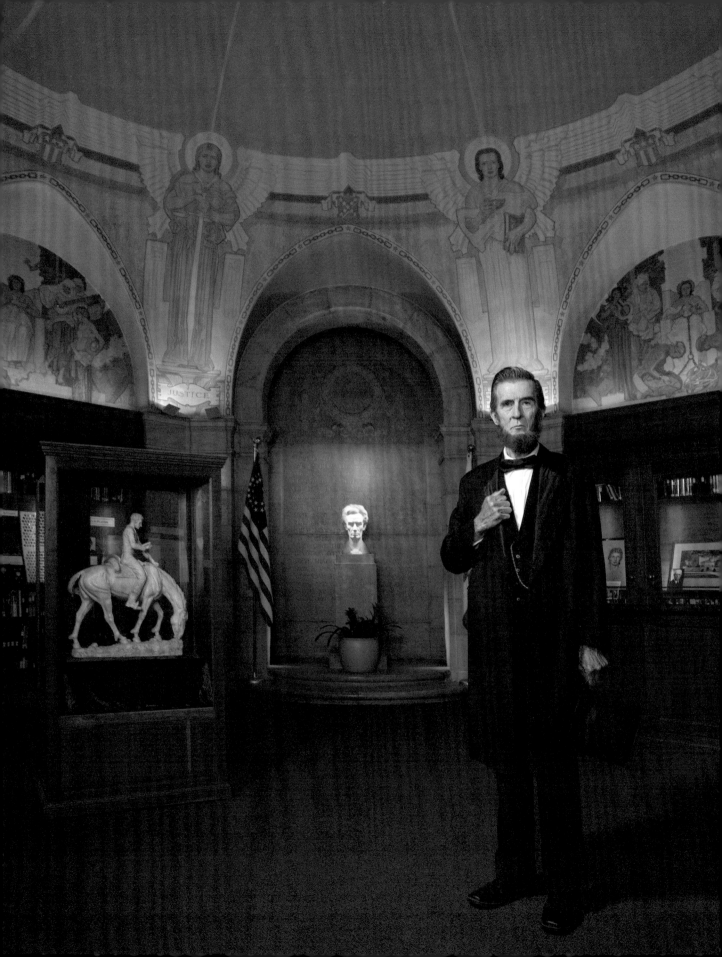

Lincoln Memorial Shrine
Redlands

Abraham Lincoln once wrote of his desire to visit California; of course, he never did, and the Golden State isn't generally known for its role in the Civil War, meaningful though it was (mostly via the infusion of Gold Rush wealth into the Union). Nevertheless, traces of the war's legacy can be found here. To view a site contemporaneous with the conflict, one can visit the Drum Barracks Museum in Wilmington, which is the only substantial Civil War military outpost in the LA area (ask them about the Camel Corps). But for a deeper study and appreciation of the great president himself, the best and only bet is the Lincoln Memorial Shrine in downtown Redlands.

This small, ornate structure was sponsored by British expat oil baron and former US Immigration commissioner Robert Watchorn, along with his wife Alma, in memory of their son Ewart, who died in 1921 at age twenty-five from injuries sustained as a fighter pilot during World War I. Ewart had been an admirer of Lincoln, which gave Robert and Alma a prompt around which to focus their grief-fueled collecting and building energy. They hired architect Elmer Gray, who had achieved renown for his work on projects such as the Beverly Hills Hotel and Henry Huntington's San Marino mansion, and in whose office the young Ewart had apprenticed. Dedicated as the Lincoln Shrine on the president's birthday in 1932 before a crowd of thousands, it was (and is) the sole Lincoln-centric museum and research library anywhere west of the Mississippi.

The idea for a standalone building that would become the Shrine first emerged from the need to protect a marble Lincoln bust against the smoky pollution of smudge pots burning to keep the nearby citrus groves from freezing. The original structure was just the central octagonal rotunda with limestone façade inscribed with passages from the orator's famous speeches. To decorate the interior dome ceiling, Gray brought in noted illustrator and muralist Dean Cornwell, who was in Southern California working on a much larger mural project for the main rotunda of the Los Angeles Central Library. The Shrine mural highlights accomplishments from Lincoln's presidency, surrounded by eight allegorical representations of his character, with attributes such as wisdom, courage, and tolerance rendered as winged androgynous figures (angels?) circling the dome's perimeter. The site is operated under the aegis of the adjacent A.K. Smiley Public Library (itself a gem that is not to be missed) through their special collections department.

In 1998, the Shrine was nearly tripled in size, with the addition of two wing galleries fulfilling the original ambitions and accommodating ninety years' worth of new acquisitions. While the collections now contain more than 5,500 letters and manuscripts from the Civil War era, not only from soldiers but also

Overleaf: Bonnie Asa—part of a family of longtime Pharmhands— with her horse, Charlie Brown.

Robert Broski, the premiere Lincoln presenter in Southern California, in the historic rotunda.

The Shrine originally consisted of just the central octagon that opened in 1932, with the two wing galleries added in 1998, according to the original plans.

from Lincoln himself, they have also built up a substantial collection of museum artifacts to showcase in their newer galleries. One might see Lincoln's cane and cufflinks, or plaster castings of his face and hands. One case holds a thirty-two-pound cannonball from the battle at Fort Sumter in South Carolina in 1861, believed by some to be the first shot fired in the Civil War, and in another an authentic pair of slave shackles are included to prompt discussion about the horrors of slavery. A giant table case in the middle of one gallery contains a rare surviving example of a so-called autograph quilt (signed by the names of its makers) from the US Sanitary Commission, many of which were used as battlefield shrouds when wood for caskets was in short supply.

One of the more colorful objects is a painted field drum that is a fantastic example of early American folk art. It was played by Grand Army of the Republic drummer boy and soldier, Benjamin Hilliker, whose tiny portrait can be seen by peering into the air vent hole in the side of the drum. Hilliker was shot in the head during a skirmish at the siege of Vicksburg, but the bullet passed straight through and he survived; he was awarded the Medal of Honor after moving to Los Angeles following the war. The medal (which cannot be legally bought or sold) is also on display.

While the museum does have regular hours, one should consider going during an open house or other special event for a full experience including music, reenactors, speeches, and perhaps an appearance by Honest Abe himself. Robert Broski, the museum's preferred Lincoln presenter (not impersonator) is an uncanny likeness and has the dedication to match. On his website, Broski lists similarities between the two men: both 6'4" and size fourteen shoes, both have a mole on the right side of their face, both married an Episcopalian in the first week of November and had four kids with the fourth named Thomas, both are known for their honesty ("wife says 'most honest man I know'"), and whereas Lincoln was president of the United States, Broski was president of a car club and his HOA.

As the site is designated as a shrine, some visitors arrive expecting to see the actual tomb of Lincoln here rather than in Illinois. And while the death mask is as close as they come, there is a sense of reverence one feels in the historic rotunda interior. Most importantly, the staff works hard to draw connections between the challenges Lincoln faced and those we must confront today. At a time when Americans are experiencing an escalation of division and polarization, there are lessons from Lincoln that we would do well to study for the betterment of the union. And for that, this historic site in Redlands is as good a place as any.

Benjamin Hilliker's
field drum.

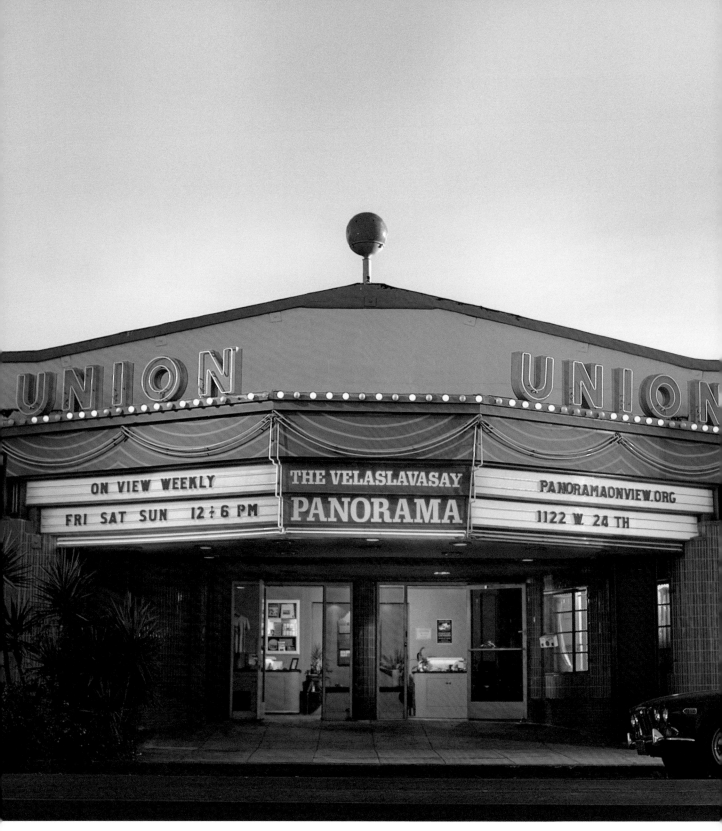

*The Panorama occupies a building with a
long history of community entertainment.*

Velaslavasay Panorama
West Adams

Despite what some hawkers of contemporary pop-up amusements might try to claim, multi-sensory and environmental attractions are far from original in the realms of art history and popular entertainment. One unique and antiquated artform, the panorama or cyclorama—a 360-degree painted and sculptural environment (most often a historical battle or religious scene) with a viewing platform in the center—was a favored type of immersive exhibition in the generations before the advent of cinema. These were most popular on the East Coast and in Europe, but even in 1880s Los Angeles there was a giant brick rotunda on Main Street between 3rd and 4th that housed *The Siege of Paris* panorama, while another showcasing a three-hundred-foot painting of the Battle of Gettysburg was briefly on view under a tent in an amusement park just south of downtown. The fad had waned by the turn of the century, and the *Siege of Paris* building would become the Panorama Stables for horses and later a skating rink before it was demolished to make way for a vaudeville theater around 1907.

A full century after the decline of the medium, a new cyclorama for Los Angeles emerged in the year 2000, and the Velaslavasay Panorama has been dazzling Angelenos who love history and seek out the unusual, now for almost a quarter century. Artist, graphic designer, and master gardener Sara Velas is the creator and ringleader at this semi-eponymous museum and generally unclassifiable cultural institution. Its cryptic name is a combination of her own surname with the maiden name of her mother (Asay) plus a nod to her Slavic heritage, all inspired by fanciful titles of attractions of old and a street sign she saw in Prague during a panorama-seeking pilgrimage around Europe just after college.

The first iteration, officially The Velaslavasay Panorama in Hollywood, occupied a quirky, pagoda-like structure on Hollywood Boulevard near Western Avenue, referred to as the Tswuun-Tswuun Rotunda and originally serving as a Chinese take-out restaurant. The inaugural painting, *Panorama of the Valley of Smokes,* imagined the Los Angeles basin two hundred years prior, before its transformation under American occupation and the ensuing march of urban development. The building was sold in 2004, forcing the Panorama to relocate, but before the demolition they were at least able to salvage the glowing orange ball from the rooftop, which has been incorporated into the façade of the present location. They can now be found near USC at the historic Union Theatre, built in 1910 as an early silent movie hall and serving as longtime local headquarters for a Tile Layers Union before being reimagined as a venue for public enjoyment yet again.

Inside, the panorama itself can be found down a darkened hall and up a tight and dramatically lit spiral staircase, where visitors emerge in the center of an experiential (and essentially unphotographable) artwork complete

Sara Velas, founder, panorama painter, master gardener, graphic designer, and organizer of curious happenings.

with 360-degree painting and sculptural elements, and a shifting light and soundscape. The first installation mounted in this space was *Effulgence of the North,* an Arctic scene inspired by accounts from the Age of Exploration and complete with sculptural icebergs emerging from the canvas and a blacklight-activated aurora borealis. In a separate space off the main entrance lobby, a compact room was transformed into the Nova Tuskhut, a fully stocked and remarkably atmospheric "Arctic trading post"—billed as the only of its kind in the lower forty-eight states.

Through Velas's role as president of the International Panorama Council, she became acquainted with a contemporary 360-degree painting movement in China and met some of its leading practitioners—introductions that would also lead to her subsequent panorama project. While having long since receded in the popular imagination of the Western world, the panorama artform has undergone a remarkable resurgence in the People's Republic of China, with more than twenty built across the country in the last thirty-five years. Through several visits and years of exchanges, Velas, together with longtime Panorama co-curator and cinematographer Ruby Carlson as well as collaborator/interpreter Guan Rong, developed the first ever transpacific panorama, depicting the city of Shenyang in Northeast China in the years 1910-1930. *Shengjing Panorama* (盛京全景图) was unveiled in Los Angeles in 2019, with the painters Li Wu (李武), Yan Yang (晏阳), and Zhou Fuxian (周福先) in attendance amidst much fanfare.

Back downstairs, there is a theater complete with a stage dressed with heavy velvet curtains and often some vintage lamps or showy bouquets that set the scene for a range of screenings, performances, lectures, demonstrations of magic lanterns or glass armonicas, and even the occasional wedding. Afterwards, visitors typically head out back past stage left, where they are transported into a lush and magical garden, with grottos, a gourd-filled gazebo (the "Pavilion of the Verdant Dream"), moon gate, water features, and handbuilt paths through expertly manicured exotic plants. In this peaceful environment,

one would be hard pressed to believe that not long ago, this space was nothing but a blacktop-paved parking area, but Velas has the "before" photos to prove that this seemingly impossible transformation did occur.

As though to suggest that her fate was sealed, Velas has been known to show off her birth certificate, proving that her arrival into this world took place within the bounds of the Panorama City section of the San Fernando Valley. Admittedly, the same cannot be said for the range of artists and other collaborators who have come together over the years to help make the Panorama into what can be seen today, including (among others) visionary builder Oswaldo Gonzalez, archivist Jade Finlinson, and Berlin-based sound artist Moritz Fehr.

The Velaslavasay is the only contemporary painted panorama in the country, where only a few historic examples remain nationwide, including one at Gettysburg National Military Park (of the 1863 battle fought there), one recently reinstalled at the Atlanta History Center (also depicting the major local Civil War battle), and one of Versailles at the Metropolitan Museum of Art. By looking to the popular art forms of the past, a new space has been created, and as little as viewers today might have in common with the average ticket holder of the 1880s, the sense of wonder this kind of experience inspires is timeless. Even if it doesn't spark a broader revival, in a city best known for the form of entertainment that superseded this analog medium, one can be grateful to have such a delightful and wonderfully anachronistic gem to find ourselves in the center of, lost in its beauty and charm.

A model of LA's lost Santa Fe train depot, La Grande Station, made by collaborator Bridget Marrin.

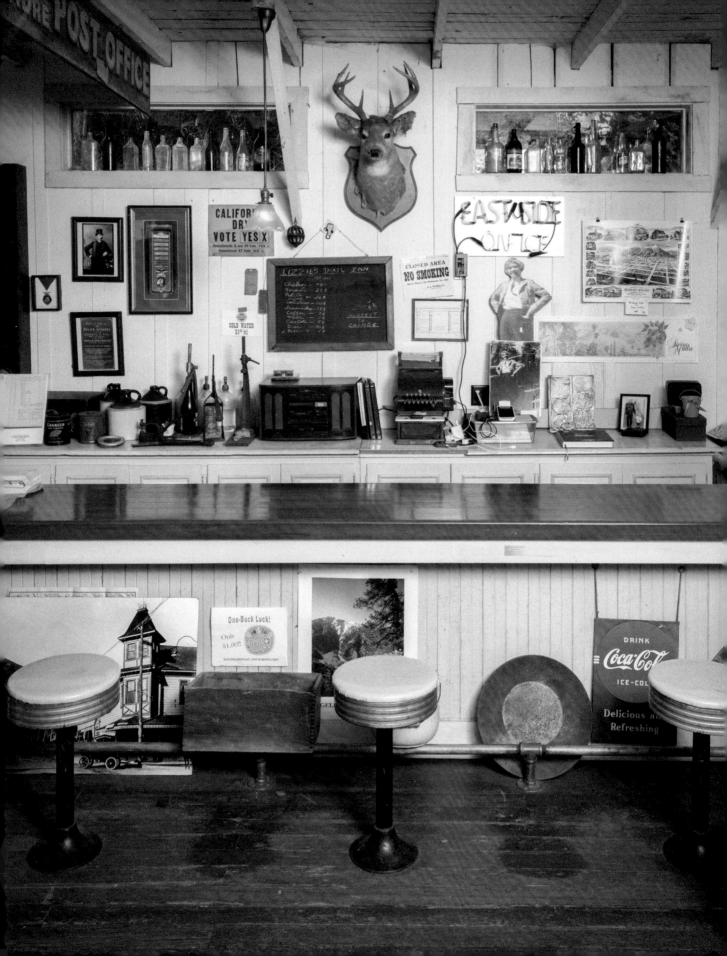

Lizzie's Trail Inn Museum & Richardson House
Sierra Madre

With a prime location at the trailhead leading from Sierra Madre's leafy streets up all the way to the top of Mount Wilson, it's easy to see why Lizzie's Trail Inn would do good business as a lunch counter serving weary hikers in need of sustenance. Some establishment of the sort was operating at this location as early as 1890, coinciding with the advent of the so-called "Great Hiking Era" across the Southern California mountains, acting also as a mule packing station to shuttle supplies up to the mountain resorts that were all the rage before they were destroyed by fires and landslides. The building was leased by various operators who failed to leave a meaningful impression; the real story seems to begin in 1925, when Elizabeth Louisa Ciez Adler Weiss Stoppel McElwain (AKA "Lizzie") bought the place on her birthday and took the reins, turning it into a more established restaurant that became locally famous for her fried chicken and handmade ravioli dinners, not to mention her big personality and many friends, clandestine business practices, and reported fluency in nine languages.

Lizzie was born in 1896 near Kyiv in present-day Ukraine. Her parents both died within a few months of her birth, and when she later learned that she was adopted, she ran away and located an aunt. Her family immigrated to the US in 1909, coming to LA and later Sierra Madre by way of Cincinnati. Though not discussed in her official biography, by the fact that her funeral service was officiated by a rabbi from Temple Beth Israel in Highland Park, and that she was interred at the Home of Peace Cemetery in East LA—resting place of much of LA's Jewish community of that era, including studio moguls and celebrities like Louis B. Mayer, Carl Laemmle, three of the four Warner Brothers, and two of the original Stooges—it can reasonably be assumed that Lizzie's family was part of the mass migration of Jews who fled Eastern Europe amidst violent antisemitic attacks known as the pogroms.

During her tenure at the Trail Inn, Lizzie lived in the adjacent Richardson House, which is also part of the museum and is the oldest remaining residence in Sierra Madre. John Richardson was a homesteader who was ranching on 150 acres here by the 1860s, and this self-built home was moved twice, changing hands a few times before landing at the present location, where it was repopulated with period antiques. A highlight of the house tour is a trap door in the back bedroom, where in the event of a Prohibition-era raid, Lizzie could hide the still for making hooch. Indeed, a framed 1926 search warrant names Lizzie's then-husband, Louis Stoppel, for crimes relating to the production and distribution of moonshine at both the home and cafe, though it seems they paid the fines repeatedly and kept up production, and it's said that patrons could turn their coffee cup a certain way to signal that they were ready for a spirited warm-up.

The interior is a true time capsule. The small cutout of a woman under the "EAST SIDE" beer sign is of Lizzie herself.

Other scandalous activities were on offer during the restaurant's heyday: dancing, pinball, a one-armed bandit (an early slot machine) tucked away behind a booth, and a few cabins out back that were made available by the hour for sexual trysts. Stoppel had left Lizzie by the early 1930s, and some health challenges prompted her to step away from the business for a year, only to assume control again in 1936 after marrying Edward Harding "Mac" McElwain, thereby acquiring both her final surname and the support needed to continue operating for her remaining years. Lizzie died in 1939, purportedly of breast cancer, and Mac followed in 1941, leaving the business to their son, Lyle McElwain, and his family, who also took up residence in the Richardson House. After closing for good in 1948 citing war-related food shortages, the Inn sat vacant for a few decades until the property was acquired by the city. The Sierra Madre Historical Preservation Society (SMHPS) undertook a partial restoration in 1976 as a bicentennial project, but it limped along over the next twenty years, and damage from a few earthquakes meant that a near total rehabilitation was needed before it could open as a proper museum in the mid-1990s.

The Trail Inn has been set up lovingly as a time capsule and still attracts hikers, though it now services their curiosity about the area's history, even if the vintage, bolted-down bar stools and the replica neon sign advertising "EAST SIDE [beer] ON ICE" make one wish this museum did offer provisions on the side. Until a refresh in recent years, there were labels written in first-person on some of the artifacts, typically forbidden in museum didactics, relating for example that "This pan was used by my mom (Elsie Orme McElwain) to cook the chicken at Lizzie's Trail Inn 1930's - 1940's." Though these were completely charming and lent an

Every mountain trailhead could use a cafe, museum, or both.

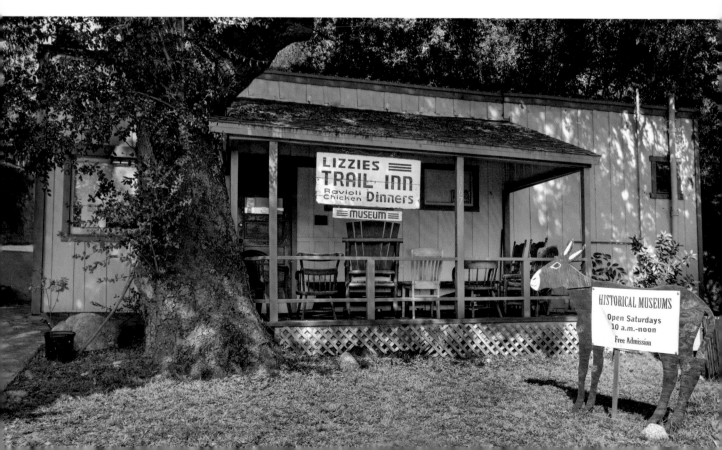

uncommon intimacy, they have since been updated for clarity, understandably, with the highly personal text rendered as a quote and attributed to Elsie's son and longtime SMHPS member, Maurice Orme.

Over the bar, a taxidermied buck heightens the rustic vibe, as does the original potbelly stove, an old-school pinball machine, and weathered signs for mountain trails, as well as one for the visitors' gallery at Mt. Wilson's 100-inch telescope (see page 99). The old bathroom is out of commission, but has been filled with historic photos, mostly of the mule packing stations in the nearby foothills. There is a bell worn by the lead burro in a pack train to alert oncoming hikers of the approaching wide load, though they usually traveled at night to avoid the traffic, using "bug" lights (early flashlights consisting of a candle in a coffee can that would attract bugs) like the rare example that is also on display. On the table in a single reconstructed booth is a laminated reproduction of a historic menu from a time when $1.50 would get you the Complete Dinner, with both the legendary ravioli and the fried chicken, along with spiced beans, potato salad, rolls, relishes, coffee, and ice cream.

During open hours on Saturday mornings, one will most often find a number of SMHPS volunteers occupying the rocking chairs on the porch, some in period attire, and all ready to relate the history of these buildings and their former occupants, along with countless other stories about this idyllic foothill community and its neighboring mountain range. It's easy to get wrapped up in their enthusiasm and generosity of spirit, but before taking off, visitors should grab a seat at the bar, sit quietly for a moment in this singular space, and imagine raising a glass in a toast, both to Lizzie herself, and to the community's success in ensuring that here her memory will long be served.

The nearby Adams Pack Station is the last remaining mule packing game in Southern California, but quite a few hikers still make the significant trek up to Mt. Wilson.

ONE WAY TRAFFIC

VALET

MAGIC CASTLE
UBER & LYFT
PLEASE PULL FORWARD

Magic Castle
Hollywood

Plenty has been written over the years about the Magic Castle, the legendary magicians' clubhouse and longtime home of the Academy of Magical Arts in the heart of Hollywood. While the vast majority of coverage is focused on divulging how the lay public can go about getting an invite, spotlighting scandals that have led to a shakeup amongst board and staff leadership in recent years, or reviewing the quality of the entertainment or the food, relatively little is ever said about the fact that it also operates very much as a living museum. Actually, the Castle has a dedicated museum space, but the artistic, architectural, and historical intrigue extends throughout the sprawling facility. That makes it perhaps the only museum around that has a strictly enforced dress code, one of many features that help to make it so iconic.

The one-time residence that forms the core of the castle was built for businessman Rollin Lane in 1909, though it's been augmented and altered nearly beyond recognition. Anyone curious to get a sense of what the mansion looked like in the early days, well before the magicians got the keys, should visit the house museum in Redlands known as Kimberly Crest (see page 149); Lane was well aware of the Inland Empire gem and contracted the same builders to erect a near copy for him in Hollywood years later. Fast forward a few decades and the Lane mansion had fallen on hard times, having been converted to a boarding house, and deteriorated considerably by the time it was acquired in the 1950s by Thomas Glover, who also owned the equally legendary Yamashiro restaurant perched on the hill above.

Magician, actor, and comedy writer Milt Larsen could see the dilapidated home from the NBC-TV offices where he worked concocting gags for the *Truth or Consequences* game show. He successfully convinced his brother, Bill Larsen Jr., that this would be an ideal location to finally launch the private club for magicians that had been the dream of their father, Bill Larsen Sr., who had already formed the Academy for Magical Arts (AMA) back in 1951. Bill was a savvy businessman and Milt had a penchant for carpentry; with this winning combination, they made a handshake agreement with Glover and announced in their *Genii* magazine that the world's only Magic Castle would be opening on January 2nd, 1963.

With Bill and his wife Irene at the helm of operations, Milt set to work transforming the space, which he would continue to do with the help of friends for many years to come. He was not only a general handyman, but was also an inveterate collector of antiques and architectural fixtures from other grand old buildings around LA that were slated for demolition, and which he could incorporate into their new club's many rooms. This includes everything from stained glass windows and skylights, lighting fixtures, and the massive metal awning over the front doors. The wall paneling in one of their theaters (the Palace

After decades of alterations and additions, the original 1909 Lane mansion is barely recognizable.

The most elaborate museum display featuring Cardini, the Suave Deceiver.

of Mystery) is actually made from hundreds of polished mahogany doors from an old hotel in Long Beach, some still with visible door knob holes and even a few with painted room numbers. Behind the bar in the Grand Salon, just beyond the hidden bookcase entrance, are backlit lantern slides advertising coming attractions for vaudeville shows from the late nineteenth century, or advocating for temperance via a touring missionary's lecture, the former rescued from the old Hippodrome Theater in downtown LA and the latter found in a junk store.

Visitors often get the feeling that the maze-like interior of the Magic Castle is impossibly more expansive than the street view would suggest, and the labyrinthine routes connecting bars and theaters gives the impression of an architectural sleight of hand. No one has likely ever guessed just by looking, but the Thomas O. Glover Sr. Annex turns out to be a masterful adaptation of a former three-story parking garage carved into the side of the hill. Originally an improvised solution when the fire department threatened to shut down a party over capacity concerns, it turned into a two-year expansion project that practically doubled the castle's usable space, including the creation of the Palace of Mystery and Parlour of Prestidigitation theaters, the members-only William W. Larsen Memorial Library, and the space known as Milt Larsen's Inner Circle that contains the designated museum.

Within the museum space are artifacts, costumes, and photographs lining the walls that surround a bar, which itself was a prop from *Hello, Dolly!*—the 1969

musical comedy starring Barbra Streisand. Exhibits include highlights of famous AMA members like Johnny Carson, the 1930s magic manufacturing plant of Floyd Thayer in what is now the downtown Toy District, and the Larsens themselves, often called the First Family of Magic, with four generations garnering recognition in the field. Erika Larsen, daughter of Bill and Irene, still serves as president of the board, and her daughter Liberty is herself a captivating performer.

The most elaborate museum installation features Richard Valentine Pitchford, better known as Cardini, the Suave Deceiver, a master of legerdemain who popularized the formal magicians' look with tuxedo, top hat, and white gloves in the 1930s. The Cardini diorama is a forced-perspective stage set complete with the tricks, cards, and costumes from his last act with his wife and assistant, Swan. Longtime AMA member Randy Pitchford, who was married on the Palace of Mystery stage in 1997 and is the grand-nephew of Cardini, paid top dollar to outbid David Copperfield for the collection. In 2022, Pitchford also purchased the Magic Castle itself, securing its stability for the next generation.

Milt Larsen passed away at age 92 in 2023, long after losing his brother Bill in 1993 and Irene in 2016. He held court at the castle until the very end, and a seat at the Owl Bar is now perpetually reserved in his honor with a memorial cocktail (an old fashioned). Despite the loss of the last founder, the castle undoubtedly still has tricks up its sleeve. With its own history on full display, the experience of a night out there will continue to be magical in every sense of the word.

Milt Larsen just a few months before his passing, with niece and board president, Erika Larsen.

Finnish Folk Art Museum
(Pasadena Museum of History)
Pasadena

Those who are devoted to small and highly unique museums are likely to reserve a special class of appreciation for the rare museum-within-a-museum (see also the Southern California Railway Museum on page 103). Granted, that isn't the only reason to love the Finnish Folk Art Museum, which is tucked into the trees behind the Fenyes Mansion, on the property now managed and known primarily as the Pasadena Museum of History (PMH). And while the PMH is one of the most renowned and professionalized of the many historical society museums across Southern California, the Finnish Folk Art Museum is the only one of its kind in the entire country, and yet remains in relative obscurity.

Viewable only on special tours, the mansion was commissioned in 1906 by artist and philanthropist Eva Fenyes, though the relevant period begins forty years later, when Yrjö "George" Paloheimo married Eva's granddaughter, Leonora "Babsie" Curtin, and moved in. Shortly thereafter in 1948, Paloheimo was appointed as the first Finnish Consul for Southern California, Arizona, and New Mexico, and the room that he converted into the official Consular Office during his sixteen-year tenure is preserved just how it was left. Only a year after taking up the post, he acquired a redwood garage from a neighboring estate on Millionaire's Row and converted it into a traditional Finnish summer cottage, or *tupa,* including architectural ornamentation and the obligatory sauna (since no Finnish home—traditional or contemporary—is complete without one).

It was in the *tupa* that Paloheimo convened a small group in 1953 to form the Finlandia Foundation, an organization seeking to strengthen diplomatic and personal ties between the US, Finnish Americans, and the mother country. To set up the museum, UCLA Professor Inkeri Rank was enlisted to travel to Finland and collect farmhouse furnishings, housewares, and various folk crafts from rural provinces around the country, though mainly from the coastal Ostrobothnia region.

The museum is meant to show a complete (and completely obsolete) way of life. This kind of home would have been almost entirely self-sustaining until as late as the turn of the twentieth century, when the advancements of the Industrial Revolution arrived even in rural Finland. Few things have been acquired in the decades since its founding; after all, the museum pays homage only to ancestral Finnish culture, and contains hardly anything relevant to modern life for the Finns, let alone Finnish Americans. The results are remarkable, but fair warning: given that Finland is one of the northernmost countries in the world, a visit here during Pasadena's summer heat is advised only for those who don't

The museum sits as a hidden gem in the mansion's backyard.

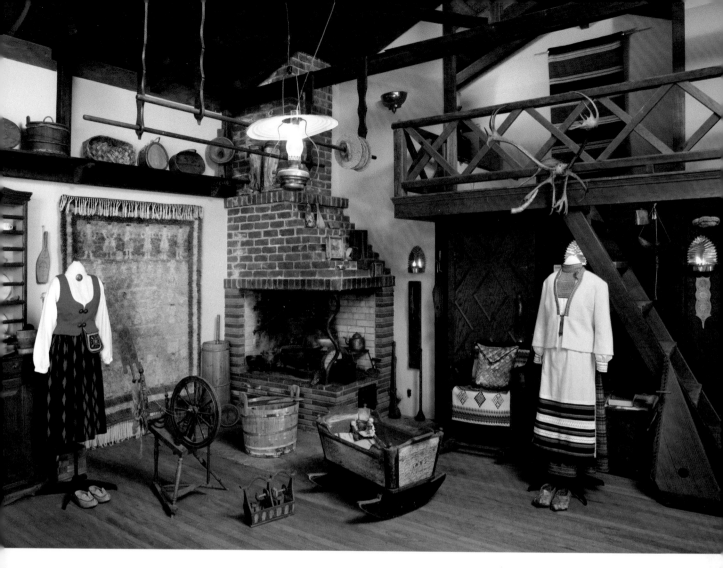

The main living, dining, and bedrooms contain a range of typical antiques and traditional crafts.

mind a little cognitive dissonance, whereas a gloomy and wet winter day will best facilitate an atmosphere conducive to mental transportation. In any case, the craftsmanship on display can be fully appreciated year-round.

A combined living room, dining room, and bedroom centers around a grand open hearth for both cooking and heating. Hanging on horizontal poles suspended from the ceiling (*leipävartaat*), discs of rye sourdough bread are dried and stored. A stylish grandfather clock would have been a status symbol, as opposed to the rag rugs woven from bits of worn out clothing and other scrap fabric (*räsymatto*), which have patterns indicative of their place of origin. Elsewhere in the room are examples of handmade wooden furniture, some painted with flower motifs, and bunk beds with curtains for privacy.

Many of the carved wooden items relate either to courting and marriage or to the demonstration of wealth and clout. The spinning wheel has an elaborately carved distaff (*rukinlapa*), the piece that holds the bundle of flax, which was typically carved and painted by young men as a proposal offering. The wheel would have then been used to fashion the flax into curtains, clothes, and linens needed for the home. Other practical items are made from the ubiquitous bark

of the birch trees, from rope and baskets to a ladle, slippers, and even, somewhat counterintuitively, a candlestick holder. There are also traditional costumes with lace and embroidery, musical instruments, and a chunk of parasitic fungus from a birch tree (*Kääpä*) that was used as a pincushion.

The entire two-acre estate was gifted to the Pasadena Historical Society in 1970, and the Finlandia Foundation has since become a national organization with chapters around the country, though it still helps manage the cottage and its contents. Many Finlandia members see it as a place of cultural nostalgia if not a pilgrimage site, even continuing to fire up the sauna at their meetings. The rest of us will have to keep our clothes on, settling for a peek at the space sans steam. With the knowledge that even a visit to rural Finland won't put one in such an environment as this, we can fully appreciate the vision through which we find this capsule of traditional culture in our midst.

An arrangement with a number of pieces made using birch.

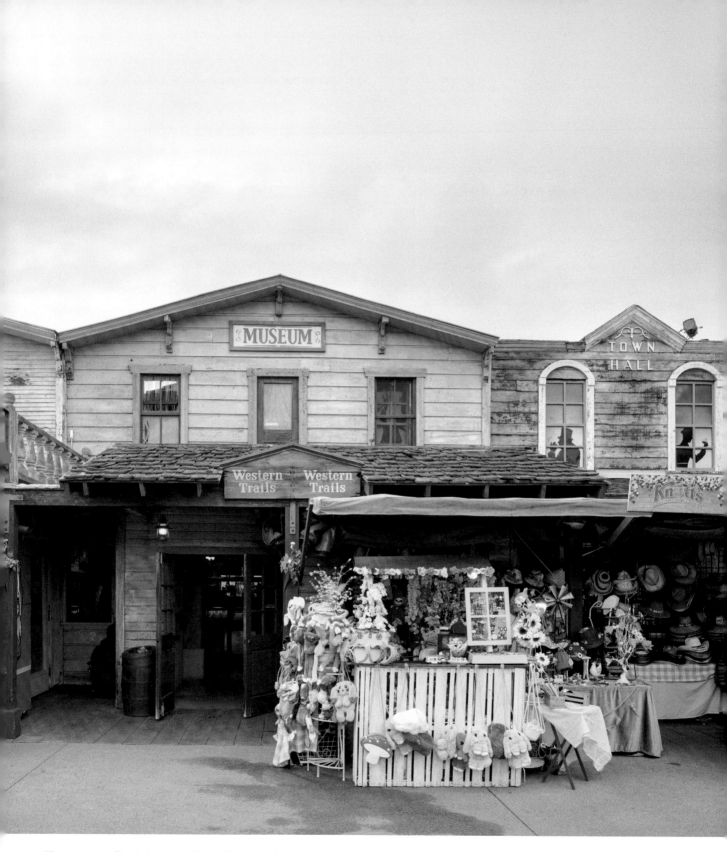

The museum fits right into its Ghost Town setting.

Western Trails Museum, Knott's Berry Farm
Buena Park

Full-scale family amusement parks are typically not where one expects to find a museum making an earnest attempt at relating US history, particularly considering that this is almost definitely not the main reason anyone might visit. But then Knott's Berry Farm, steeped in themed nostalgia and family-operated until 1997, is in some ways not your typical amusement park. At one time or another, Knott's has been home to a boxing museum, piano museum, and Mott's Museum of Miniatures—all private collections brought by concessionaires who eventually moved on and took their attractions with them. Yet one museum has outlasted them all, and remains in the heart of the beloved Ghost Town environment. That's in part because founder Walter Knott loved his American history, but in fact it would not exist without a friend of his, Marion Speer, whose legacy is not as well secured as the berry farmer himself, but nevertheless lives on in the Western Trails Museum.

Born in 1885, Speer was a mining engineer who followed the oil booms from his native Texas out to Southern California. He was also an amateur historian who turned out to be a more obsessive explorer and collector than most. Speer would take epic road trips and backcountry hikes across the Southwestern US, visiting sites of gold rushes, battles, Indigenous settlements, and colonizers' ghost towns and mines, helping himself to whatever sunbaked, rusted relics he could uncover along the way. He reportedly logged more than 300,000 miles tracing every documented nineteenth-century overland trail in the country, and he and his wife Nettie even spent their honeymoon hiking five hundred miles of an old Utah trail. In 1931, he self-published an account of his expeditions along these dusty byways in a book titled *Western Trails*.

Just a few years later, Speer opened up the Western Trails Museum in a standalone building next to his home in Huntington Beach, on a small side street that still bears his surname. At that time, the Knotts's place nearby was little more than a berry stand, and had only recently started serving Walter's wife Cordelia's famed chicken dinners on their wedding china. The amusements and historic structures, brought in to entertain visitors who were soon waiting hours for a table, wouldn't evolve into Ghost Town until years later, with Speer encouraging its development and contributing articles to Knott's in-house periodical, *Ghost Town News*. In 1956, when Speer tired of running the Western Trails Museum on his own and it was time to find a new home for his thirty thousand artifacts, Knott didn't hesitate to make space in his expanding park. As one condition of the transfer, Speer would stay on as resident curator, which he did for another thirteen years.

Branding irons galore opposite a diorama of a Twenty Mule Team hauling borax. The back room is the Berry Farm Memory Corner.

As in Speer's day, the museum still contains plenty of gems and minerals, antique firearms, horseshoes, arrowheads, barbed wire, and dozens of branding irons all splayed out across a long, low table. The largest object is a nineteenth-century horse-drawn fire engine, along with other arguably random heirlooms such as ornate old cash registers and wax cylinder record players. By one of the entrances hangs a scroll signed by many of Speer's colleagues at Texaco, honoring him on his retirement after twenty-eight years, with a small metal plaque affixed to the bottom of the frame reading, "MY. MOST. TREASURED. POSSESSION." An even more personal exhibit features Speer's membership cards to rockhound and Western history clubs, framed alongside his childhood report cards, a picture of him as a baby, and even his social security card.

One section of the museum contains numerous wooden whimsies that were whittled, carved, and donated by a range of hobbyists who visited, including striking pieces like a tiny chain crafted from a single toothpick by J.M. Reed of Redondo Beach, and a surprisingly intricate pair of salad tongs with seven operable

joints, all carved from a single block by Bill Peeler of Hollywood. Mounted on the ceiling are two large paintings of Western figures Buffalo Bill and Jim Bridger, done by artist and designer Paul von Klieben, a legend in Berry Farm lore who was responsible for much of the look of Ghost Town. These complement an area called the Berry Farm Memory Corner that highlights some of the history of the park itself, with old maps, menus, photos, tickets, and newspaper clippings.

Despite the feeling of being trapped in time (as is the mandate for all of Ghost Town), the museum has been in various states of disarray since Speer's death in 1978. The original space was three times the size of the one it has occupied for the last few decades. Some of the antiques have been repurposed as decor throughout the park, while others were auctioned off in 2017. Worse than that, if a horse or mule in the adjacent livery stables (Old MacDonald's Farm) kicks the uninsulated wall that is shared with the museum, it can knock over objects on display. The corporate entity that has been running the park for the last quarter century still considers the museum on-brand, even if fantasy and entertainment is valued over education; in other words, there's a general preference for uncomplicated history, if any. While it may not meet expectations at more professional standalone museums, it is admittedly still more than most would expect given the setting.

There is at least someone looking out for the museum: J. Eric Lynxwiler, an urban anthropologist, neon preservationist, and graphic designer who co-wrote the definitive book on the park *(Knott's Preserved: From Boysenberry to Theme Park),* has become a notable advocate, undertaking efforts to support the museum and the history it contains. Lynxwiler works as a consultant for Knott's, designing things like historically inspired labels for their new line of preserves (available exclusively in the on-site market and not to be confused with Knott's Berry Farm branded jellies, the rights to which were ironically sold to Smucker's and discontinued in early 2024). He has also created a new font (which he calls Marion Speer) just to reprint some of the faded handwritten museum labels, taking out some of the more egregiously offensive descriptions of objects in the process.

The Cedar Fair company, which bought the park from the Knott family in the 1990s, is now set (as of this writing) to merge with Six Flags, consolidating into an even more massive family entertainment empire. The museum might hang on if future consumers demand a sense of "authenticity" and "character" that it is seen as satisfying, though if faced with pressure to present a more equitable and just portrayal of the history of the American West, operators may be equally likely to scrap the whole thing in favor of a more fictionalized and sanitized approach. At the end of the day, most people come to Knott's seeking little more than a fun escape. If an imperfect yet still impressive museum can contribute to that experience it's a win overall, and if there's any chance it can get them to think more deeply about stories of the West and how they are preserved and told, even better.

Museum of Jurassic Technology
Culver City

Beyond a relatively unassuming façade, the Museum of Jurassic Technology (MJT) fosters such a sense of intrigue that visitors are often left feeling they've stumbled into an alternate universe. It lodges in the memory as something more like a dream, judging by the way it's talked about with a sense of uncertainty as to what it really is. Forget that the museum has been referenced in countless publications and featured in mainstream media outlets both locally and even internationally for over thirty years, or that its founder was awarded the prestigious and high-profile MacArthur "Genius Grant," or that it is the subject of a book that was a Pulitzer Prize finalist (*Mr. Wilson's Cabinet of Wonder* by Lawrence Weschler). Such everlasting mystique is only possible because of the effect it has on visitors, mixing a sense of personal discovery with the disorientation we might feel around the edges of our comprehension. There has emerged a general consensus, amongst those in the know, that this is one of the great, singular experiences one can have, not just in Los Angeles but in the world of museums, broadly speaking.

David Wilson, a filmmaker and special effects artist by training, founded the museum in the early 1980s together with his wife, Diana Drake Wilson. For the earliest iteration, he was given a temporary space in Pasadena by the late Terry Cannon, a longtime supporter and friend of the museum who was also the visionary founder of both the Baseball Reliquary and Pasadena Filmforum (now Los Angeles Filmforum) as well as a magazine publisher and beloved librarian. After a few itinerant years of temporary exhibitions, guest lectures, and loans to other institutions, the MJT landed in the present Venice Boulevard location by the end of 1988, and the rest is Lower Jurassic history.

The museum is often described as a contemporary *Wunderkammer* or cabinet of curiosities, and much commentary over the years has fixated on the presence of unverifiable details and confounding references in its didactics. Others have noted its role as a critical reflection on the historical development of museums in the Western world and the never-ending pursuit to organize and encapsulate all knowledge. More thoughtful observers argue that, beyond the question of truth versus fiction, the higher purpose of the museum—and the reason it continues to resonate with visitors after so many years—is in fostering an overwhelming sense of wonder, taking pleasure in the act of contemplation, and acknowledging there will always be realities beyond human perception. To that end, the beauty and skill of its execution can't hurt.

Nearest the entrance are some of the older and by now most iconic exhibits, such as that on the South American *deprong mori* bat which can

The upper level balcony of the Fauna of Mirrors *exhibit.*

The rooftop courtyard and aviary is a particularly nice place to take one's tea.

fly through solid objects, or the single small fruit pit, which a label describes as being carved with, among other things, a scene containing some twenty different animals, and an "unusually grim" Crucifixion. Later exhibits expanded the footprint deeper into the space—such as the unbelievable micro-miniature sculptures of Armenian American violinist Hagop Sandaldjian. The museum eventually took over a second floor apartment (now the cozy Tula Tea Room) and the rooftop, which was transformed into a lush courtyard containing a fountain, resident doves, and a columbarium.

The museum is ever evolving, and each new transformation of space is more wondrous than the last. The Medieval manuscript-inspired exhibit, *Fauna of Mirrors: A Catadioptric Bestiary,* is a fantastical space with stairs down to a lower level that had to be partially excavated, and up to an encircling balcony. Niches within niches hold dioramas featuring a selection of creatures viewed through the mirror (catoptric) and lens (dioptric) optical devices alluded to in the title, and paintings of mostly mythical beasts cover the walls and the domed ceiling that culminates with a cupola radiating filtered light onto a hanging

chandelier. The murals were painted by the late Guadalajara-based artist and bookmaker, José Clemente Orozco Farías, grandson of the legendary Mexican muralist who shared his name, and supplemented by the work of another longtime museum collaborator, artist and filmmaker Nana Tchitchoua. The museum's newest project is an experiential exploration of Islamic architecture set for completion in 2024, with enough *muqarnas* and *laceria* to make one feel transported to a palace in Al-Andalus.

 A community of artists and outsiders has long gravitated to the MJT, coming and going over the years to lend their talents to the cause and bask in the enjoyment of being affiliated with such a magical and legendary institution. Many who have spent an afternoon wandering its darkened halls, or an evening taking in a virtuosic performance of one of the ancient and obscure musical arts they've hosted, would surely agree: even if the Museum of Jurassic Technology isn't easy to define or pin down, it stands as one of the greatest cultural assets Los Angeles can claim.

A Soviet space dog portrait overlooks a stage set for a most unique ensemble. Museum founder David Wilson can sometimes be spotted playing the accordion or nyckelharpa (at left)

HALL OF LIFE
From Stars to Early Civilization

A Grand Staircase of Rock

PLEASE DO NOT
TOUCH THE FOSSILS

Afterword

Amidst the existential uncertainties that arose when the coronavirus pandemic hit, there appeared a number of hand-wringing think pieces about the projected cultural paradigm shift and financial devastation that would inevitably result in as many as forty percent of American museums closing their doors for good. While these dire predictions were presumably referring only to major museums with huge overhead expenses rather than those run by volunteers in donated space (like most all news about "American museums"), it turned out that the rate of closure during these challenging and traumatic years was not noticeably higher than in non-pandemic times. This is a testament not only to the robust relief packages that were forthcoming, but also to one of the few things virtually all museums have in common: the tenacity and dedication of the people running them.

The region has recently lost the Annenberg Space for Photography in Century City, the California Museum of Art Thousand Oaks, the Museum of Pinball in Banning, and the Museum of Torture at Medieval Times in Buena Park. But new museums have continued opening up, like the American Honda Collection Hall at the company's Torrance headquarters, or the Compton Art & History Museum (see page 41), or the interactive Vintage Synthesizer Museum that relocated from the Bay Area to a former yoga studio in Highland Park in 2021, as well as (you can't make this up) an unrelated Medieval Torture Museum occupying a six-thousand-square-foot basement on Hollywood Boulevard. Emerging spaces will continue filling cultural, historic, scientific, and other unidentified voids, reinforcing the mutability of the museum-scape as well as the resilience, and in some cases strangeness, of those who will be part of it.

By taking a longer view, we can see the true magnitude of what we have lost in the world of museums. Through my research, I've become aware of nearly two hundred across greater Los Angeles that have shuttered over the last century (plus a few dozen which have publicly announced plans to open and apparently never did). Personally, I regret not having the chance to visit the long since closed Bulah Hawkins Doll Museum & Hospital in Santa Monica, the Parker Lyon Pony Express Museum in Arcadia, the Honey & Bee Museum in Canyon Country, Dr. Blythe's Weird Museum in Hollywood, the Carol & Barry Kaye Museum of Miniatures in Mid-City, Slammers Wrestling Gym & Museum in Sun Valley, the United Business Interiors Heritage Museum downtown, the Museum of Hair in Pasadena, or the Nellie Kuska Museum in Lomita. The subject of departed local museums certainly warrants a book of its own, but why undertake such a depressing project when there are hundreds of amazing places that are still around?

The massive slab of Coconino Sandstone, with 275-million-year-old animal tracks, greets visitors as they enter the Raymond M. Alf Museum of Paleontology.

While the big museums continue to confront issues of inadequate diversity amongst their staff, holdings, or perspectives, the very existence of a plethora of smaller museums, each with an exceedingly narrow focus and particular frame of reference, can be taken together to represent its own kind of diversity of thought and experience. To facilitate maximum parity, I propose that we could use many more of them. In fact, let's have a museum for everything that can be studied or appreciated, everything that someone has a desire to share. Where are the museums dedicated to the Cambodian, Ethiopian, and Ukrainian diasporas, to mariachi or landsailing or Quakerism, to animation or the Hollywood sign or kitsch? Efforts towards some of these are already underway, and for the rest, who can say? Perhaps you, reader, are in a position to help get one started, sharing your own thoughts, creations, collections, knowledge, stories, traditions—and opening the door for those who may come. If so, I certainly hope you will call me when you do.

A miniature wooden model of the cathedral from the Armenian town of Etchmiadzin, by Hovhannes Guedelekian at the Ararat-Eskijian Museum.

Further Reading

In addition to the published titles below and direct communication with museum creators and representatives, countless print and digital articles, videos, and podcasts were referenced to confirm details of the featured institutions and the broader histories with which they intersect, with special recognition for Huell Howser's public television broadcasts as well as the *Los Angeles Times* historical archives (freely accessible with a Los Angeles Public Library card). Every effort has been made to ensure the accuracy of the information presented, and any corrections will gladly be considered for incorporation in future printings; please write to: **museumsoflosangeles@gmail.com**

Further Exploring— Every Museum in Greater LA

This book features only a fraction of the full museum-scape of Greater Los Angeles, where well over 750 museums can be found. For a comprehensive listing, visit the companion website at: **everymuseum.la**

Adamson, Jeremy. The Furniture of Sam Maloof. Smithsonian American Art Museum, W.W. Norton & Co. (2001).

Apostol, Jane. El Alisal: Where History Lingers. Historical Society of Southern California (1994).

Arany, Lynne & Hobson, Archie. Little Museums: Over 1,000 Small (and Not-So-Small) American Showplaces. Henry Holt & Co. (1998).

Boulé, David. The Orange and the Dream of California. Angel City Press (2013).

Candlin, Fiona. Micromuseology: An Analysis of Small Independent Museums. Bloomsbury Academic (2017).

Esoteric Art of Benjamin Creme, The. Share International Foundation (2017).

Fishburne, James with Erkki Huhtamo & Ruby Carlson (eds.) Grand Views: The Immersive World of Panoramas. Velaslavasay Panorama with Forest Lawn Museum (2023).

Freely, Roger. California's Golden Museums and Historical Places. Freely Press (2006).

Friends of the Antelope Valley Indian Museum. Guide to the Antelope Valley Indian Museum. California State Parks (2010).

Gordon, Betsy & Rogers, Jane (eds.) Four Wheels and a Board: The Smithsonian History of Skateboarding. Smithsonian Books (2022).

Gordon, Tammy S. Private History in Public: Exhibition and the Settings of Everyday Life. AltaMira Press (2010).

Guzmán, Romeo with Carribean Fragoza, Alex Sayf Cummings, & Ryan Reft (eds.) East of East: The Making of Greater El Monte. Rutgers University Press (2020).

Heidt Jr., Horace. Horace Heidt: Big Band Star-Maker. Horace Heidt Productions, Inc. (2015).

Hitt, Marlene A. and Little Landers Historical Society. Sunland and Tujunga: From Village to City. Arcadia Publishing, the Making of America Series (2002).

Kath, Laura. Forest Lawn: The First 100 Years. Tropico Press (2006).

Kirshenblatt-Gimblett, Barbara. Destination Culture: Tourism, Museums, and Heritage. University of California Press (1998).

Kohne, Dan & Polyzoides, Stefanos (eds.) A Temple of Science: the 100-Inch Telescope at Mount Wilson Observatory. Mount Wilson Institute (2018).

Larsen, Milt. Hollywood Illusion: Magic Castle. Brookledge Corporation (2000).

Lofgren, Don & Liu, Jennifer. Moment of Time: The Life of Raymond Alf and the History of the Peccary Society. (2018).

Los Angeles Poverty Department. Agents & Assets: Witnessing the War on Drugs and on Communities.
Queens Museum (2014).

Mandelkern, India. Electric Moons: A Social History of Street Lighting in Los Angeles. Hat & Beard Press (2023).

Margolie, John. Pump and Circumstance: Glory Days of the Gas Station.
Bulfinch Press (1996).

Marie, Carol. Milt Larsen's Magic Castle Tour. Brookledge Corporation (1998).

Matsuda, Michael. Martial Arts History Museum: How it All Began. (2011).

McCue, Don (ed.) Treasures of the Lincoln Memorial Shrine. Watchorn Lincoln Memorial Association (2008).

Mermelstein, Mel. By Bread Alone: The Story of A-4685. Auschwitz Study Foundation (1993).

Merritt, Christopher and Lynxwiler, J. Eric. Knott's Preserved: From Boysenberry to Theme Park, the History of Knott's Berry Farm. Angel City Press (2015).

McTavish, Lianne. Voluntary Detours: Small-Town and Rural Museums in Alberta. McGill-Queen's University Press (2021).

"Keys to the City" presented to Horace Heidt by towns large and small, at the Horace Heidt Big Band Museum, Sherman Oaks.

The Museum of Jurassic Technology: PRIMI DECEM ANNI; Jubilee Catalog. Society for the Diffusion of Useful Information Press (2002).

Okura, Albert. The Chicken Man with a 50 Year Plan, LCM Publishing (2015).

Purcell, Rosamond with Linnea S. Hall and René Corado. Egg and Nest. The Belknap Press of Harvard University Press (2008).

Rubin, Saul. Offbeat Museums: The Collections and Curators of America's Most Unusual Museums. Santa Monica Press (1997).

Rugoff, Ralph. Circus Americanus. Verso (1995).

Saari, Jon L. Black Ties and Miners' Boots: Inventing Finnish-American Philanthropy. Finlandia Foundation National (2010).

Stanic, Borislav. Museum Companion to Los Angeles. Museon Publishing (2011).

Sutton, Matthew Avery. Aimee Semple McPherson and the Resurrection of Christian America. Harvard University Press (2007).

Thompson, Mark. American Character: The Curious Life of Charles Fletcher Lummis and the Rediscovery of the Southwest. Arcade Publishing (2001).

Traversi, David C. One Man's Dream: The Spirit of the Rubel Castle, Strange Publications, Ltd. (2002).

Weschler, Lawrence. Mr. Wilson's Cabinet of Wonder: Pronged Ants, Horned Humans, Mice on Toast, and Other Marvels of Jurassic Technology. Vintage Books, Random House (1996).

Wood, Beatrice. I Shock Myself: Beatrice Wood, Career Woman of Art, Schiffer Publishing (2018).

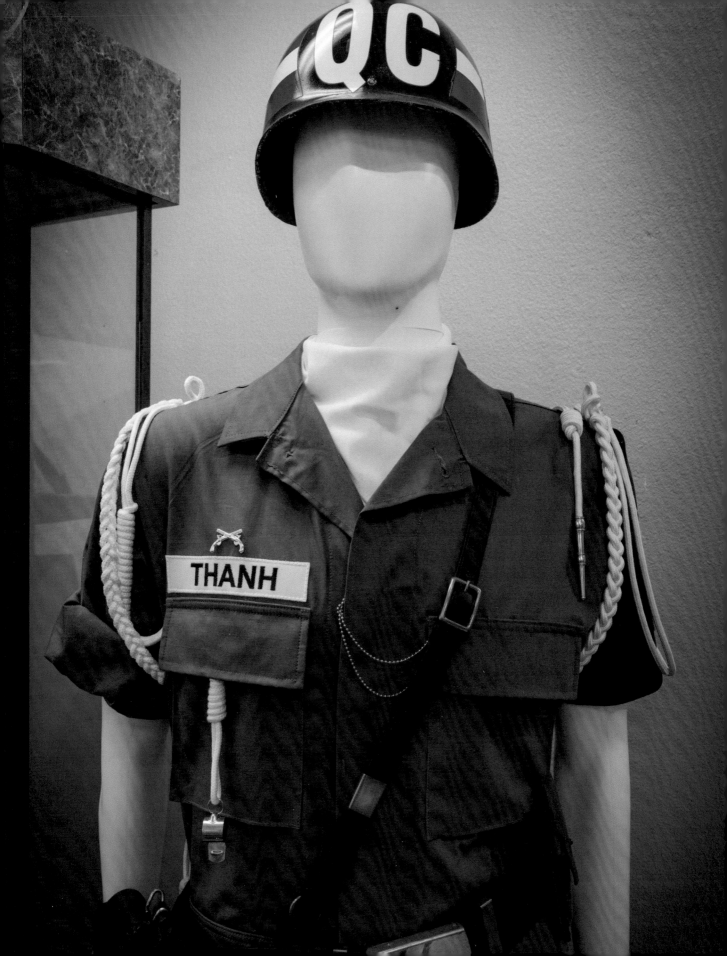

Acknowledgments

I must first express my gratitude to all those who are responsible for bringing the featured museums into the world and keeping them open: creators, founders, curators, directors, collectors, historians, caretakers, docents, students, volunteers, rangers, entrepreneurs, employees, adherents, family, and community members...and anyone else involved in sustaining these spaces, allowing others in to see and be enlightened, and inviting me to highlight and celebrate their stories. And though the scope of this project was limited by necessity, my appreciation and respect goes to the operators of all museums, large and small; the world would be poorer without their efforts.

Ryan Schude has been much more than an outstanding photographer for this project, even if the exceedingly high quality of the results *(museum quality!)* was foreseeable. Whether or not he was fully aware just how many miles we would travel, how much energy would be expended capturing all these sites, and how many hours it would take over several years to sort and edit the hundreds of resulting images, his commitment has been nothing short of heroic. It cannot be overstated the degree to which this book has benefited from his contributions, and I am forever grateful for his collaboration, dedication, and for lending his widely recognized talents to ensure its success. Undoubtedly, thanks must also be extended to Agatha French for her encouragement and support behind the scenes.

At Angel City Press, Terri Accomazzo deserves all the flowers and more. Her thoughtful and thorough editing has resulted in a product that is more consistent, more considered, and entirely better all around. But to call her simply an editor overlooks her larger role as capable project manager, staunch ambassador, and constant steward from start to finish. The book would quite simply not exist without her unwavering support. Hilary Lentini and her colleagues at Lentini Design & Marketing, Inc. have brought their depth of experience to create something beautiful, and I am privileged to be the beneficiary of their sensitivity and expertise.

I thank Angel City Press founders Paddy Calistro and Scott McAuley for their early enthusiasm for this project and for their long, successful career building and sustaining ACP as the premiere publishing imprint dedicated to the history and culture of Los Angeles. Their decision to donate the business to the Los Angeles Public Library was in keeping with their established visionary outlook and will benefit Angelenos for many generations to come.

At the Los Angeles Public Library, I am indebted to City Librarian John Szabo, Assistant City Librarian Susan Broman, and librarians and LAPL

A reproduction of a South Vietnamese Quân Cảnh (military police) uniform at the Museum of the Republic of Vietnam.

staff members too numerous to list. They have not only shepherded the continuation of Angel City Press under their banner, and shown their belief in and encouragement of me personally, but also support the spirit of this work through their daily efforts to preserve and share the stories of the communities they serve. It is an honor to work with this critical institution, and I am proud that the collection of stories this book represents has found a home here.

At the Library Foundation of Los Angeles, my gratitude goes to President and CEO Stacy Lieberman, who through her belief in me and this project not only allowed the space and time required to make it happen, but also advocated for it and helped to garner excitement more broadly. I continue to find deep fulfillment personally and professionally in working with her and with all of my colleagues at LFLA in support of our libraries.

An original wheel from Horace Heidt's wildly popular 1930s Pot O' Gold radio program is on display at Horace Heidt Big Band Museum.

A special class of appreciation is reserved for my mentor and dear friend, the late Ken Brecher, whom I have to thank not only for this but for all future successes with which I may be blessed. To this it must be added that Rebecca Rickman has likewise taught me a thing or two about life, work, and friendship.

My wife, Bridget Marrin, is the rare individual who can save lives by day and create incredible artwork and exhibits by night. She has not only supported me throughout the protracted process of bringing this project to life, but has also created enduring works that make the museum-scape richer and more interesting.

My mother, Yvonne Lerew, has always encouraged my obscure interests and the obsessive manner in which I pursue them, and it's to her I credit my belief that people are basically good and that everyone's story matters. My late father, Ed Lerew, continues to inspire me through his fearlessness, his generosity, his determination, and his tendency to view so much of his work as a form of play.

I am thankful for the many friends who have accompanied me on small museum marathons and day trips, and for everyone who has brought to my attention yet another museum that I had otherwise failed to discover. Lastly, thanks to the curious readers, and to curious people everywhere, who help foster the open exchange of ideas and stories, making the world more wondrous and life more meaningful.

About the Author

Todd Lerew is Director of Special Projects for the Library Foundation of Los Angeles, curating eclectic exhibitions and programs in support of the Los Angeles Public Library. He is a composer of experimental music and inventor of acoustic instruments such as the Quartz Cantabile, which converts heat into sound. He was winner of the 2014 American Composers Forum National Composition Contest and has had his work performed across the US and Europe. He received the 2022 National Outstanding Eagle Scout Award, and has served as a volunteer fire lookout at Keller Peak in the San Bernardino National Forest since 2016. He holds a BFA from Hampshire College and an MFA from CalArts, and collects library cards, pictorial maps, and all-black postcards that claim to depict a certain location at night.

About the Photographer

Ryan Schude is an editorial, advertising, and fine art photographer. Had it remained viable, he might still be working at the rollerblade magazine that shaped his formative years, but a pivot into commercial photography happily funded his personal projects for the past two decades. Often employing a staged narrative approach akin to theatrical tableaux, environmental portraiture remains integral to his work, connecting him with artists, educational institutions, and just about any character willing to engage in the process. He recently moved to a small town just outside of Los Angeles with his wife, Agatha, daughter Antonia, and mother-in-law, Jessie. Ryan teaches photography and media arts at the Ojai Valley School.

Vintage PlayPlace equipment at the First Original McDonald's Museum in San Bernardino.

The dining room table at the Kimberly Crest museum is set for the season, spring in this case.

Also on View: Unique and Unexpected Museums of Greater Los Angeles

By Todd Lerew

Copyright © 2024 Todd Lerew

Photographs © 2024 Ryan Schude

Mel Mermelstein Museum/Orange County Holocaust Education Center images:
All artworks and underlying copyrights are owned by the Auschwitz Study Foundation

Design by Lentini Design & Marketing, Inc.

10 9 8 7 6 5 4 3 2 1

ISBN-13 978-1-62640-119-8

All rights reserved. No part of this book may be reproduced or transmitted in any form or by any means, electronic or mechanical, including photocopying, recording, or by an information storage and retrieval system, without express written permission from the publisher.

"Angel City Press" and the ACP logo are registered trademarks of Los Angeles Public Library. The names and trademarks of products mentioned in this book are the property of their registered owners.

Library of Congress Cataloging-in-Publication Data is available.

Published by Angel City Press at Los Angeles Public Library

www.angelcitypress.com

Printed in Canada